A SHORT HISTORY OF
FLORIDA RAILROADS

*This book is respectfully dedicated to the many employees of Florida's railroads—
past, present, and retired. The men and women who have
"walked the walk. . . ."*

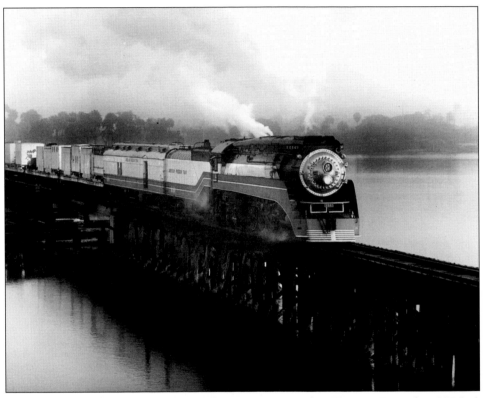

*Seaboard Coast Line Railroad hosted the American Freedom Train in December 1976. A
fully-restored Southern Pacific "Daylight" steam locomotive hauled the consist, seen here
passing through Gibsonton, Florida. (Courtesy Fred Clark Jr.)*

THE
MAKING OF AMERICA
SERIES

A SHORT HISTORY OF
FLORIDA RAILROADS

GREGG TURNER

ARCADIA
PUBLISHING

Published by Arcadia Publishing
Charleston SC, Chicago IL, Portsmouth NH, San Francisco CA

Printed in the United States

Library of Congress control number: 2003100020

For all general information contact Arcadia Publishing at:
Telephone 843-853-2070
Fax 843-853-0044
E-Mail sales@arcadiapublishing.com
For customer service and orders:
Toll-Free 1-888-313-2665

Visit us on the Internet at www.arcadiapublishing.com

FRONT COVER: *Both freight and passengers were carried on the Seaboard's "Vegetable Mixed," seen here en route to Sarasota in the early 1900s. It stopped at farm fields and platforms for vegetable crates. A velocipede often preceded the slow-moving consist. At primitive road crossings, the track employee with a broom would jump off and sweep debris from the rails. (Courtesy Florida State Photo Archives.)*

Contents

ACKNOWLEDGMENTS

This short history of Florida's railroads would not have been possible without the help of certain individuals and organizations. With pleasure I would like to personally thank Joan Morris, curator, Florida Photographic Collection; Cynthia Wise, specialist, Florida State Library; Boyd Murphree, Florida State Archives; John K. Gilchrist, Florida Department of Transportation; James Cusick, curator, P.K. Yonge Library of Florida History, University of Florida; and Nick Wynne and Debbie Morton of the Florida Historical Society.

Other professionals deserving mention include Stan Mulford, Fort Myers Historical Museum; Dorothy Korwek, Venice Archives and Area Historical Collection; David Southall, Collier County Museum; Alyssa McManus, Tallahassee Trust for Historic Preservation; Sandra Johnson, Pensacola Historical Museum; Jeanette Henderson, Baker Block Museum; Patrick Grace and Jim Shelton, Tampa-Hillsborough County Public Library; Sam Boldrick, Miami-Dade Public Library; Joan Pickett, Jacksonville Historical Society; Dawn Hugh, Museum of Southern Florida; Linda Hawkins, Taylor County Public Library; Gregory Ames, St. Louis Mercantile Library; Don Bonsteel, Enoch Pratt Free Library, Baltimore; and Paul Brothers, Bruno Business Library, University of Alabama.

I am also indebted to Larry Goolsby of the Atlantic Coast Line and Seaboard Air Line Railroads Historical Society, as well as the National Railway Historical Society, the Railway & Locomotive Historical Society, the Norfolk Southern Corporation, Florida East Coast Industries, Tri-Rail, and CSX Transportation.

Lastly, a number of individuals kindly supplied research information or made available materials from their own collections. A special word of thanks goes out to Jo Talbird, Jeanne Hickam, Mike Mulligan, Rollins J. Coakley, Fred Clark Jr., Scott Hartley, Dr. and Mrs. Theodore VanItallie, J.W. Swanberg, Sherrie Stokes, Russell Tedder, Don Hensley Jr. of Taplines, and Bob Pickering of Florida Railfan.

Your assistance and support is sincerely appreciated.

~ Gregg M. Turner
GreggTurner@msn.com

INTRODUCTION

Without doubt the greatest factors in Florida's progress are her Railroads.
~ Governor Edward Perry's message to the legislature, 1887

Florida's railroad heritage began in the 1830s, when the future Sunshine State was still a territory and fighting Native American tribes. Since that era, an extraordinary number of railway events and milestones have occurred, many of which—though not all—are recounted in the pages ahead. That railroads have played a decisive role in Florida history can hardly be argued. As agents of change, they conquered the state's vast interior, linked population centers, brought in tourists, and carried off the wealth of Florida's mines, factories, forests, and agriculture. Although their golden age has come and gone, the railroads' mission—according to business historian Alfred Chandler Jr.—remains unchanged: that of furnishing the passenger and shipper with fast, regular, dependable, all-weather transportation.

Prior to the "Iron Horse," waterways were the arteries of Florida transportation. After all, nearly three dozen major rivers course through the land, nearly 8,000 lakes exist, plus the Atlantic Ocean and the Gulf of Mexico wash much of the Florida land mass, which is greater in size than England and Wales combined. Since the 1820s, Floridians aspired to link their waterways with canals, though few were built due to engineering obstacles or lack of capital. The largest of all proposed canals was to stretch across the neck of the peninsula at "Big Bend." Proponents argued that a cross-state ditch would reduce transit times between Gulf ports and eastern seaboard cities, aid the national defense, and eliminate the often perilous journey through the Florida Straits. It was never built.

A twist of events occurred in 1828, when the territory's legislative council chartered the Chipola Canal Company to construct either a canal "or Rail-way" from the Chipola River to St. Andrews Bay. Although rails were not put down, their mention in the act confirms that railway promoters were on the scene. Two years later, Congress was asked to fund a survey and cost estimate for a railroad line running between St. Marks, Florida and Augusta, Georgia. Again nothing was accomplished. Finally, in 1831, legislators approved Florida's first true railroad enterprise: the Leon Rail-Way Company. Although several years lapsed before a successor firm built the line from Tallahassee to the

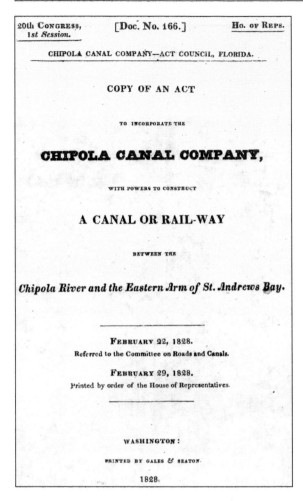

20th CONGRESS, [Doc. No. 166.] HO. OF REPS.
1st *Session.*

CHIPOLA CANAL COMPANY—ACT COUNCIL, FLORIDA.

COPY OF AN ACT

TO INCORPORATE THE

CHIPOLA CANAL COMPANY,

WITH POWERS TO CONSTRUCT

A CANAL OR RAIL-WAY

BETWEEN THE

Chipola River and the Eastern Arm of St. Andrews Bay.

FEBRUARY 22, 1828.
Referred to the Committee on Roads and Canals.

FEBRUARY 29, 1828.
Printed by order of the House of Representatives.

WASHINGTON:

PRINTED BY GALES & SEATON.

1828.

The Chipola Canal Company of 1828 was empowered to build either a canal "or Rail-Way." The legislative act was the first in Florida history sanctioning a railroad.

ancient Spanish fortress at St.-Marks, the measure signaled the start of Florida's railway age.

Literally hundreds of railroad companies were chartered in Florida during the nineteenth century. Many were built, others partly so, while dozens never saw the light of day. All too frequently, a company became financially embarrassed, its directors underestimated construction costs, or hoped-for traffic never materialized. Until the 1880s, the land's sparse population and lack of big industry also served to retard railroad development. As Henry Poor, the famed chronicler of railroad securities, once remarked, "all the early railroads of Florida were unsuccessful, and speedily upon their opening they went into the hands of receivers from whom no information, as a rule, can be obtained."

Our journey into Florida's railroad past begins in the Panhandle with projects of a local nature. Most connected two navigable bodies of water or ran from a good harbor to the interior. Of four railway lines built during territorial days, merely one survived to statehood in 1845: the Tallahassee Railroad, successor

to the Leon Rail-way. Construction quickened, however, once the legislature passed the Internal Improvement Fund Act in 1855. Qualified firms were given generous land grants and a tax-free existence, plus the state guaranteed their bond interest. These incentives sparked construction, but the Internal Improvement Fund eventually became mired in debt and litigation and practically bankrupted the state.

Several important routes opened in Florida around the time of the Civil War, including a strategic cross-state rail line (mimicking a cross-state canal) between Fernandina and Cedar Key. During the war itself, all of Florida's railroads suffered reversals and many were badly damaged physically. Little construction occurred during the difficult years of Reconstruction, with the event of note being a scurrilous securities fraud against the state involving carpetbaggers.

Florida's greatest period of railway development occurred in the 1880s, thanks to several spectacular developers such as Henry Plant, Henry Flagler, and William Chipley. The state's first railroad system also emerged that decade: the Florida Central & Peninsular, whose owners looked beyond local and intrastate traffic. In 1886, most Southern railroads converted to standard gauge track (in lieu of narrow or broad gauge rails), which greatly facilitated the interchange of cars and the running of through trains. A year later, Florida finally established its first railroad commission.

As the nineteenth century closed and a new age began, Florida's biggest railroads were acquired by out-of-state corporations. The Seaboard Air Line purchased the Florida Central & Peninsula, while the Atlantic Coast Line obtained the Plant System. Previously, the Louisville and Nashville had established itself as the preeminent player in the Panhandle. Also, the Southern Railway surfaced at Jacksonville and Palatka by absorbing the Georgia Southern & Florida. Henry Flagler's Florida East Coast Railway did not succumb to outsiders. In 1912, the firm completed the "8th Wonder of the World," its famed Key West Extension. By and large, these corporate ploys overshadowed the state's numerous logging

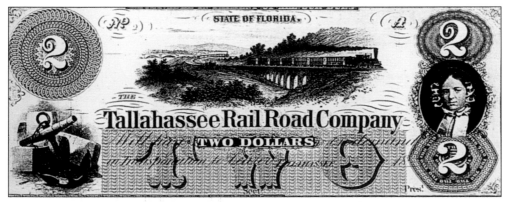

When real currency was scarce, the Tallahassee Railroad issued its own scrip. (Courtesy Florida State Photo Archives.)

railways, whose owners were often wealthy lumberman. Some remained independent, others were acquired by some of the aforementioned firms, while still others quietly vanished along with the huge timber deposits. A similar fate befell the industrial railroads that tapped the state's rich phosphate deposits.

During World War I, the federal government took control of Florida's railroads along with all others in America. After the hostilities, the carriers were returned to their stockholders, often worse for the wear. Then, a colossal land boom took place in Florida. Rail traffic soared as never before, forcing the "Big Three" (Atlantic Coast Line, Seaboard Air Line, and Florida East Coast) to build new lines and make major improvements. The railway map of the state swelled to its greatest extent during the 1920s, but the prosperity was short-lived. Hurricanes wreaked havoc, the stock market crashed, banks closed, real estate buyers vanished, and a national depression set in. Railroad traffic of course nose-dived, as did earnings. Throughout the Depression, Florida's railroads faced intense competition from cars, buses, airplanes, and refrigerated ships. Yet, the carriers persevered by slashing costs, trimming payrolls, purchasing flashy streamlined passenger trains along with diesel-electric locomotives, and offering new freight services.

The federal government did not take possession of the nation's railroads during World War II, as it had for the previous conflict. In Florida, rail traffic reached unprecedented levels, as the land was home to dozens of military installations

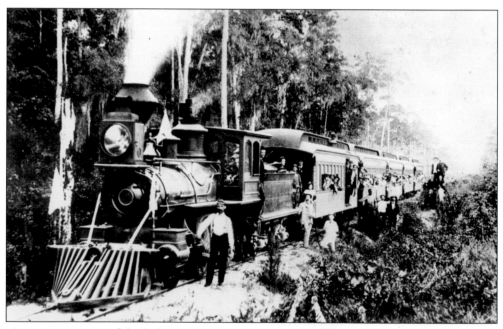

An excursion train of the Jacksonville, St. Augustine & Halifax River Railway momentarily halts for a photographic souvenir near Daytona. Henry Flagler acquired the firm in 1885. (Courtesy Florida State Photo Archives.)

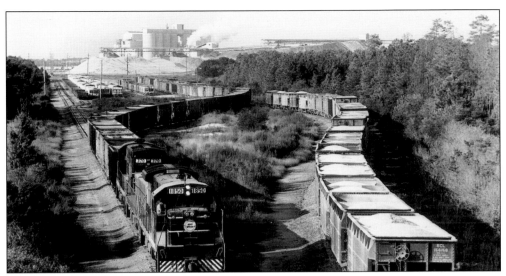

A Seaboard Coast Line Railroad train of phosphate is readied in the "Bone Valley" at Pierce. Then it's off to Rockport (below Tampa) where the mineral will be loaded into awaiting ships. The big processing plant of Agrico is visible in the distance (Courtesy Fred Clark Jr.)

and war-related industries. Rail use benefitted further from the submarine menace that curtailed maritime shipments of citrus, phosphate, sugar, and other manifests. After the war, many businesses and newcomers relocated to the state. Radio communication and computers enhanced railroad operations, while many firms discovered a new revenue stream from "piggyback" traffic (truck trailers moved on railroad flatcars). A historic event took place in 1967, when the state's two biggest competitors, the Seaboard Air Line and the Atlantic Coast Line, merged as the Seaboard Coast Line Railroad Company. Amtrak passenger trains appeared four years later, and in 1980, the Seaboard Coast Line helped forge the CSX Corporation.

Today, CSX Transportation controls more than half of Florida's network of rails. By spinning off little-used routes, the company has created opportunities for small railroad firms called "shortlines." Several now exist in Florida, along with old standbys like the Apalachicola Northern and the Bay Line. Other players include the Florida East Coast, the Norfolk Southern (successor to the Southern Railway), Amtrak, Tri-Rail, and a few industrial operations. At the state level, Florida's Department of Transportation actively monitors railroad operations, promotes safety programs, and oversees several funding initiatives.

For at least one generation, perhaps more than one, the story of Florida railroading will be something of a surprise. Hopefully, this work will enhance the knowledge of this unique and colorful legacy. As historian Oliver Jensen reminds us, "behind the chuffing locomotives and little wooden cars followed the farmer, the miner, the merchant, the immigrant, and all that adventurous company who laid the rails, filled the empty lands, and made the desert . . . blossom like a garden."

1. Territorial Lines

Many of them are little known or completely unknown in the northern part of the United States. Even the geographers appear to be ignorant of the railroads of Florida, for one looks in vain for them on the latest map of North America.
~ Franz Anton von Gerstner, *Early American Railroads*, 1839

Florida became a United States territory in 1821. For years afterwards, the land lacked good transportation primarily because it was so thinly populated. To spur settlement, Florida's legislative council chartered many "internal improvements" such as canals, roads, and railroads. Four railroad lines were ultimately built during the territorial era. Two emanated from St. Joseph to the Apalachicola River, a third connected Tallahassee with St. Marks, while a tiny shortline briefly existed in Escambia County.

Formed by the Flint and Chattahoochee Rivers, the Apalachicola River flows in a southerly, sometimes corkscrew manner before emptying into the Gulf of Mexico at Apalachicola. Steamboats once plied this important waterway, and during the 1830s, "Apalach" became an important cotton port. About 25 miles west of the town lay St. Joseph, which owed its existence to a bitter land dispute. During the time of Spanish colonization, a trading company had acquired huge tracts of land in the region. Once Florida became a U.S. territory, a legal battle arose as to who owned the parcels. The case was eventually heard by the U.S. Supreme Court, which decided that the Forbes purchase was valid. The land firm was willing to settle with the squatters, but at such expensive prices that many pulled up stakes in Apalach and started a new community on St. Joseph Bay.

In practically no time at all, the town of St. Joseph arose, replete with substantial brick buildings, several palatial homes, a gambling house, and even a horse track. Its deep water harbor was frequently crowded with ships and lusty sailors, earning it a reputation as "the wickedest city in the Southeast." But St. Joseph had one handicap: it lacked communication with the Apalachicola River. If a canal could be dug, thought the town fathers, then the cotton and produce manifests destined for Apalach could be diverted to St. Joseph. In February 1835, the Lake Wimico and St. Joseph Canal Company was chartered for that purpose. In June, stock subscription books were opened and within minutes, $250,000 was subscribed.

However, the canal's promoters soon had a change of heart and decided to build a railroad instead. Although the company lacked the authority to do so, laborers began grading the right-of-way in October. At the next legislative session, the canal charter was duly modified.

The Lake Wimico & St. Joseph Canal and Railroad Company constructed an 1,800-foot wharf into St. Joseph Bay, allowing trains directly to meet ocean-going ships. The railroad track then wended its way through town and proceeded to Columbus Bayou on Lake Wimico, a navigable arm of the Apalachicola River. Here, another steamboat wharf was erected together with several buildings for cotton bales. The line was built with broad gauge track (5 feet between the rails), having wooden rails with iron strap tops. The rails, in turn, were attached to pine crossties.

The Lake Wimico firm opened in March 1836, making it the first railroad to operate on Florida soil. It originally used horse-drawn trains, but two 12-horsepower steam engines were purchased from Mathias Baldwin in Philadelphia. On September 5, "a steam locomotive drawing a train of twelve cars containing upwards of 300 passengers passed over the railroad connecting the flourishing town of St. Joseph with the Apalachicola River." The journey took 25 minutes.

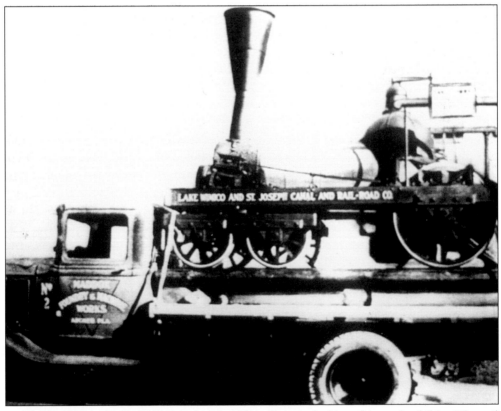

A Panhandle foundry built this locomotive replica, then trucked it to fairs and exhibits. The rail line to Lake Wimico was the first in Florida history. (Courtesy Florida State Photo Archives.)

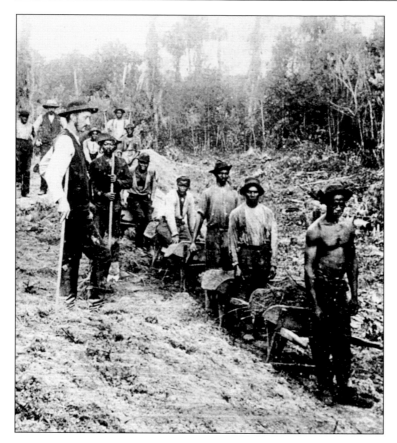

African Americans labored on most of Florida's railways. Such work was not for the faint of heart. (Courtesy Florida State Photo Archives.)

Constructing and equipping the 8-mile route cost $120,000, or roughly $15,000 per mile. During the slow summer months, the Baldwin locomotives were stored and horses again became the prime movers.

At first, freight traffic on the Lake Wimico line was transported for free. Then, tariffs were intentionally kept low until the town of St. Joseph was built up. A passenger ticket cost 25¢, while a bale of cotton was conveyed for 15¢. Cotton was the economic engine of middle Florida and in 1838, the railroad conveyed about 38,000 bales. When wood-burning locomotives were employed, they were placed at the rear of the train and pushed the cars, so that sparks and embers could not ignite the cotton.

The Lake Wimico operation was—from the outset—cursed by the hazards at Columbus Bayou. The steamboat channel often became obstructed with tree branches, sand silted up, and vessels frequently grounded in summer months due to low water. The railroad's directors pondered the problem at length, then decided to rebuild the track from St. Joseph to a more favorable location up the Apalachicola River at Iola. Although a new charter was not needed (the railroad could build to any river locale), directors did request and received a right-of-way through federally owned lands, together with 640-acre sections for each station.

The $325,000 rebuilding contract was given to Benjamin Chaires, reputedly the wealthiest man in the Florida territory. Work commenced in March 1837, the year in which a national financial panic gripped America. Currency became scarce, credit dried up, businesses closed, and soon the railroad had to issue scrip to pay bills. Chaires, though, refused to be paid in this manner. To protect his interests, Florida's first millionaire gathered up all the company's notes, deeds, and mortgages. He allowed construction to continue but at a very slow pace.

Several swamplands were encountered on the 28-mile route to Iola. To overcome Dead Lake, workers had to construct some 5,800 feet of trestlework. The Chipola River was crossed by a lattice swing bridge "of superior construction, several hundred yards in length." Near it, the company had a steamboat dock installed. At Iola, a dock and warehouse were erected on the western bank of the Apalachicola River. Finding laborers to build the Iola line proved difficult. Wages ranged from $30 to $40 a month, depending on skills and experience. In the fall of 1837, an Indian scare occurred on the line. Benjamin Chaires, "fearful that his Negroes may revolt and join the Indians," sent a company of volunteers up the railroad line to the Chipola River. According to one newspaper, "the volunteers did not snap their guns, but they fancied they smelt powder, and like prudent men they hurried home." The line to Iola did not open until May 1839—later than expected due to the financial panic. Two additional steam locomotives were purchased and the inventory of freight and passenger cars was nearly doubled.

Once the railroad opened, price wars erupted. Steamboat firms dropped their rates and tried to keep traffic flowing past Iola to Apalachicola. The railroad, in turn, dropped its rates. With profits declining, the railroad's owners even thought of abandoning their new line and replacing it with a canal, enabling vessels to proceed directly to St. Joseph. There was also talk of a railroad linking St. Joseph with the rival port of Apalachicola. Alas, neither scheme materialized. Yellow fever descended upon St. Joseph, followed by several severe storms. Gradually, the "wickedest city of the Southeast" became a ghost town. The railroad itself was eventually seized by creditors and its assets were sold to a logging railway in Georgia. Interestingly, in the early twentieth century, parts of the old railroad right-of-way out of St. Joseph were used by the Apalachicola Northern Railroad. In the 1930s, its splendid harbor attracted the huge Port St. Joe Paper Mill.

Although the railroad to Lake Wimico was the first to open in Florida history, it was not the first one chartered. That honor went to the Leon Rail-Way Company of 1831, which was empowered to build a line from Tallahassee down to the ancient Spanish fortress of St. Marks. Governor William Duval—no friend of corporations—vetoed its charter, but was overruled by the territory's legislative council. Raising funds for the cotton carrier proved difficult and at the next legislative session, the firm was rechartered as the Leon Railroad Company. Again nothing materialized. The Tallahassee Railroad emerged as another reincarnation on February 10, 1834. By that June, sufficient stock was subscribed and the corporation was duly organized.

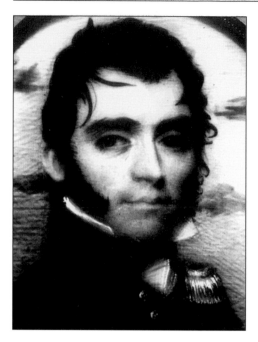

Richard Keith Call controlled the Tallahassee Railroad. A wealthy landowner, lawyer, and politician, he was General Andrew Jackson's aide de camp during the War of 1812. (Courtesy Florida State Photo Archives.)

General Richard Keith Call, a prominent plantation owner, was president of the Tallahassee Railroad. Because he owned so much stock, the firm was often referred to as "Call's Railroad." Call hired Lieutenant George W. Long of the U.S. Army Corp of Engineers to locate the 22-mile route. Congress gave the firm a right-of-way through federal lands, plus a 10-acre parcel at the junction of the St. Marks and Wakulla Rivers. Some of the railroad's investors "loaned" slave labor to work off their stock purchases, and 50 such workers were toiling on the line by late 1834.

The initial rate of construction displeased Call and the directors, who in the following year, hired John and William Gray, railroad builders from Columbia, South Carolina. The pace quickened, and the line—built with wooden rails having iron strap tops—partly opened in 1836, using mule-hauled trains. Not until the following year was the railroad completed to St. Marks. Although the company acquired two steam locomotives, they were only intermittently used because of poor and shifting track conditions. One actually became a runaway and careened into the St. Marks River. Passenger coaches on the Tallahassee Railroad were primitive affairs, consisting of a wooden box with several benches that could accommodate eight guests. A passenger ticket on the line cost $1.50, while a bale of cotton was conveyed for 75¢. Two years after opening, the line was extended past St. Marks to Port Leon at the mouth of the Wakulla River. Here, the railroad purchased 30 building lots and created a company town. A substantial drawbridge carried rails over the St. Marks River.

Franz Anton von Gerstner—the eminent German-Prussian engineer whose monumental book, *Early American Railroads,* has become indispensable to railroad

historians—visited Florida in 1839. He noted that the Tallahassee Railroad owned a steam sawmill about 12 miles south of the capital, which fabricated rails and crossties, cut pinewood for fueling the locomotives, and supplied building materials for Port Leon. Additionally, the railroad owned about 4,000 acres of timberland, a 1,000-acre plantation (on which Indian corn was grown for the railroad's many horses and mules), and 23 slaves. Gerstner says that a trip over the line took about 2.5 hours, at a speed of 9 miles per hour with two horses or mules. Six animals were harnessed together to move freight trains, which were formed with 6 to 8 cars. In 1838, gross revenues of the company amounted to $43,795. Freight traffic accounted for $34,375, passenger traffic for $5,993, and warehousing charges for $3,427. After expenses, a profit of $19,795 was realized. About 30,000 bales of cotton traveled down the line that year, along with manifests of produce and bone fertilizer.

The railroad's primitive construction, crude coaches, and animal-drawn trains drew comments from many quarters. The noted French naturalist and scientific traveler Francis de La Porte (Comte de Castelnau) traveled the line in 1838, and called the Tallahassee Railroad "the very worst that has yet been built in the entire world." However, he went on to say that the firm had proved very useful, as it was almost impossible to take a heavy load of cotton down the route "into which horses sink at every step." The count also noted that at each end of the railroad "a very fine building or depot" existed. He even took time to sketch the one at Tallahassee.

A hurricane and tidal wave visited Port Leon in September 1843. The railroad drawbridge over the St. Marks River was blown off its piers and carried upstream, while the cotton warehouses were reduced to shambles. The company town was subsequently abandoned, but a new terminal was quickly established where the railroad met the river.

The Tallahassee Railroad was the only firm in operation when statehood was granted to Florida in 1845. Later, it was acquired by the Pensacola and Georgia Railroad and rebuilt with iron rails. Decades later, the Seaboard Air Line Railway came into possession of the cotton carrier, and today its right-of-way is a very popular biking and hiking trail.

Little information has been unearthed about the Arcadia Railroad, the fourth firm to open during territorial days. Arcadia itself was a mill village situated on Pond Creek near Bagdad in what was then Escambia County. It was also home to the busy sawmill enterprises of Forsyth & Simpson. In 1835, the Pond Creek and Black Water River Canal Company was chartered to facilitate the transportation of lumber between those two streams. Three years later, the charter was amended and the Arcadia Railroad emerged. The 3-mile line ran mule-hauled trains, but what became of this shortline is a mystery.

No account of territorial days would be complete without mentioning the era's greatest project, yet one never completed. As first proposed, the 210-mile Florida, Alabama & Georgia Railroad was to link Pensacola with Columbus, Georgia—the head of navigation on the Chattahoochee River. Its promoters were keen to tap the rich cotton traffic of Georgia and Alabama and deliver it to the deep water

port of Pensacola, Florida. Cotton growers embraced the project, but the city of Mobile, Alabama feared that Pensacola would usurp its port's prestige. Florida's legislative council chartered the Florida, Alabama & Georgia on February 14, 1834 with capital of $2 million. Later, Alabama chartered the Alabama, Florida & Georgia. In 1835, Florida accepted the Alabama charter and its corporate name. Stock subscription books were then opened in Pensacola and approximately $1.5 million was subscribed. (Shares only needed a small down payment.) Captain William H. Chase, a Massachusetts native and former officer of the U.S. Army Corps of Engineers, was named company president. The territory indirectly lent credit to Chase's firm by allowing the Bank of Pensacola to sell bonds and use the proceeds to buy railroad stock. (The bonds were signed by the governor in the name of the territory.) In April 1835, the bank floated a $500,000 bond issue. The bonds themselves sold quickly and were purchased by a variety of investors, including many residing in England and Holland.

Congress responded to Chase's project by supplying a free survey of the route and giving the railroad a right-of-way through federally owned lands. Major J.D. Graham of the Army Corps of Engineers estimated the line's cost at $1.5 million, or about $6,800 per mile. In April 1836, construction bids were solicited for the first 50 miles of track. To save money, the directors specified that wooden rails with iron strap tops be used in lieu of ones made entirely of iron. Because the project would require a large labor force, advertisements soon appeared in the newspapers of New Orleans and Mobile, while commissioned agents scoured North Carolina and New York for workers. Foreigners were also hired: a large

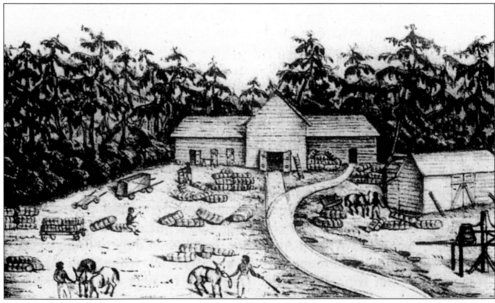

Rail cars were stored inside the Tallahassee depot, seen here in Count Castelnau's sketch, while cotton bales dot the landscape. (Courtesy Tallahassee Trust for Historic Preservation.)

Captain William H. Chase was president of the Alabama, Florida & Georgia Railroad. (Courtesy Pensacola Historical Museum.)

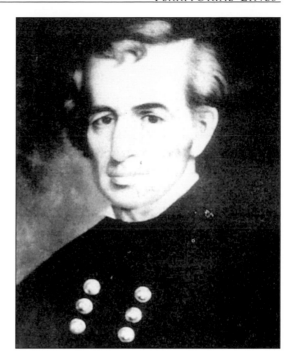

contingency of Irish were eventually recruited, as were Dutchmen—the latter demanding two glasses of beer each work day.

The coming of the railroad sparked a building boom in Pensacola. Railroad officials cleverly terminated the line at a company town called New Pensacola. The Pensacola Land Company acquired the necessary land, a $30,000 hotel was built, and lots were sold at expensive prices to customers from as far away as New York and Europe. Profits helped fund the railroad project.

While laborers graded the route through the Escambia Swamp and towards Alabama, Chase announced that a new northern terminus had been selected: Montgomery. Even though the length of the project was now substantially reduced, it necessitated the purchase of the Montgomery & West Point Railroad, an investment the Pensacola firm could ill afford. Then, the Panic of 1837 set in. The Bank of Pensacola failed and interest on the bank's bonds had to be temporarily paid by the United States Bank "to save the Honor of the Florida Territory." The governor and legislators became aghast at the situation and after much reflection, they concluded that no one ever had the power to endorse the bonds in the first place—much less pledge the territory's credit. With bondholders clamoring for interest, legislators decided to repudiate the securities, which cast a long, dark shadow over Florida for many years to come. How much money was lost in Pensacola's railroad and bank debacle will never be known. For certain, stockholders and bondholders were wiped out, while miles of the railroad route stood silent and unfinished. Yet, Pensacola's dream of obtaining railroad service never died, and from these ashes the proverbial phoenix later arose.

2. FROM STATEHOOD TO SECESSION

Transportation and settlement always go hand in hand; the former makes possible the latter, while the latter creates demand for the former.
~ Kathryn Abbey, *Florida, Land of Change,* 1941

On his last day in office, March 3, 1845, President John Tyler signed the act that created the state of Florida. Even though less than 100,000 people called Florida home that day, the land was still sparsely populated and lacked good transportation resources. Just one railroad company existed at that historic moment: the Tallahassee Railroad, whose mule-hauled trains still transported bales of cotton between the capital and St. Marks. Florida's first state constitution stipulated that the government should encourage "a liberal system of Internal Improvements." To prime the pump, when it was admitted to the Union, Congress gifted Florida 500,000 acres of land, which could be sold and the proceeds applied towards transportation projects. Five years later, Congress ceded all the swamp and overflowed land it owned in the state (some 10 million acres) for purposes of drainage, reclamation, and—thought many—inducements for railroad companies.

To manage the largess, Florida's general assembly organized an internal improvement board in 1851. Three years later, its members issued an exhaustive report showing how the lands might be used to finance a system of railroads running from Jacksonville to Pensacola (with branches to the St. Marks River, Apalachicola Bay, and St. Andrews Bay) and from Amelia Island to Tampa Bay (with an extension to Cedar Key). The report recommended that the railroad lines should be built by corporations and not by the state, and that the newly acquired lands should be used as inducements. Helping to draft the report was United States Senator David Levy Yulee and Dr. Abel Seymour Baldwin of Jacksonville, both of whom became railroad presidents.

Based on the Board's report, the general assembly crafted the Internal Improvement Fund Act of 1855, legislation that would profoundly effect state history for decades to come. The fund itself was to be vested in five trustees: the governor, the comptroller of public accounts, the state treasurer, the state's attorney general, and the registrar of state lands. Railroad companies already existing, and those that the board wanted to have built, had six months to accept

the act's provisions. At that point, they would receive a 200-foot-wide right-of-way through state-owned lands, all nearby building materials (earthwork, stone, timber, etc.), all of the alternate odd-numbered sections of swamp and overflowed land lying on both sides of their completed railroad track, and a tax-free existence for 35 years. To make the legislation even more attractive, the Internal Improvement Fund also guaranteed the bond interest of approved companies—a gesture that years later cast the fund into a legal morass that nearly bankrupted Florida. (Bonds were issued by railroads to pay for construction costs.) The bonds, which the state endorsed, could be issued for up to 35 years and carry a maximum interest rate of 7 percent. Further, bond proceeds could be used only to purchase iron rails, spikes, tie plates, rolling stock, or to fund certain bridge projects. Lastly, the act allowed towns and municipalities to purchase the state endorsed bonds.

Legislators did everything possible to protect the state insofar as the bond interest guaranty. For example, the bonds could not be endorsed by the governor until certain events occurred, such as when crossties were installed or when a company received its iron rails. Further, all construction work was to be inspected and certified by the state engineer. Railway officials also had to furnish the trustees

Interest on this bond was guaranteed by the State of Florida. The trustees of the Internal Improvement Fund had to endorse each security. (Courtesy Florida State Photo Archives.)

Dr. Abel Seymour Baldwin helped craft the Internal Improvement Fund Act and spearheaded Jacksonville's first railroad project. He was a pioneer of the Duval County medical profession. (Courtesy Jacksonville Historical Society.)

with sworn statements about earnings. If a company failed to pay interest, then the Internal Improvement Fund would make good on the defaulted amount, though in such cases the company had to give the trustees a like amount of railroad stock. Lastly, the trustees were given the right to sell a firm at public auction should it default, this after a 30-day notice. In retrospect, the Internal Improvement Fund Act was carefully conceived, with the framers no doubt believing that most of the companies would be profitable and trustee intervention rare. But as the next chapter relates, the opposite happened.

Governor James Broom signed the act into law on January 6, 1855. A year later, Congress—at the behest of Senator Yulee—extended yet another land grant to Florida's railroads. This one was very similar to that of the Internal Improvement Fund and involved land inventories not yet conveyed to the state nor necessarily located near a company's track. The news, of course, enticed railroad promoters. Not only could they launch projects in a most inviting atmosphere, but they could now enter the land business on a scale never thought possible.

The biggest railroad project visualized by the fund's framers involved a line from Jacksonville, across the Panhandle, to Pensacola, but building this 350-mile route all at once was beyond the financial capabilities of any Florida corporation in the 1850s. Nevertheless, it was eventually constructed, though in piecemeal fashion by several firms over many decades. In fact, the long-awaited link from Chattahoochee to Pensacola was not finished until 1883.

The Jacksonville-to–Lake City leg was undertaken by the Florida, Atlantic & Gulf Central Railroad. Dr. Abel Seymour Baldwin, a pioneer of Duval County's medical profession and a civic light of Jacksonville, was the project's prime mover. Chartered in 1851, the firm was empowered to build a rail line from the St. Marys River on the Atlantic Ocean to the Gulf of Mexico. For several years the company remained dormant while Baldwin arranged finances. On January 7, 1853, the legislature permitted the company to connect "some navigable river in East Florida to a Gulf coast point west of the Apalachicola River." Three million dollars in capital was authorized.

Raising funds for the "Central" (as it was popularly called) became easier after Baldwin helped craft the Internal Improvement Fund. Shortly after its passage, Baldwin wrote to the fund's trustees accepting the provisions of the act. By then, the company's route had been fixed from Jacksonville to Alligator, a community located some 60 miles west of the St. Johns River. (Named for a crafty Seminole Indian chief, Alligator was renamed Lake City in 1859.) The City of Jacksonville aided the project by issuing $50,000 of municipal bonds—the first in city history— and using the proceeds to buy railroad stock. Columbia County, where Alligator was located, also responded by issuing bonds totaling $100,000. Other funds for construction and equipment were raised through sale of stock, bonds, and acreage that the company later received from the Internal Improvement Fund.

Surveys of the railroad route began in the fall of 1855 with construction commencing a few months later. About 150 laborers were hired and paid $1 per day. The railroad's engineer estimated the cost of preparing the right-of-way at $240,000, with an additional $600,000 needed to purchase iron rails, locomotives, and rolling stock. Engineering expenses and contingencies were placed at $40,000. Thus, the total cost was to be about $880,000, or $15,000 per mile.

Colonel John P. Sanderson, a prominent Jacksonville lawyer, became company president in 1857. Installation of iron rails began that summer, but work thereafter was interrupted by labor shortages, delays in iron rail shipments from England, and an outbreak of yellow fever. Consequently, the line to Lake City (by way of Baldwin and Olustee) was not finished until March 13, 1860—some five years after construction began. Two days later, a special train was run to Lake City, where celebrants enjoyed a barbecue. On March 21, excursionists from Lake City were entertained in Jacksonville. The Florida, Atlantic & Gulf Central initially purchased five steam locomotives, most from the Rogers Locomotive Works in Patterson, New Jersey. Each was of the "American Standard" variety and carried a name. From other sources, the railroad acquired freight and passenger cars— though many boxcars were built in the company's shops at Jacksonville. The

railroad also ordered a first-class passenger coach salon from William Cummings in Jersey City.

In addition to subscribing to stock, the city of Jacksonville gave the Central a free right-of-way to the St. Johns River, where the company installed a substantial wharf. Additionally, city fathers gave the firm free land for shops and buildings together with a 35-year immunity from corporate taxes. When the railroad was first built, 13 lumber mills were operating near the city. The railroad transported large amounts of lumber and logs, as well as cotton, animals, hides, vegetables, produce, and naval stores. In retrospect, the Central was conservatively run. During the Civil War, the line incurred much damage and failed to meet its obligations to the Internal Improvement Fund. A reorganization took place and litigation ensued over ownership, though in time stability was restored. Today, this important route is used by both CSX Transportation and Amtrak trains.

Extending rails west of Lake City became the mission of the Pensacola and Georgia Railroad. Chartered on January 8, 1853, the P&G route was vaguely stated as running "from the city of Pensacola . . . to some point on the boundary line between the states of Florida and Georgia." Among its incorporators was Captain William H. Chase, who had been involved with Pensacola's failed railroad dream in territorial days. For several years, the directors of the P&G deliberated as to

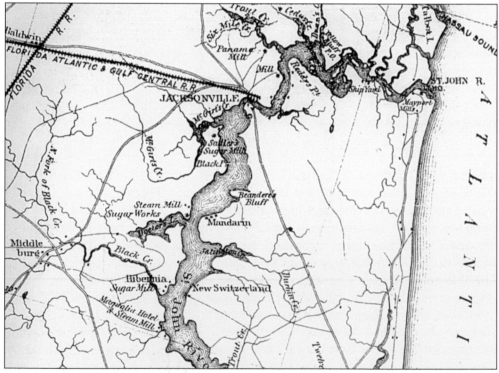

The Jacksonville terminal of the Central was located on the St. Johns River. At Baldwin, the Central intersected Senator Yulee's Florida Railroad.

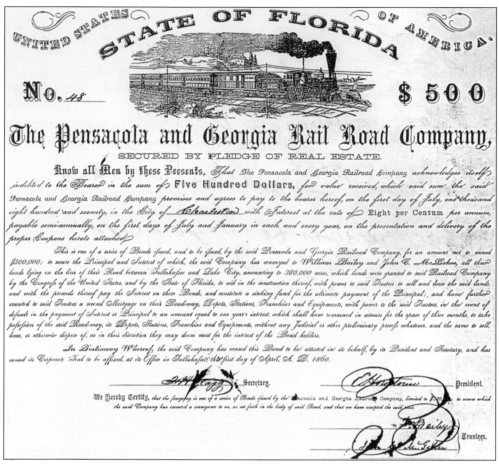

Many railroad bonds were issued without a state guarantee of interest. This $500 example carried an 8 percent interest rate. (Courtesy Florida State Photo Archives.)

where their line should be constructed. However once the Internal Improvement Fund was created, the idea of building to Georgia was dropped, as more mileage constructed in Florida meant a bigger land grant. The legislature modified the company's charter in December 1855, allowing it to build from Lake City to Pensacola. Finances, however, continued to plague the project and ultimately, the directors concluded that they could only fund a line from Lake City to Quincy. The 180-mile gap from Quincy to Pensacola was left to be built by others.

Construction commenced at Tallahassee in the spring of 1856. Here, a connection was made with the Tallahassee Railroad to St. Marks. Later that year, the P&G obtained control of the 22-mile line, which still used mule-drawn trains and wooden rails. The little cotton carrier was outfitted with new crossties and iron rails and its animals were put to pasture, replaced by two steam locomotives. The first train down the refurbished St. Marks branch ran on July 16, 1859. Construction materials for the P&G mainline were then landed by ship at St.

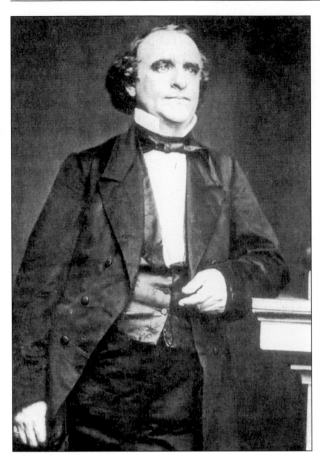

United States Senator David Levy Yulee helped prepare Florida's Internal Improvement Fund Act of 1855. He also became president of the Florida Railroad. (Courtesy Florida State Photo Archives.)

Marks, brought up the branch to Tallahassee, then dispatched eastwards towards Lake City. The mainline itself was divided into several sections. Subcontractors performed most of the work and were compensated with a combination of cash, stock, and bonds. At one point, nearly 400 laborers were on the scene cutting vegetation, grading the line, and installing bridges, crossties, and iron rails. Many of those who built the P&G were slaves, "loaned" to the railroad by stockholders to work off their stock purchases. In 1858, the company published a rule book to govern employees and the movement of trains. Apparently the firm, like the Tallahassee Railroad, owned slaves even after the line was constructed. At least one regulation reveals how recalcitrant workers were to be handled:

> Overseers must not strike a Negro with any other weapon than a switch, except in defense of their person. When a Negro requires correction, his hands must be tied by the overseer and he will whip him with an ordinary switch or leather strap not exceeding thirty-nine lashes at one time, nor more than sixty in one day, or for one offense, unless ordered to do so by the supervisor and his presence.

The P&G opened between Tallahassee and Capitola in November 1857. Drifton was reached the following January, the same month the branch between Drifton and Monticello was finished. Greenville—first known as Station Five, because it was the fifth railroad station east of the capital—received the Iron Horse in March 1858. That July, the track was completed to Madison. Other labor gangs simultaneously worked west from Lake City, obtaining materials and supplies by rail from the Central. In the summer of 1858, the railroad opened between Lake City and Wellborn, while the final gap from Wellborn to Madison (by way of Live Oak and Ellaville) was completed on New Year's Day 1861. Ironically, the Pensacola and Georgia Railroad neither served Pensacola nor Georgia. In fact, its mainline was not completed west of Tallahassee to Quincy until 1863—one of the few railroad projects constructed in Florida during the Civil War. Like the Central, the P&G later defaulted on its obligations to the Internal Improvement Fund, and it was subsequently auctioned to new owners.

The legislative session that created the P&G also sanctioned the Alabama & Florida Railroad in January 1853. Among its incorporators was the indefatigable Captain William H. Chase. Chase's new venture proposed to build a railroad from Pensacola to the Alabama state line in an almost direct northerly fashion. From there, an Alabama project would carry rails into Montgomery. The City of Pensacola responded by bonding itself for $250,000, using the proceeds to purchase A&F stock. Another $116,000 was raised through public stock sales. Once constructed, Chase's railroad received about 27,000 acres of land from the Internal Improvement Fund and even more under the federal grant. During 1856, the 45-mile line was located from Pensacola to Pollard, Alabama by way of Cantonment, Florida. At Pensacola, a bayside wharf was erected at the foot of Tarragona Street. Enthusiasm for the railroad ran high, and the Pensacola *Gazette* remarked that "in a few years it will be necessary for people in New Orleans to send to us for the necessaries of life, and Mobile would be desolate only for us."

Considerable merrymaking accompanied the Pensacola groundbreaking on April 12, 1856. Three months later, 10 miles of line were graded in Escambia County. A $400,000 bond issue was then floated to purchase iron rails, locomotives, and rolling stock. Several private individuals purchased most of the issue, because the railroad was willing to pledge all of its assets and anticipated land grants. Another bond issue amounting to $154,000 was prepared in early 1861. In April, the A&F finally opened between Pensacola and Pollard. However, by that time Florida had seceded from the Union and an unpleasant fate awaited Chase's railroad company.

Greatest of all projects built between statehood and secession was the Florida Railroad—the pet project of United States Senator David Levy Yulee. An Atlantic-to-Gulf railroad line had been discussed since territorial days and several were chartered, though none built. Proponents insisted that such a project would trim 800 miles from the maritime journey between New Orleans and New York City and prevent vessels from having to round the dangerous and tricky Florida Straits. Under the plan, ships emanating from a Gulf port would proceed to the

railroad's terminal on Florida's west coast. Cargoes then would be unloaded and placed into rail cars, then hustled across the peninsula to the railroad's east coast terminal. There, manifests would be reloaded into vessels for the trip up the Atlantic seaboard or to Europe. Arrangements would be reversed for traffic going to the Gulf of Mexico.

At Yulee's bidding, Congress funded a survey for an Atlantic-to-Gulf line in 1842, from the St. Marys River to Cedar Key. Yulee suggested that the state, rather than private enterprise, build and operate the firm. To finance the company, he proposed selling some of the 500,000 acres of federal land that Florida would receive when admitted to the Union. Although the plan failed to materialize, the project tantalized Yulee to the extent that he and his colleagues quietly began to acquire terminal properties at both Fernandina and Cedar Key. The company that finally brought the cross-state plan to fruition was the Florida Railroad, which had been chartered January 8, 1853 with Yulee as its president and principal stockholder. Its charter vaguely described the route as running from the Atlantic coast to some Gulf port south of the Suwannee River, with each terminal having sufficient depth to accommodate "sea steamers." Yulee was quite convinced that his railroad would one day turn Florida into a thoroughfare of trade and travel.

While public and investor interest was being aroused, Yulee played a conspicuous role in drafting Florida's Internal Improvement Fund Act of 1855, which—as noted—gave railroads free land grants and guaranteed bond interest. Once the act became law, Yulee wrote to the fund's trustees and accepted its provisions, then asked state legislators to amend his railroad's charter, which they did. The firm then recapitalized at $9 million and formally defined its route: from Amelia Island to Tampa, with an extension to Cedar Key. Company headquarters were established at Fernandina, where the firm also constructed a dock, warehouses, and shops. Its track was then to proceed to the mainland (via trestlework and a drawbridge) and pass through Hart's Road, Callahan, Baldwin, Waldo, Gainesville, and Archer. At Baldwin, the line would intersect the Florida, Atlantic & Gulf Central Railroad—making that station an important junction. That Yulee was going to build Cedar Key first angered many Tampa citizens, who burned the senator in effigy.

The contract to construct the Florida Railroad was awarded to Anson Bangs in January 1855. He performed little work on the project and after his firm failed, a new contract was drawn up with J. Finnegan & Company. Joseph Finnegan, a self-made Irish immigrant who later became a Confederate general, headed the enterprise, assisted by railroad builder General Alexander McRae of Wilmington, North Carolina. Finnegan insisted that his company be paid largely with land parcels. Iron rail for the project was secured through the import partnership of Vose, Livingston, & Company in New York—who accepted mostly Florida Railroad bonds. Finnegan's firm completed the bridge and trestle work at Amelia Island in September 1856, while work simultaneously advanced on the mainland. About a year later, state engineer Francis Dancy reported to the trustees of the Internal Improvement Fund that Finnegan was having difficulty laying track in

Joseph Finnegan ran a construction company that built part of the Florida Railroad. Later, the Confederate general won the Battle of Olustee. (Courtesy Florida State Photo Archives.)

the Alachua Ridge. In fact, work was left incomplete at one interval, which later caused Yulee much angst.

In November 1857, a somewhat unusual meeting took place in Fernandina between Governor Madison Starke Perry, Senator Yulee, and the railroad's directors. After pleasantries were exchanged, the state's chief executive—who owned a large plantation near Micanopy and extensive land holdings in Alachua County—revealed that he wanted the Florida Railroad to bypass Gainesville in favor of Micanopy. Yulee replied that it was not possible to make such a change, especially since certain land grants by the state and federal governments were based on the current route. A heated exchange followed and Perry—once an ardent Yulee supporter—stormed out of the company offices determined to prevail.

Early the following year, the *American Railroad Journal* reported that the Florida Railroad had opened between Fernandina and Starke and that 35 additional miles were graded and ready for iron rails. The article also noted that the line to Cedar Key would be complete by October. Not mentioned, however, were the financial problems of the Florida Railroad and its contractor, J. Finnegan & Company. The national financial Panic of 1857 had severely reduced the availability of investment capital for railroad projects. Further, real estate buyers vanished, banks failed, and

businesses closed. Both the Yulee and Finnegan firms were fastly running out of cash and teetering on bankruptcy. Anxious to restore stability, Yulee knew of only one solution: bring in Northern investors—and quickly. Fortunately, Yulee found a white knight in the form of Edward Dickerson, a wealthy New York lawyer who had successfully defended the rubber patent of Charles Goodyear. Dickerson quickly formed an investment syndicate that acquired more than half of all Florida Railroad stock. (The group's biggest investor was Marshall O. Roberts, president of the United States Mail Steamship Company.) The treasury of the Florida Railroad was refreshed, assuring the completion of its line to Cedar Key. Later, the Dickerson group helped Yulee secure telegraph services and a mail contract between New York City and Cuba. In the process, Yulee had to surrender his controlling interest in the Florida Railroad.

While Yulee sorted out his company's financial problems, the trustees of the Internal Improvement Fund were busily meeting in Tallahassee. Governor Madison Starke Perry, remembering his earlier run-in with Yulee, revealed to his colleagues that the state engineer had given the Florida Railroad a certificate of completion for a stretch of track in the Alachua Ridge, even though it did not meet state standards. More importantly, the trustees had endorsed bonds based on the work having been finished. There were other issues: Perry was convinced that

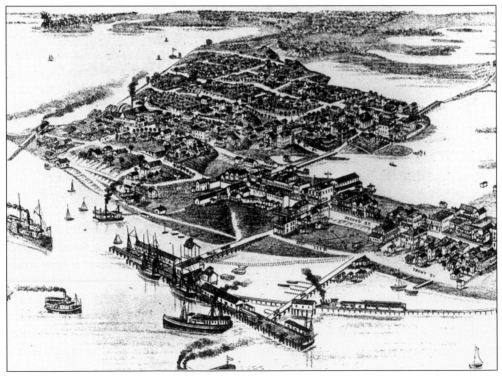

At Cedar Key, trains of the Florida Railroad met vessels at dockside. (Courtesy Florida State Photo Archives.)

the railroad's drawbridge near Amelia Island was poorly constructed and that state bonds for the structure had been misappropriated. The governor also felt that the Cedar Key terminal lacked sufficient water to accommodate sea steamers.

After hearing these accusations, the trustees directed Perry to hire counsel and an investigating engineer. Alfred Sears—a former engineer of the Florida Railroad, by then discharged—presented a preliminary report to the governor saying that Finnegan & Company did indeed have trouble laying track on the questionable stretch of right-of-way. He also admitted that while on a brief trip, the contractor told the company's secretary that the stretch was completed and certified, when in fact it was not. The secretary, in turn, notified the trustees, who illegally endorsed some $200,000 worth of Florida Railroad bonds. The engineer whom Perry hired to investigate the matter more fully, Jonathan Bradford, submitted his report in June 1858. Bradford acknowledged that the bridgework between Amelia Island and the mainland was indeed poorly, perhaps unsafely constructed and that such a structure could not have cost $100,000—though state bonds for that amount had been endorsed by the trustees. He further reported that track on the mainland was installed hastily, lacked good drainage, and in many spots exhibited inferior workmanship. That November, Perry delivered a message to the legislature citing the Florida Railroad irregularities. The accusations could not be ignored, and a joint select committee was formed to investigate the matter more fully.

After months of testimony and political finger-pointing, the committee exonerated Yulee and his Florida Railroad, although several minority reports criticized company policies and its founder. The bridgework from Amelia Island was judged adequate, the poor track conditions were remedied, the harbor at Cedar Key was found able to accommodate sea steamers, and the incorrectly-endorsed bonds had caused no great harm to the Internal Improvement Fund. Construction of the railroad continued, and in early 1860 the 156-mile line to Cedar Key at last was opened. Afterwards, the remaining state and federal land grants were transferred to the firm and by March of the following year, the railroad was declared fully complete—just in time for the Civil War.

If the Florida Railroad was the longest project built between statehood and secession, the shortest was the 15-mile St. Johns Railroad. Chartered on the last day of 1858, the company's prime mover was Dr. John Westcott, a New Jersey native who had come to Florida during territorial days. Westcott studied engineering at the United States Military Academy at West Point and at one point was surveyor general of Florida. Surprisingly, he gave up that career to become a physician. Westcott resided in historic St. Augustine, whose citizens for years clamored for canals to the outside world. Supporters thought that ditches would best serve residents and visitors, and convey the fruits and vegetables grown in the area. Westcott and his associates, though, convinced the townsfolk that a railroad, not canals, would best serve their needs.

The St. Johns Railroad ran from Tocoi Landing on the St. Johns River to New Augustine, a village near the San Sebastian River. Its track was built with wooden

rails and iron strap tops—a throwback to territorial days—while mules and horses hauled the company's first trains. The animals were known to lay down and rest in the course of a journey, which sometimes lasted up to four hours. Although a passenger ticket cost only $2, infuriated patrons complained directly to Westcott. The good doctor's response, however, never varied: "There is simply no other railroad in the United States were a man can ride so long for that kind of money." In 1860, the St. Johns line was rebuilt with iron rails. A primitive steam engine joined new freight cars and a sumptuous passenger salon was ordered from the Murphy & Allison Manufactory in Philadelphia. The pint-size carrier's future seemed bright . . . until the Civil War.

The horse-drawn trains of the St. Johns Railroad often halted while the animals rested. (Courtesy Florida State Photo Archives.)

3. CIVIL WAR, RECONSTRUCTION, AND FRAUD

Railroads shall remain free from toll or other charges upon the transportation of any property or troops of the State of Florida, or of any other Government legitimately succeeding to the powers, right and privileges of the late United States.
~ Florida Laws, 1860–1861, Section 8, p. 84

The Civil War was the first American conflict to involve railroads. Approximately 27,000 miles of lines existed in the United States when the hostilities began, a third of which were located in Southern states. From the war's outset, the Union enjoyed a superior railroad advantage, as a tremendous expansion of lines had occurred in the 1850s. Further, most of the Northern firms were better-built, better-equipped, and better-managed than their Southern counterparts. During the war itself, Southern railways experienced many problems, including a dramatic increase in the cost of supplies and materials. Lubricating oil jumped from $1 a gallon to $50, car wheels rose from $15 to $500, and a bushel of locomotive coal spiraled upward from 12¢ a bushel to $2. Even glass for car windows became scarce, as did kerosene for coach lighting. Wages, too, increased. Payrolls frequently ran late or were never made at all, especially when hard currency was in short supply.

Few assets of any railroad—North or South—were more prized than its roster of steam locomotives. Again, Northern roads maintained the edge: the Pennsylvania and Erie railroads, for instance, had almost as many steam engines as the entire Confederacy. Further, states north of the Potomac River had a dozen locomotive manufacturing plants for every single facility that existed in Southern states. The famed Tredegar Iron Works in Richmond at one time produced locomotives, but had to put such orders aside when the Confederate war machine demanded ordnance. Iron rails—another prized commodity—were almost always in short supply on Southern railways. Although some tonnage was produced by regional mills and foundries before the war, much had to be imported from England and Wales, which became problematic once Lincoln ordered the blockade of Southern ports. When the situation became acute, the

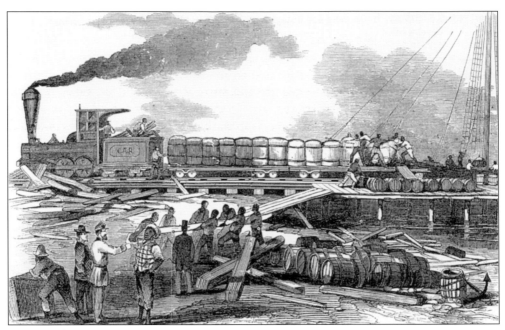

Union soldiers supervise the unloading of a captured Florida Railroad train at Fernandina. Cotton bales and barrels of turpentine abound. (Courtesy Florida State Photo Archives.)

Confederacy had no choice but to meet demands by impressing (or taking up) existing rail from less-important lines.

Robert E. Lee visited Florida in November 1861 and advised Jefferson Davis and Floridians to protect not the state's 1,400 miles of coastline but its valuable interior, where cattle and agricultural products were produced in abundance. Most of the provisions were shipped by rail, along with troops, munitions, and wartime supplies. The five railroads built between statehood and secession were all open when the war began; during the hostilities, most experienced a mixture of prosperity, decline, and destruction.

David Yulee's Florida Railroad was the first to experience the Union's wrath. In January 1862, the Union warship *Hatteras* entered the almost-deserted harbor of Cedar Key. The "Feds" went ashore, burned several ships laden with cotton and turpentine, and torched the railroad's depot, freight cars, and warehouses. Even telegraph lines were torn down. Two months later, a Union naval squadron arrived at Fernandina. The visit, however, was not entirely unexpected, and many inhabitants—including Yulee—had already packed their effects for flight to the state's interior. As the last Florida Railroad train eased over trestlework to the mainland, the Union gunship *Ottawa* commenced firing. The ensuing explosions demolished the train's last car and killed several passengers, one of whom was seated next to Yulee. Immediately the train halted, the last car was uncoupled, and the journey resumed. According to legend, Yulee himself jumped from the train and escaped to the mainland in a canoe. The railroad's

headquarters then were relocated to the safety of Gainesville, where they remained until the war's conclusion.

After the Fernandina raid, there was concern that Union forces would use the Florida Railroad to reach the state's interior. Yulee met with government and military officials and agreed to take up and store a portion of his railroad's iron rails. However, when he discovered that Florida Governor John Milton wanted to use the rails for other railroad projects in the state, Yulee vehemently protested. Undeterred, Milton insisted that the impressment would occur and that the militia would arrest anyone interfering with the process. Yulee, no stranger to the court, obtained an injunction to stop the work. The order quelled the action until Milton made another attempt two years later.

While events unfolded in east Florida, another scenario played out at Pensacola. The Florida & Alabama Railroad—the pride and joy of Pensacola—ran north of the Gulf port to Pollard, Alabama. In early 1862, Confederate forces around Pensacola were withdrawn for service elsewhere. Realizing that the F&A was too valuable a prize to leave behind for Union raiders, the company's directors supported a military plan to remove its iron rails from Pensacola to Pine Barren Creek, some 27 miles distant. But when military powers insisted that even more mileage be pried up, company officials became incensed. The line's president, O.M. Avery, vociferously complained to the Confederate Secretary of War and even traveled to Richmond and put the matter before the government in person. Secretary of the Navy Mallory, who resided in Pensacola, called the action a "damned outrage." Nevertheless, the military got its way. Even rails on the Pensacola and Mobile

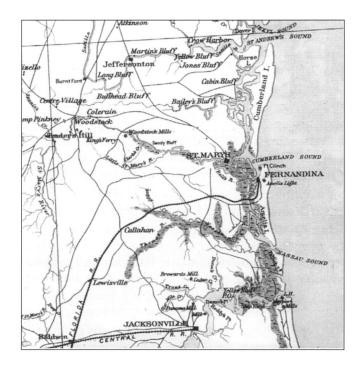

Iron rails on the Florida Railroad from Fernandina to Baldwin were impressed by the Confederate military. After the war, they were returned. (Courtesy Florida State Photo Archives.)

Railroad & Manufacturing Company were impressed. (The firm, one of the few railroads built in Florida during the war, transported pine logs and lumber harvested in the Perdido River area.)

The railroad picture in middle Florida proved far less contentious. The Pensacola and Georgia Railroad became a strategic supply artery between Lake City and Tallahassee, along with its branch from the capital down to St. Marks. In fact, during the war the P&G undertook two important projects: extending its mainline west of Tallahassee to Quincy and constructing a line from Live Oak north to Lawton, Georgia. Quincy was the war headquarters of middle Florida, and was once commanded by General Joseph Finnegan, former contractor of Yulee's Florida Railroad. However, this seat of Gadsden County lacked railroad transportation. The P&G advanced rails west of Tallahassee to Gee's Turnout, 4 miles shy of Quincy, in December 1862. Service to Quincy proper began two months later. Iron rails for the project had arrived from England just before the war started and once the hostilities commenced, the P&G seized them from the U.S. Custom House at St. Marks—without paying the appropriate duties and tariffs, an oversight that sparked litigation years later.

The most important Florida railroad project of the war was the building of the Live Oak-Lawton Connector, a 47-mile line conceived to expedite the movement of troops, munitions, and foodstuffs into Georgia. Work commenced in 1861. The Confederate military asked the P&G to grade the route from Live Oak to the Georgia border (by way of Marion and Jasper) and install the requisite crossties. Meanwhile, a Georgia firm worked south of Lawton to the Florida border. While

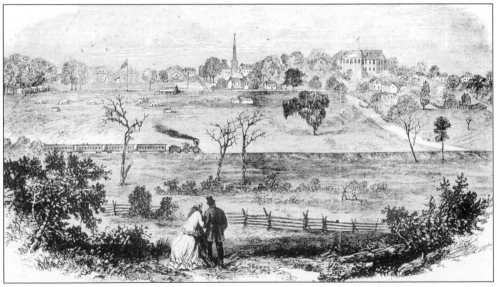

This drawing of Tallahassee, showing a Pensacola and Georgia Railroad train, appeared in Frank Leslie's Illustrated Newspaper *in 1868. Note the Stars and Stripes flying over a Union encampment.*

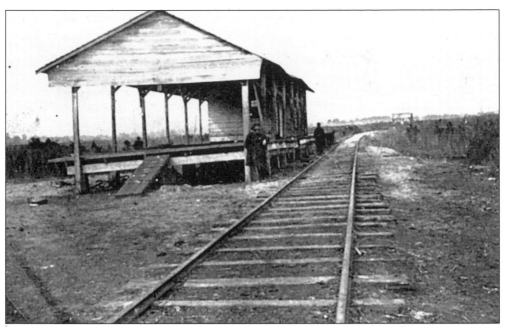

This Civil War–era view is of the White House station on the Florida, Atlantic & Gulf Central Railroad, located just west of Jacksonville. (Courtesy Railway & Locomotive Historical Society.)

construction unfolded, the Confederate military searched for ever-precious iron rails. Enough were found for the Georgia portion of the project, but not the Florida segment—that is, until Florida Governor John Milton entered the picture. Milton again hounded Yulee and the Florida Railroad for rails, but the former Senator was no more receptive to impressment than he had been two years earlier. Milton even wrote a series of letters to Yulee, reminding him of his patriotic duty to the Confederacy, but his efforts proved fruitless.

In the spring of 1864, the Confederacy's engineering bureau directed Major Minor Merriweather to impress rail from Yulee's line. Yulee again turned to the courts for help and obtained another injunction, but Merriweather and Lieutenant Jason Fairbanks were told by their superiors to ignore the court order and proceed as planned. Under military guard, workers started to yank rails between Fernandina and Baldwin. When a sheriff attempted to arrest Fairbanks, the guard sprang into action with fixed bayonets, all of which prompted the lawman to retreat. Milton and Yulee took their disagreement all the way to the upper echelons at Richmond, which in the end sided with the military. The Live Oak-Lawton Connector finally opened on March 4, 1865, but too late to help the Confederacy: one month later, Lee surrendered at Appomattox.

The Florida, Atlantic & Gulf Central Railroad figured into Florida's biggest Civil War event, the Battle of Olustee. Union forces occupied Jacksonville four times during the war. Before the first invasion, departing Confederates destroyed

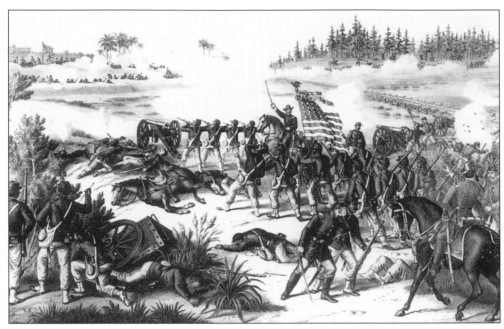

The Battle of Olustee was fought near the Florida, Atlantic & Gulf Central Railroad, whose track appears in the right background. (Courtesy Florida State Photo Archives.)

parts of the Central between Jacksonville and Baldwin. However, it was the fourth invasion in 1864 that brought the rail line into significance. That February, huge numbers of Federal troops arrived in Jacksonville under General Truman Seymour. Seymour aimed to invade middle Florida, disrupt supply lines, and destroy the Pensacola and Georgia Railroad bridge over the Suwannee River near Ellaville. To reach the bridge, Seymour's troops marched along the Central's track from Jacksonville to Baldwin, some 20 miles distant, arriving on February 9. The soldiers then destroyed the railway junction along with several Confederate supply buildings. Confederate General Joseph Finnegan, who happened to be in the vicinity of Lake City, was determined to draw Seymour into battle and called for reinforcements. Finnegan selected good ground for the encounter at Olustee, between Ocean Pond and a swamp. Skirmishes delayed Seymour's advance and allowed time for Finnegan's reinforcements to arrive. On Saturday afternoon, February 20, the famed Battle of Olustee began. Some 5,000 Union soldiers clashed with a similarly sized Confederate force. By evening, the encounter was over with Finnegan winning handily. The Federal troops made a hasty retreat along the railroad back to Jacksonville, while their counterparts gathered up the spoils.

Even the St. Johns Railroad, smallest of lines built between statehood and secession, suffered wartime damage. In March 1862, the Union gunboats *Ottawa*, *Seneca*, and *Pembia* sailed up the St. Johns River with orders to destroy every dock, warehouse, cotton gin, and sawmill. The raiders demolished the railroad's dock at Tocoi Landing, burned the company's rolling stock, ripped apart its lone steam

locomotive, and confiscated its new iron rails, which were then shipped off to Hilton Head, South Carolina. Its owners were crestfallen, and almost five years passed before the line was partially rehabilitated.

Marshall law prevailed in Florida after the Civil War. In the fall of 1865, William Marvin was named provisional governor and a new constitutional convention was held. Congress passed the First Reconstruction Act in 1867, and Florida's new constitution took effect the following year. The war itself had crippled or destroyed almost half of all Southern railroad companies. "Of the ten southern states," notes railroad scholar John Stover, "Florida had the fewest, the weakest, and the poorest railroads in the decade after the Civil War." The U.S. Army briefly controlled the state's railroads in the postwar period. Some received repairs and all were returned to their rightful owners, but the military could not restore their financial health. Most went bankrupt and failed to meet their obligations to the Internal Improvement Fund. Bond interest was skipped and little or nothing was paid into sinking funds to retire bond principal. Thus, the fund's trustees had no choice but to seize and sell many of the railroads.

The Florida & Alabama Railroad not only lacked money after the war, but was devoid of iron rails, engines, and rolling stock. President O.M. Avery sued to recover impressed rails and obtained a business loan to purchase a new locomotive and freight cars. Meanwhile, the railroad's bondholders clamored for their interest. Unable to meet their demands, the firm's principal stockholder, the City of Pensacola, allowed the F&A to enter bankruptcy. A Kentucky syndicate

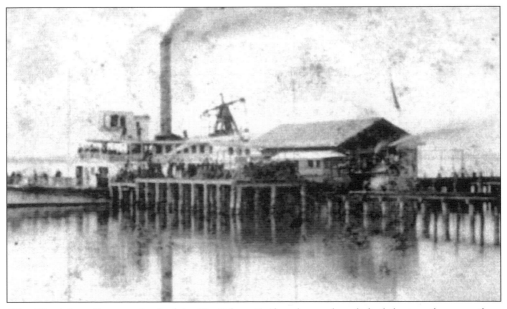

The Tocoi Landing terminal of the St. Johns Railroad was demolished during the war, then rebuilt. Steamboat General Sedgewick *has just met a single-car train. (Courtesy Florida State Photo Archives.)*

gained control and reorganized everything as the Pensacola & Louisville Railroad. Even though the new owners refurbished the line and erected a 2,000-foot wharf into Pensacola Bay, financial problems continued to hound the company. Another sale took place in 1872, and five years later the firm emerged as the Pensacola Railroad. Pensacola banker Daniel Sullivan, now in control, hired an aggressive railroader named William D. Chipley to run the property. In 1880, Sullivan sold out to the Louisville and Nashville Railroad.

Other lines managed to flower in Pensacola during Reconstruction. In 1870, the Pensacola and Mobile Railroad & Manufacturing Company reopened between Cantonment (on the F&A line) to Muscogee. In addition to its rail line, the firm owned several large timber tracts near the vicinity of the Perdido River and also acquired ten blocks of valuable land at the Pensacola waterfront. That same year, service was inaugurated on the 8-mile Pensacola and Barrancas Railroad running from Pensacola to Fort Barrancas by way of Woolsey and Warrington. In 1874, the 5-mile Pensacola and Perdido Railroad began hauling lumber products from Millview (a company-owned town) to its commodious dock in Pensacola, where manifests were loaded into awaiting schooners. At one point, the P&P owned 5 locomotives, 72 freight cars, and a lone passenger coach.

The Florida Railroad suffered the most damage during the war. Among its reversals were the following: both its Atlantic and Gulf terminals were destroyed, miles of its iron rails were impressed for the construction of the Live Oak-Lawton Connector, many of its locomotives and cars were seized, and Union

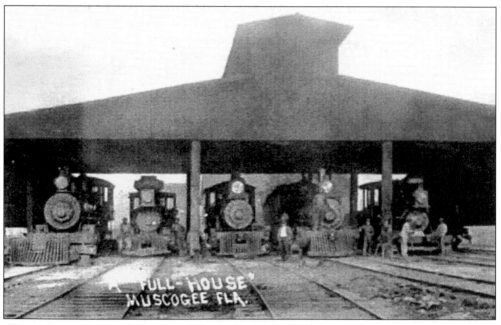

The Muscogee engine shed was built by the Pensacola & Mobile Railroad and Manufacturing Company. (Courtesy Florida State Photo Archives.)

forces destroyed the company's track from Cedar Key to about 30 miles inland. Further, the railroad's physical plant was in a derelict condition, its rails were rusting, its crossties and bridgework were rotting, and much of its right-of-way was overgrown with vegetation. The Dickerson syndicate, principal stockholders of the Florida Railroad, operated parts of the line while founder David Yulee (and other Confederate figureheads) did prison time at Fort Pulaski near Savannah, Georgia. Although a few repairs were made and a few trains operated, the company remained poor. The firm defaulted on its obligations to the Internal Improvement Fund, prompting the fund's trustees to auction the company in the fall of 1866. The same parties who owned the railroad before the sale (the Dickerson syndicate) became its new owners, but they were no longer responsible for the previous debt. The trustees used the auction proceeds to extinguish the railroad's first mortgage bonds, offering bondholders a meager 20¢ on the dollar. Francis Vose—who had supplied Yulee with iron rails when the railroad was first built—refused the settlement and in 1870, filed a lawsuit against the fund and its trustees.

By the late 1860s, the tiny St. Johns Railroad had scraped together enough money to resume operations, though the firm remained in a primitive state. Conditions had hardly improved a decade later, when Charles Hallock—author of the 1876 book *Camp Life in Florida*—took a trip on the impoverished line:

> Two hours strolling about under the shade-less pine trees used up our time while a little asthmatic tea kettle of a steam engine was being tinkered into going condition. It was hitched to two dilapidated boxes on wheels. The railroad itself is more disgraceful than the cars. The rails of pine cypress (no iron!) were worn, chipped, slivered, and rotten. We smashed one flat to the crossties and had a narrow escape from being capsized into a swamp. We crawled along for nearly five hours, delaying at times to put a new rail on the track, to dip a few bucketfuls of muddy water from a ditch into the boiler, or to cut up a log to furnish nutriment for our wheezy little engine. At last the 15 miles accomplished, we reached St. Augustine tired and worn out. May we never go over that road again!

Around 1870, the St. Johns Railroad was bought by millionaire William Astor of New York City. The line was again rebuilt, but curiously its trains continued to be hauled by both steam engines and horses. Occasionally, journeys had to be halted while the conductor cajoled sleeping alligators from the track. The colorful short line was eventually acquired by developer Henry Flagler, who later abandoned it between Tocoi Junction (near St. Augustine) and the river landing.

The Florida, Atlantic & Gulf Central restored its Jacksonville terminal after the war, reopened its mainline between that city and Baldwin, and rebuilt the wrecked junction at Baldwin. Still, the Central failed to make payments to the Internal Improvement Fund and was sold in March 1868. Four months later, a new corporation arose: the Florida Central Railroad. George Swepson, railroad embezzler from North Carolina, was its majority stockholder. In 1870, the firm

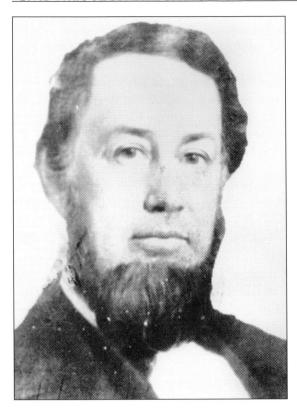

George Swepson bilked the State of North Carolina using railroad bonds. He then committed an even greater scam in Florida. (Courtesy North Carolina Office of Archives and History.)

was taken over by Swepson's infamous Jacksonville, Pensacola & Mobile Railroad, whose story will be recounted later.

The Pensacola & Georgia Railroad in middle Florida survived the war intact and undamaged. After the conflict, President Edward Houstoun secured loans for crossties, locomotives, and materials to build boxcars. The company partly owned the Live Oak-Lawton Connector, allowing the P&G to funnel traffic to Savannah. However, the connector's rails in Florida rightfully belonged to the Florida Railroad. Houstoun ultimately returned them and installed new iron on the link by October 1866. During Reconstruction, the P&G was unable to extend its mainline west of Quincy to Pensacola, greatly disappointing citizens of western Florida. In fact, resentment mounted during Reconstruction, to the extent that there was serious talk of west Florida annexing itself to Alabama. Despite Houstoun's erstwhile efforts, the P&G's finances worsened. Bond interest was skipped and sinking fund payments were not made to the Internal Improvement Fund. The fund's trustees sold the firm together with the Tallahassee Railroad in March 1869. Again, George Swepson ultimately surfaced as purchaser. Interestingly, Swepson acquired the two firms with a large quantity of depressed railroad bonds and a worthless check for $472,065. (State Comptroller Robert Gamble later testified that Swepson had bribed Attorney General Meek with $5,000 to accept the bogus check.) Many privy to the transaction felt that the

State of Florida had been defrauded, which indeed it had, although nothing was immediately done to rectify the gaffe. Swepson then organized the two firms into a new corporation with an old name, the Tallahassee Railroad. The North Carolinian thus controlled a railroad line extending from Jacksonville to Tallahassee and Quincy, and from the capital down to St. Marks. Swepson and his charming associate General Milton Littlefield next proceeded to manipulate the Florida legislature and committed fraud on an even grander scale.

Harrison Reed, Florida's ninth governor, was a former newspaper editor. In 1861, he moved to Washington, D.C. and was hired by the Treasury Department, an agency that occasionally sent him to Fernandina as a tax commissioner. His reputation for honesty got him the position of Florida's postal agent in 1865. Reed eventually entered politics and became the state's chief magistrate in 1868. The Reed administration inherited a bankrupt railroad system, a fractious Republican party, and little money to correct Reconstruction's problems. Not without enemies, Reed survived several impeachment attempts—one of which involved his connections with George Swepson and General Milton Littlefield. Reed knew that the state's railroads needed help. All had financial problems, service was sporadic, and west Florida was seriously considering secession. The governor came to the conclusion that state aid, even though it could be ill-afforded, should

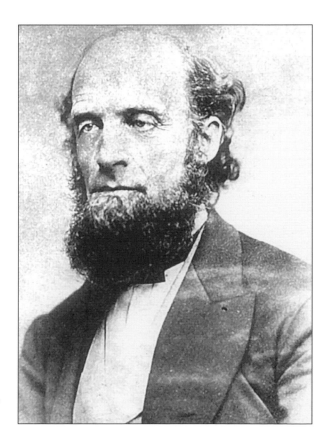

Harrison Reed, Florida's ninth governor, survived several impeachment attempts. (Courtesy Florida State Photo Archives.)

be extended to railroads in certain cases. At the moment, there was bipartisan support for a railroad linking Quincy with Pensacola—cultivated in large part by George Swepson and General Littlefield.

Littlefield, who had recruited and trained African-American troops during the Civil War, had the ear of Governor Harrison Reed—whom he knew from his days in Fernandina. Glib of tongue, the general freely distributed wine and liquor to politicians, lavishly entertained, and handed out generous cash bribes to secure votes. Littlefield's scheming came to a head on June 8, 1869, when Harrison Reed convened a special session of the legislature to consider "An Act to Perfect the Public Works of the State." This act, of course, was the railroad charter that Littlefield and Swepson desired to fill in the gap between Quincy and Pensacola. Littlefield courted politically influential carpetbaggers, who crowded the capital city that month as never before. As chronicler John Wallace related:

> The poorest and the most shabby carpet-bagger could be seen drinking sparkling champagne and wearing fine beavers. The famous Littlefield was too much engaged to walk, and his carriage was kept at the hotel

General Milton Littlefield, the "Prince of Carpetbaggers," committed fraudulent acts in Florida, but was never imprisoned. (Courtesy North Carolina Office of Archives and History.)

in readiness to convey him to any part of the city to see the different members of the Legislature.

When the railroad bill was first read, legislators felt that Littlefield's demands were extreme. Consequently, the bill was reworked so that the Jacksonville, Pensacola & Mobile Railroad Company could only issue $14,000 of bonds—at 7 percent for 30 years—for every mile of railroad it completed. More importantly, it had the right to exchange those bonds dollar-for-dollar for state bonds, which could then be sold in the open market. Interest and principal were guaranteed by the State of Florida. For security, the state would place a first lien upon the railroad's assets. However, before any bond exchange could occur, the governor, comptroller, and treasurer had to be convinced that Littlefield and Swepson had clear title to the properties being pledged. Of course, this meant revisiting a touchy subject: Swepson's worthless check. Swepson had no intention of making good on his bad check, nor did he want the state to place a lien on the railroad's assets. Littlefield, in turn, saw no reason why either he or Swepson had to prove clear title on the "new" Tallahassee Railroad. So the crafty general bribed a state employee to omit the contentious clauses just before the act was officially recorded in the secretary of state's office and became law. *The Floridian* newspaper of Tallahassee deplored the brazen action as "cunning fraud, boldly and adroitly perpetrated." Nevertheless, the deed was done.

The Jacksonville, Pensacola & Mobile Railroad Company was born on June 24, 1869. An organizational meeting was held in New York City in July, with Littlefield being named president and Swepson a director. Further charter amendments allowed the railroad to issue bonds at $16,000 a mile and extended its time to reach the Gulf port of Pensacola from 1873 until 1875. Naturally, the company wasted little time in issuing bonds and exchanging $3 million worth with those of the state. Littlefield then placed the crisp new state securities with S.W. Hopkins & Company in New York City. However, just as the state bonds were being sold there, the New York *World* newspaper ran a disparaging article condemning the illegally-issued securities. The market for them immediately collapsed, prompting Hopkins to engage sales agents in far-away London. The picture seemed to brighten until the London papers also ran condemnatory articles. Unfazed, Littlefield sailed for Europe, lived lavishly, and helped the Hopkins network unload the bonds on the innocent. After all parties had deducted their "commissions and expenses" from the bond issue, a few hundred thousand dollars made its way to the forlorn Jacksonville, Pensacola & Mobile Railroad—barely enough to complete 20 miles of track between Quincy and Chattahoochee.

Naturally, attempts were made to prosecute Littlefield and Swepson, but in the end, there was always a convenient lack of witnesses. Governor Harrison Reed was thought by many to be part of the ring and was subjected to several failed impeachment attempts. Lawsuits arose over ownership of the Jacksonville, Pensacola & Mobile Railroad. One even made its way to the U.S. Supreme Court, which concluded that Littlefield and Swepson had committed "the most shameless

frauds." In 1877, the Florida legislature repudiated the bonds it had exchanged and declared that interest and principal would never be paid—incensing many British and Dutch investors. Slowly, Florida recovered from one of the most despicable episodes in its history.

Jacksonville, Pensacola & Mobile
RAIL ROAD.

On and after Sunday, July 2, 1871,

PASSENGER TRAINS ON THESE ROADS will run as follows, every day, except Sundays:

Trains Going East:

Leave Quincy	8.40 A. M.
Arrive at Tallahassee	10.20 "
Leave Tallahassee	10.50 "
Leave Monticello	12.18 P. M.
Leave Madison	3.20 "
Leave Live Oak	5.35 "
Arrive at Savannah	6.25 A. M.
Leave Lake City	7.14 P. M.
Leave Baldwin	10.11 "
Arrive at Jacksonville	11.27 "

Trains Going West:

Leave Jacksonville	6.30 A. M.
Leave Baldwin	8.10 "
Leave Lake City	11.18 "
Leave Live Oak	1.16 P. M.
Leave Madison	3.30 "
Leave Monticello	5.02 "
Arrive at Tallahassee	7.50 "
Leave Tallahassee	8.20 "
Arrive at Quincy	10.00 "

Passenger Train Going East:

Leave Savannah	10.15 P. M.
Leave Live Oak	10.00 A. M.
Leave Lake City	11.18 "
Leave Baldwin	1.35 P. M.
Arrive at Jacksonville	2.35 "

Passenger Train Going West:

Leave Jacksonville	4.00 P. M.
Leave Baldwin	5.10 "

This 1871 timetable was issued by the Jacksonville, Pensacola & Mobile Railroad before it extended its line west of Quincy to Chattahoochee.

4. A System Emerges

The Florida Railway and Navigation Company, comprising over 500 miles of main track, is destined to materially affect the entire commerce as well as the entire railway transportation system of the Union.

~ *The Key Line Book*, Florida Railway and Navigation Company, 1884

America's greatest era of railroad construction took place in the 1880s. Nearly 75,000 miles of track were built that decade—a figure never surpassed in any part of the world. When the decade began, about 500 miles of railroads existed in Florida. Ten years later, that number swelled to 2,489 miles—a 480 percent increase. The surge in construction was driven by two factors: the resumption of land grants by the state's Internal Improvement Fund and the work of several spectacular developers. Other important events occurred. In 1886, almost every Florida railroad converted its broad or narrow gauge track to standard gauge (4 foot 8.5 inches between the rails), greatly facilitating the exchange of cars and the handling of through trains between the various carriers. The following year, the state established its first railroad commission.

Florida's policy of giving railroads free land grants dated back to 1855. The Internal Improvement Fund Act, which was fathered by United States Senator David Yulee, also guaranteed interest on railroad bonds if companies fulfilled certain criteria. Yulee's firm, the Florida Railroad, partook of this largess and issued bonds to purchase iron rails from Vose, Livingston, & Company—a New York importer headed by Francis Vose. The Florida Railroad, like many firms, failed to meet its obligations during the Civil War, and was ultimately sold at auction by the fund's trustees. Proceeds were used to settle differences with the company's first mortgage bondholders, who were offered $200 for each $1,000 bond they held. Vose, however, refused the settlement, demanding that he be paid every dollar of past due interest and the full face value of each bond. In 1870, after years of wrangling, Vose filed a federal lawsuit against the fund, charging its trustees with fraud and land misappropriation. The court found in Vose's favor and subsequently issued an injunction forbidding the trustees from issuing any further land grants until Vose was fully repaid. The trustees, of course, lacked the money to do so, so the court appointed an administrator to take custody of the

fund. Interest continued to mount on the defaulted portfolio of railroad bonds and the state inched closer to insolvency.

The Vose claim was still unpaid when William Bloxham became governor in 1881. Bloxham knew, as did his predecessors, that the only way the state could extricate itself was to sell some of its huge tracts of land and apply the proceeds to its most pressing obligations. The governor learned that Hamilton Disston of Philadelphia, whose family had made a fortune manufacturing saws, was hunting and fishing with friends near Tarpon Springs. Bloxham joined the party and pitched his state's predicament. In short order, Disston became convinced that the state's swamp and overflow lands could be drained and made productive for agricultural purposes. Negotiations continued in secret, and later that year Bloxham announced that Disston's syndicate (which included British investor Sir Edward Reed) had purchased 4 million acres of land. Florida rejoiced, but the sale was sharply criticized in some quarters because the governor had sold the land so cheaply, at just 25¢ per acre. Nevertheless, the transaction was validated, the proceeds erased the Vose claim, and the land grants to railroads resumed in great style. Disston, who was now America's largest private landowner, began to develop his newly acquired wilderness of prairie, swamp, and hammock. He established a land company at Allendale (which was later renamed Kissimmee), built canals, dredged rivers, connected lakes, and planted sugar cane and vegetables. Disston's dream was short-lived, however: he ran out of money and later committed suicide.

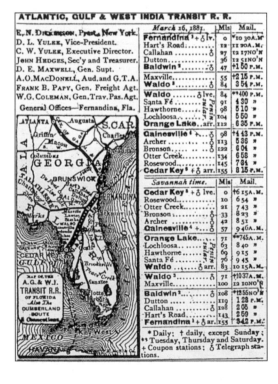

This 1881 timetable is from the Atlantic, Gulf & West India Transit Railroad. Although David Yulee's name appears on the masthead, New Yorkers controlled the firm.

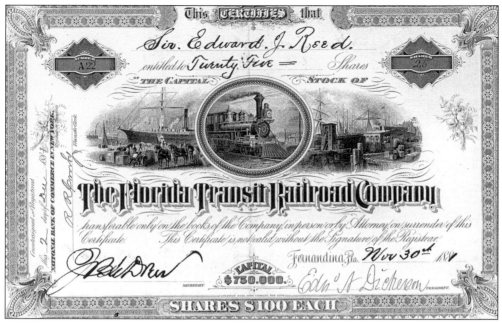

This is a stock certificate of the Florida Transit Railroad Company. Sir Edward Reed, its prime mover, owned a majority of the shares. (Courtesy Florida State Photo Archives.)

After the Disston sale was consummated and land grants resumed, railway fever spread throughout the state as never before. Towns and cities without railroad transportation clamored for the Iron Horse. To attract companies to a specific locale, free land was often given to railway companies along with cash gifts. Many northern capitalists and developers came to the state, bringing with them railroad expertise and funding. Although many local and intrastate projects were built in Florida during the 1880s and 1890s, a new strategy of railroad building emerged: consolidation and system-building.

The first big consolidation of lines is today remembered by only a few railroad specialists. When formed in 1885, the Florida Railway and Navigation Company immediately dominated the railroad affairs of the state. Four years later, it was recast into Florida's first system, the Florida Central & Peninsular Railroad Company. How these two firms evolved was rooted in the difficult years of the Reconstruction. Readers will recall that David Yulee's Florida Railroad was empowered to build a cross-state line from Fernandina to Tampa Bay, together with an extension to Cedar Key. Yulee built the extension first, via Waldo, though he never forgot the plan to Tampa Bay. In fact, he started to grade the route to the Gulf port (from Waldo) before the Civil War, but work ceased once the hostilities erupted. Yulee lost financial control of the company before the line was completed to Cedar Key. In 1872, the Dickerson syndicate had the Florida Railroad reorganized as the Atlantic, Gulf, and West India Transit Company. The Transit Company ended up constructing the line from Waldo to Tampa, but

British capitalist Sir Edward James Reed was fond of Florida and its railroad bonds. (Courtesy British Institute of Naval Architects.)

in piecemeal fashion, using several subsidiaries. The Peninsular Railroad, for example, graded and ironed the line to "the vigorous and prosperous" town of Ocala, some 45 miles distant. The contractor also built a 2-mile branch near Ocala to the popular tourist attraction of Silver Springs. Both lines benefited from state land grants and were completed on Independence Day of 1880. That same year, the Transit Company leased the Fernandina and Jacksonville Railroad, whose line connected Hart's Road station (a point on the Florida Railroad, later called Yulee) to Jacksonville proper. Conceived by New York financiers Edward H. Harriman and Bayard Cutting, the property furnished a useful shortcut into Jacksonville proper and avoided the circuitous city entrance via Baldwin Junction. The line was leased at $12,000 per year. Harriman was the Transit Company's biggest bondholder. Years later, the famed yet controversial mogul turned the Union Pacific Railroad into the finest railroad property in the world.

The Tropical Florida Railroad was organized in 1881 to complete the 34-mile stretch of track from Ocala down to Wildwood and Panasoffkee. Wildwood, named for its remote woodsy location, was reached in June 1882. However, its residents did not take kindly to the railroad, believing that once trees were felled for the right-of-way, the wind would blow down the route and destroy their crops. The railroad's contractor spent considerable time overcoming the challenges of the Panasoffkee Swamp, where sometimes the track would sink overnight. Service to the village started on New Year's Day, 1883.

While construction work advanced towards Tampa, the Transit Company experienced financial difficulties, to the extent that a reorganization occurred and a new company arose in April 1881, the Florida Transit Railroad. British capitalist Sir Edward James Reed was the company's prime mover and also represented certain English and Dutch investors. Reed himself was a distinguished naval architect, designer of warships, prolific author, member of Parliament, and founder of the huge Milford Dry Docks company. Knighted in 1868, he was part of Hamilton Disston's syndicate that purchased 4 million acres from Florida in 1881. (With 2 million of those acres, Reed formed the Land and Trust Company of Florida, based in Jacksonville.) Reed now controlled a fiefdom that included the Florida Transit Railroad from Fernandina to Waldo and Cedar Key, the Peninsula Railroad between Waldo and Ocala with its branch to Silver Springs, the Tropical Florida Railroad from Ocala to Panasoffkee, and the leased Fernandina and Jacksonville Railroad. Yet, even under Reed's hand, the new firm continued to be financially plagued, as its underlying companies all had serious debt loads. Consequently, the Florida Transit and Peninsular Railroad came into existence in January 1883 and again, the company's debt was restructured.

Our story now momentarily shifts to the infamous Jacksonville, Pensacola & Mobile Railroad, whose unsavory existence was recounted in the previous chapter. The JP&M constructed just 20 miles of line between Quincy and Chattahoochee, which opened in March 1872. Pensacola was never reached, and the State of Florida later repudiated the bonds it had exchanged with the company. By then, the company was being sued from every quarter. (Federal authorities litigated for unpaid duties and tariffs on the iron rails that the old Pensacola & Georgia Railroad had illegally taken from the U.S. Custom House at St. Marks.)

This rather impressive coach of the Florida Transit Railroad was built by Jackson & Sharp in 1881. (Courtesy Railway & Locomotive Historical Society.)

Further, bondholders of underlying firms that formed the company had instituted a complicated series of lawsuits and receiverships. Naturally the JP&M went bankrupt, and from its ashes a new firm arose in 1882, the Florida Central and Western. Behind the reincarnation was bondholder Sir Edward Reed, who began assembling the biggest railroad consolidation in state history.

The Florida Central and Western possessed a railroad line running from Jacksonville to Chattahoochee together with two branches: Drifton to Monticello and Tallahassee to St. Marks. The company signed a merger agreement with Sir Edward's Florida Transit and Peninsular Railroad in March 1884. Other signatories included the Fernandina and Jacksonville Railroad and the partially-built Leesburg and Indian River Railroad from Wildwood to Leesburg—both of which were leased lines. Sir Edward then rolled the constituent entities into one big new firm, the Florida Railway & Navigation Company. On January 19, 1885, an organizational meeting took place at company headquarters in Fernandina, and immediately the company became the largest railroad corporation in Florida. Its network of rails, totaling slightly more than 500 miles, was divided into three divisions: the Western Division ran between Jacksonville and Chattahoochee and included the branches to Monticello and St. Marks; the Central Division connected Fernandina with Cedar Key along with Hart's Road to Jacksonville; the Southern Division linked Waldo to Panasoffkee together with the branch to Silver Springs. The "Navigation Company" continued to lease the Leesburg and Indian River Railroad between Wildwood and Leesburg, which it completed in June 1885.

Reed's new firm now began a series of construction projects. At Leesburg, crews installed 10 miles of track to Tavares, extended the mainline south of Panasoffkee

Engine No. 46 of the Florida Railway and Navigation Company was built in 1885 by New Jersey's Rogers Locomotive Works. African Americans usually served as locomotive firemen, but never as engineers.

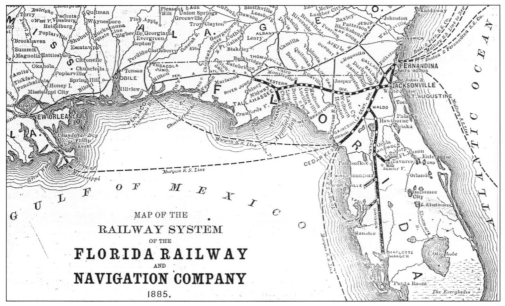

Sir Edward Reed founded the Florida Railway & Navigation Company in 1885. Component lines like the old Tallahassee Railroad to St. Marks are visible.

to Terrell and Plant City, and opened a tiny branch into Sumterville, seat of Sumter County. The Navigation Company also supervised construction of, then leased, the Fernandina and Amelia Beach Railway together with the Jacksonville Belt Railroad, whose track connected the Fernandina and Jacksonville Railroad with the old Florida Central and Western.

On the surface, the Florida Railway & Navigation Company seemed quite prosperous. For instance, in 1884, it owned 525 miles of track, 37 engines, 33 passenger coaches, and 535 freight cars. It also controlled the DeBarry Steamboat Line, whose vessels plied between Fernandina and Savannah, as well as on the St. Johns River. That year, the company transported 190,000 passengers and 283,000 tons of freight. Revenues amounted to just over $1 million. After deducting $600,000 of expenses, the firm realized a net income of $385,197. However, Navigation Company was saddled with considerable mortgage debt. After paying bond interest of $343,900, a surplus of just $41,297 remained. No doubt these kinds of returns disturbed its big New York investors, including Bayard and Fulton Cutting, Edward H. Harriman, and Edward Dickerson. The solution became obvious: a new company had to be formed, its debt had to be restructured, and the railroad had to increase market share. Sir Edward Reed now left the enterprise and the company's next chapter was written by its New York owners.

A receiver began running Navigation Company's affairs in November 1885. The following July, the property was sold at foreclosure and a new corporation was organized, The Florida Central & Peninsular Railroad Company. The FC&P eventually operated some 940 miles of lines and became a strategic corridor for

Engine No. 13 of the Florida Central & Peninsular Railroad was inherited from the Atlantic, Gulf & West India Transit Railroad. It was built by Rogers Locomotive Works in 1880 and later became Engine No. 309 on the Seaboard Air Line Railway. (Courtesy of J.W. Swanberg.)

railroad traffic moving between Florida and Richmond, Virginia. To reach Tampa, the company had to hand traffic over to Henry Plant's South Florida Railroad at Plant City. Relying on a competitor to reach the growing Gulf port disturbed the New Yorkers, and thus they built their own line into Tampa from Plant City beginning in 1889. However, acquiring property near Tampa's old military reservation became problematic, as many parcels were occupied by homesteaders. In fact, the homesteaders tried to block the railroad from crossing their parcels and threatened to obtain an injunction. Regardless, during one weekend, crews installed rails across the properties in question. The matter was favorably resolved (the railroad paid handsomely) and the 22-mile leg (via Turkey Creek, Valrico, and Brandon) was completed on May 1, 1890.

In the following year, the FC&P built a feeder from Archer down to the phosphate mines at Early Bird. The company then acquired several firms in central Florida. In 1891, the FC&P purchased the Tavares, Orlando, and Atlantic, which operated a line between Tavares and Orlando via Zellwood and Apopka. On New Year's Day, 1892, it leased the East Florida and Atlantic Railroad from Orlando to Oviedo. This latter carrier had built no lines itself, but was created from the Orlando and Winter Park Railway from Orlando to Winter Park and the Osceola and Lake Jessup Railway from Winter Park to Oviedo. In May, work was finished on the 4-mile extension linking Turkey Creek with Durant. In 1892, the FC&P also built an extension from Oviedo over to Lake Charm. That same year, Florida's biggest railroad corporation started constructing a major extension of its mainline north from Yulee to Savannah, Georgia, which opened for service on New Year's

Day, 1894. The FC&P then leased the South Bound Railroad, extending its reach north of Savannah to Columbia, South Carolina. One of the last acquisitions the company made in Florida involved the Atlantic, Suwannee River and Gulf Railway, a 57-mile line that ran west of Starke. The latter transported lumber products and served Sampson City, Burnett's Lake, and Alachua. In 1897, the FC&P extended its track beyond Alachua to the community of Buda.

A great variety of traffic was carried by the Florida Central & Peninsular during its heydey. In addition to passengers, express, and mail, the firm conveyed huge quantities of cotton, hides, citrus, produce, lumber, naval stores, and phosphate. In 1898, it owned nearly 1,000 miles of track, 72 locomotives, and 2,165 freight and passenger cars. Curiously, the firm never paid a stock dividend, which caused many to regard it as a speculative enterprise—particularly after another reorganization occurred in 1893. Nevertheless, the FC&P was strategically located and a big player in Florida—a fact much appreciated by its major stockholder, the Seaboard Air Line Railway. The Seaboard operated the FC&P from 1900 to 1903, when it purchased the property. The life of Florida's first system then came to a close, ending a unique chapter in state railroad history.

This Florida Central & Peninsular Railroad Company advertisement is from 1892.

5. The Connecticut Yankee

In the Dixie-land he has made the desert blossom like the rose, changed waste places into fertile fields, the sand heap into a Champs Elysees, and reproduced the palace of Versailles on the banks of Tampa Bay.

~ Tribute to Henry Bradley Plant, Leesburg, Florida, 1896

Henry Bradley Plant was at the ready when the Internal Improvement Fund resumed its land grants in the early 1880s. Plant's railroad endeavors profoundly affected Florida and other Southern states. When his heirs sold the Plant System of Railroads to the Atlantic Coast Line Railroad in 1902, no less than 2,200 miles of lines could be counted. He was also one of the wealthiest men in the South, known for his courteous manners and fair treatment of employees. Plant was born in the seaside village of Branford, Connecticut in 1819. Fatherless at age six, he declined a college education and became a captain's boy aboard steamboats between New Haven and New York City. He then apprenticed in the package express business. Plant married Ellen Blackstone and the couple raised one son, Morton. Before long, Henry was running the New York office of Adams Express Company. In 1853, after his wife had contracted a lung disorder, the couple traveled to Jacksonville, Florida, hoping the winter climate would restore her health. It did, temporarily. Plant later became the Southern superintendent of Adams Express, headquartered in Augusta. The Connecticut Yankee scoured the South for express business, developed transportation contacts, and gained a thorough knowledge of railroad and steamboat services.

Fearing its Southern assets would be confiscated during the Civil War, the Adams firm sold out to Plant, who organized the Southern Express Company. Although no friend of the conflict, Plant met with Jeff Davis and proposed that Southern Express be allowed to handle the Confederacy's payrolls and currency shipments in return for freely transporting packages of Confederate soldiers. Davis liked Plant's forthrightness, agreed to his proposal, and even exempted Southern Express employees from the draft. The war years were lucrative for Plant; however, Ellen died in 1863. The widowed executive, worn and sick, obtained a Confederate passport and left for Europe, from where he continued to run his business affairs. Later, he purchased a substantial home on Fifth Avenue

Henry Bradley Plant founded the Plant System of railroads, hotels, and steamship lines.

in New York City (his office was at West Twenty-third Street). Among his newly found friends was General Henry S. Sanford, who eventually headed Adams Express and developed citrus groves in Florida near Lake Monroe.

Plant was convinced early on that the South would rebuild after the war, presenting unlimited economic opportunities. The key to the renaissance would be effective transportation, and to that end he began collecting destitute railroad companies. Others, he built from scratch. The Plant Investment Company frequently handled the purchase details, and among Plant's partners were Baltimore merchant William Walters, New York financier Morris Jessup, General Henry Sanford, and Standard Oil kingpin Henry Flagler. Whereas Plant himself understood only the basics of railroading, he relied upon several key executives for advice and guidance. Among them was Colonel Henry S. Haines, a New Englander by birth, who had charge of Confederate transportation in South Carolina. Even though Haines lacked a college education, he was particularly astute in railroad construction and operational matters, even writing several treatises. Robert G. Erwin, a graduate of Connecticut's Trinity College, was the legal brains behind Southern Express Company, and subsequently became general counsel for the Plant system of railroads.

Plant launched his invasion of Florida using a Georgia firm, the old Atlantic & Gulf Railroad, which arced down from Savannah to Waycross, Dupont (formerly Lawton), Climax, and Bainbridge. Plant acquired the line in 1879 and reorganized it as the Savannah, Florida & Western Railway. During the waning days of the Civil War, recall that the Confederacy opened its Live Oak-Lawton Connector between

Live Oak, Florida and Lawton, Georgia. After the hostilities, in July 1866, the Pensacola and Georgia Railroad sold its interest in the connector to the Atlantic & Gulf; thus when Plant purchased the line he immediately obtained an entrance to middle Florida. Plant's next target was Jacksonville, regarded as the transportation gateway to the peninsula. To reach it, Plant allowed a Georgia firm to build from Waycross to the state line, whereupon the East Florida Railway advanced rails—using leased convict labor—to Hilliard, Callahan, and Jacksonville. The so-called Waycross Short Line opened in May 1881 and immediately reduced transit times between Jacksonville and Savannah. The third Florida entry emanated from Climax, Georgia. Again, Plant organized a Georgia firm to build to the state line, then his Chattahoochee & East Pass Railway constructed a short stretch of track to Chattahoochee (River Junction), which opened in June 1883. From there, the Savannah, Florida & Western intercepted traffic on the Flint and Chattahoochee Rivers and made connections with the Pensacola and Atlantic Railroad—an important division of the Louisville and Nashville Railroad.

This trio of entrances was just the beginning, for Plant really wanted to build down the peninsula to Tampa Bay and Charlotte Harbor. To extend service south

This advertisement is for the Florida Southern Railway. Its narrow-gauge tracks measured 3 feet between the rails.

of Live Oak, Plant had the Live Oak and Rowlands Bluff Railroad organized. Again, convict labor was leased and the push was made to Branford. At Rowlands Bluff, on the Suwannee River, Plant allowed the steamboat *Cato Belle* to convey passengers and freight down the river, out into the Gulf, and down to Cedar Key. The Live Oak, Tampa, and Charlotte Harbor Railroad advanced construction beyond Brandford to Fort White, High Springs, and Newnansville, which was reached in 1883. In fact, crews were laying track south of Newnansville towards Gainesville when they met a competitor building north, the Florida Southern Railway.

The Florida Southern (formerly the Gainesville, Ocala, and Charlotte Harbor Railway, chartered 1879) was empowered to construct a line from Lake City south to Charlotte Harbor together with a branch from Gainesville to Palatka, in order that its trains could connect with steamboats on the St. Johns River. Company officials built the Gainesville-Palatka branch first, with grading commenced by way of Rochelle in March 1880. Iron rails arrived from England the following spring, and the 49-mile narrow gauge branch opened for business in August 1882. Construction then proceeded from Gainesville north towards Newnansville, where Plant's Live Oak, Tampa, and Charlotte Harbor was encountered. Plant met with Florida Southern officials (several were New England capitalists) and made the following proposal: if the parallel line would cease construction and allow the Live Oak, Tampa, and Charlotte Harbor to use its roadbed into Gainesville, Plant's firm would halt construction. Florida Southern officials liked the idea. In fact, they liked Plant even more, to the extent that in 1883 they gave him a controlling interest in the company. Plant's crews now removed the narrow gauge rails north of Gainesville, widened the roadbed, and installed broad gauge track between Newnansville and Gainesville. However, residents of Lake City did not take kindly to the change of plans, for it meant that the Florida Southern would not connect their town with Charlotte Harbor. Litigation ensued, and Plant was ultimately forced to build a 19-mile branch from his mainline near Fort White into Lake City proper. The matter was no doubt a minor annoyance, more than offset by what the Internal Improvement Fund would eventually grant the Florida Southern: the biggest land grant of any Florida railroad company, 2.7 million acres.

Construction of the Florida Southern now resumed south of Rochelle towards Charlotte Harbor. Ocala was reached in December 1881 and two years later, the company began service to Leesburg. In 1884, Pemberton Ferry (renamed Croom) got the Iron Horse. Nearby Brooksville, however, was not so lucky, but eager citizens there raised $20,000 for a branch track. The Florida Southern obliged, and by January 1885, trains were running from Pemberton Ferry into Brooksville. Numerous citrus groves and lakes dotted this region of the state, and soon the Florida Southern was advertising itself as the "Orange Belt Route." Henry Plant allowed his South Florida Railroad to build the gap between Pemberton Ferry to Lakeland and Bartow, which opened that September. Then, the Florida Southern resumed construction of its final leg from Bartow to Arcadia and Trabue (renamed

This Victorian-era promotional piece was prepared by the South Florida Railroad. The company's mainline ran from Sanford to Tampa by way of Plant City.

Punta Gorda). The 75-mile "Charlotte Harbor Division" was surveyed by Albert Gilchrist, a future Florida governor, and opened in August 1886. Trabue became the railroad's southern terminus, as Colonel Isaac Trabue gave the railroad free land and a right-of-way. At the hamlet's southern tip, a 4,200-foot dock was constructed into Charlotte Harbor, permitting trains to meet steamboats directly. The railroad's real estate division then erected a palatial hotel in Punta Gorda, and before long, tourists and travelers from around the country flocked to the Charlotte Harbor area for its excellent fishing, hunting, boating, and tropical weather.

The aforementioned South Florida Railroad was initially owned by several wealthy New Englanders, who envisioned their line linking Lake Monroe with both Tampa and Charlotte Harbor. Groundbreaking occurred in Sanford on January 10, 1880, with General Ulysses S. Grant throwing out the first shovel of dirt. (General Henry Sanford, namesake of the town, was also present.) Late that year, the line reached Orlando—a haven for rheumatics—by way of Longwood, Maitland, and Winter Park. Kissimmee got the Iron Horse the following March. Henry Plant rode the inaugural train from Sanford to Kissimmee, and as the trip unfolded, he discussed with South Florida president James Ingraham how he might acquire the firm and extend it to Tampa. The discussions led to the Plant Investment Company acquiring a controlling interest in that line in May 1883.

Although the South Florida Railroad had the authority to build to Tampa, a potential competitor of Henry Plant had the same right and, in fact, possessed a better land grant. Plant approached the cash-strapped Jacksonville, Tampa & Key West Railway with an offer: if the firm would sell its franchise between Kissimmee and Tampa, Plant would help finance construction of its mainline between Jacksonville and Sanford. The timing was perfect. Plant paid $30,000 for the franchise, but there was one catch: the 74-mile line had to be built quickly, for its land grant was about to expire. Plant's railroad adjutant, Colonel Henry S. Haines, swung into action. Haines organized some 1,600 laborers and commenced work at both Tampa and Kissimmee. Vegetation was quickly cleared, the roadbed rapidly graded, and rails and crossties installed at breakneck speed. Toiling day and night, the two gangs met one another just east of Lakeland at Carter's Kill on January 22, 1884—just a few days before the grant expired. Opening ceremonies for regular service from Sanford to Tampa began shortly afterwards, with Plant entertaining Governor William Bloxham and his entire cabinet.

About 700 people called Tampa home when the South Florida Railroad came to town. Rows of unpainted houses dotted the landscape. Streets were nothing more than lanes of sand. However, once the Iron Horse arrived, its population began to soar. New industry appeared, such as wholesale fish dealers and cigar makers. Plant later extended the railroad for an additional 9 miles to Port Tampa, where he built the world's largest phosphate wharf—able to accommodate 26 ships at once. Plant's steamboats also used the facility, conveying passengers and freight to such destinations as Key West, Havana, the West Indies, Fort Myers, and Mobile.

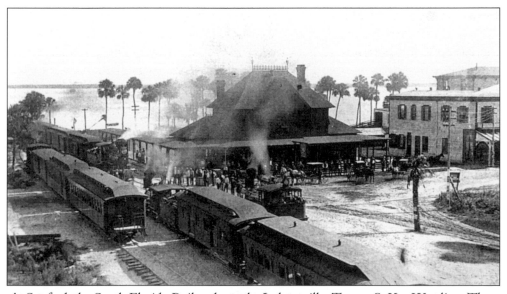

At Sanford, the South Florida Railroad met the Jacksonville, Tampa & Key West line. Three trains and a switch engine are seen in this 1883 image, composed by Stanley J. Morrow. Lake Monroe is in the distance. (Courtesy Florida State Photo Archives.)

To handle the growing ranks of tourists and travelers, Plant opened the Moorish-inspired Tampa Bay Hotel in 1891. (Today, it is a national treasure and the home of the University of Tampa.) During the Spanish-American War, Tampa was a port of embarkation and Plant's "Palace in the Wilderness" was used as army headquarters.

Even though the Tampa projects consumed much of Plant's time and resources, the Plant system of railroads never ceased to expand. In 1883, the South Florida Railroad leased the Sanford & Indian River Railroad, a citrus feeder that connected Sanford with Orono and Lake Jessup. (Later the subsidiary built an extension from Orono down to Oviedo and Lake Charm.) In 1885, the South Florida opened a branch from Lake Alfred down to Bartow, where rails met the mainline of the Florida Southern Railway. Another South Florida extension, connecting Pemberton Ferry with Inverness, opened in 1891. A year later, the South Florida leased the St. Cloud & Sugar Belt Railway, which connected Kissimmee with St. Cloud and Narcoossee—an area that had become headquarters for several lumber and naval store operators.

Meanwhile, Plant's Florida Southern Railway was aggressively expanding. South of Ocala, the company installed a branch from its mainline into Micanopy, which opened in September 1883. (It was later extended to Tacoma.) Another

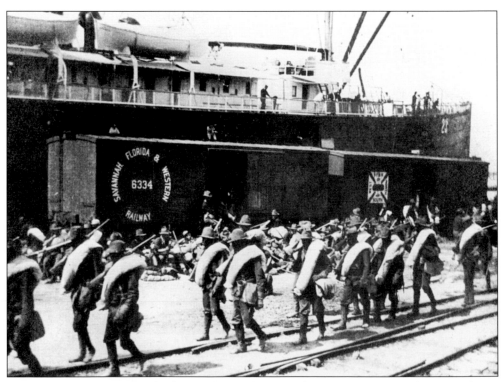

Tampa became a port of embarkation during the Spanish-American War, and Henry Plant's empire benefitted. Here, the Tenth U.S. Calvary prepares to leave for Cuba. (Courtesy Florida State Photo Archives.)

The Jacksonville, Tampa & Key West Railway had great potential until financial problems set in. Its mainline ran from Jacksonville to Sanford. Henry Plant bought what was left in 1899.

opened in 1884 between Proctor and Citra, a region that produced huge quantities of citrus. A year later, the company leased the 48-mile St. Johns and Lake Eustis Railway. William Astor of New York helped promote the latter, which ran from Astor on the west bank of the St. Johns River to the Lake Eustis area—a region being developed by lumbering and agricultural interests. The line opened to Fort Mason in 1880, where a company steamboat made connections to Leesburg via Lakes Eustis and Harris. A few years later, the railroad was extended down to Tavares and Lane Park, which was named for the railroad's president, A.J. Lane of Volusia. In 1884, the mainline was again extended from Fort Mason to Leesburg, allowing the firm to directly connect with the Florida Southern Railway. Bondholders of the Florida Southern briefly leased their company to the Jacksonville, Tampa & Key West Railway beginning in 1890. Then, the FS passed through a receivership (it was burdened with mortgage debt) and emerged as the Florida Southern Railroad with Henry Plant firmly in charge. Plant died in 1899 and three years later, the Florida Southern acquired the Yalaha & Western Railway, a 6-mile appendage connecting tiny Okahumpka—a lumber and turpentine community near Leesburg—with Yalaha.

After the Jacksonville, Tampa & Key West Railway sold Henry Plant its franchise between Kissimmee and Tampa, the firm began constructing its mainline. Coal magnate Robert Coleman of Cornwall, Pennsylvania was the company's prime

mover. In 1883, workers began laying track from Jacksonville to Palatka via Green Cove Springs. Service began in March of the following year. A year later, work resumed to Seville and Sanford, using the charter of the Palatka & Indian River Railway. Service to Sanford started in early 1886. At Sanford, the broad gauge JT&KW met Henry Plant's narrow gauge South Florida Railroad. Both firms converted to standard gauge track that June (as did most other Southern railroads), enabling cars and through trains to be interchanged easily. Shortly before Coleman's firm came to Sanford, the Atlantic Coast, St. Johns and Indian River Railway was completed from Titusville to Maytown and Enterprise—a village on the eastern shore of Lake Monroe. Eager to obtain an outlet to the east coast, Coleman built a 4-mile connecting track from Enterprise Junction near Sanford to Enterprise. There, the JT&KW leased the Titusville firm and its steamboat line on the Halifax River. The JT&KW also acquired the 28-mile Sanford and Lake Eustis Railway in 1887. The latter's track linked Sanford with Tavares by way of Paola and pretty Mount Dora. Three years later, the JT&KW purchased the DeLand & St. Johns River Railroad. A predecessor firm had initially installed rails from the village of DeLand to DeLand Landing on the St. Johns River. After the JT&KW came to town, DeLand's old rail line to the river was abandoned.

Despite its strategic location and ability to move traffic faster than steamboats on the St. Johns River, the JT&KW produced mixed results for its investors. Part of the problem was the fact that the "Tropical Trunk Line" was poorly capitalized. A receiver was appointed to the property in 1893 and the next few years of operation proved tortuous. A national financial panic occurred, bond interest was skipped, several disastrous freezes impacted citrus revenues, and yellow fever epidemics scared passengers away. After five court attempts to sell the firm, the railroad's remaining assets were acquired by the Plant Investment Company in 1899. Henry Plant then had everything reincorporated as the Jacksonville and St. Johns River Railroad, then allowed his Savannah, Florida & Western Railway to run the property.

The Savannah, Florida & Western—the Plant System's biggest component—also grew during the 1880s and 1890s. For example, in 1888, the company opened a 24-mile branch from Thomasville, Georgia to Monticello, Florida. Two other extensions appeared in 1893: one from High Springs to Archer and another from Morriston to Juliette. The SF&W also purchased the colorful Orange Belt Railroad. This 156-mile line, which had opened in 1888, served such Florida communities as Sanford, Sylvan Lake, Claroona, Winter Garden, Lacoochee, Dunedin, and Clearwater. Peter Demens, a Russian immigrant who operated a sawmill at Longwood, was the company's tireless promoter. The railroad's western terminus was Pinellas Point, which Demens renamed St. Petersburg in honor of his Russian birthplace. But Demens's firm was fraught with problems. Construction delays occurred frequently, land grants were forfeited, workers rioted for back wages, and financing periodically collapsed. Creditors forced a foreclosure sale in 1893, with the new owners reorganizing themselves as

the Sanford & St. Petersburg Railway. Two years later, the Plant Investment Company emerged as owner and operations were turned over to the Savannah, Florida & Western.

The SF&W also acquired the Silver Springs, Ocala and Gulf Railroad, which ran between Ocala and Dunnellon, where huge deposits of phosphate and limestone were located. The line opened in 1887. A year later, service was extended to Homosassa and by 1891, to Hernando and Inverness. Henry Plant obtained a financial interest in the company, but it was not formally consolidated into the SF&W until 1901. That same year, the SF&W acquired the Tampa and Thonotosassa Railroad—a 13-mile line that had opened in 1893. To penetrate the Bone Valley, the SF&W purchased the Winston Lumber Company in 1892. The latter had initially constructed a logging line from Winston (near Lakeland) down to the phosphate town of Pebbledale. Later, the track was extended to the mining towns of Phosphoria and Tiger Bay. Phosphate—a key ingredient of fertilizers—was brought by rail to the Plant System's Port Tampa complex for shipment or was sent from the processing plants in special hopper cars to myriad destinations around the country.

Occasionally, the Plant Investment Company directly purchased a firm, such as the 49-mile Florida Midland Railway. Organized by New England capitalists, this line ran from the Lake Jessup area to Ocoee, Dr. Phillips, Harpersville, and Kissimmee. Construction commenced at Longwood in 1886. The following year, a branch was installed from Apopka to Rock Springs, while work resumed on the mainline south of Ocoee to Windemere and Isleworth. Rails reached

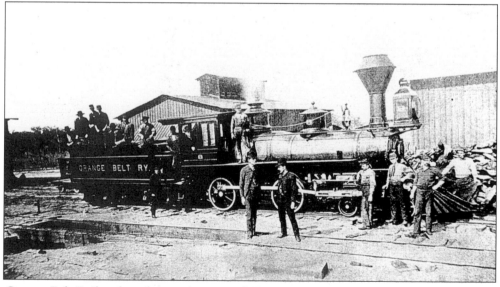

Orange Belt Railroad workers gather around Engine No. 8. Built by Brooks, the narrow-gauge wood burner had 42-inch driving wheels and was bought used in 1888. (Courtesy Railway & Locomotive Historical Society.)

Harpersville in 1889 and Kissimmee a year later. Agricultural and timber products were carried over the Florida Midland. In 1894, that portion of the railroad between Longwood, Apopka, and Rock Springs was leased to the Starbird Lumber Company for private operation. The Plant Investment Company took charge of the Florida Midland beginning in 1896.

Henry Bradley Plant died in New York City at age 80 on June 23, 1899. He was buried in Branford, Connecticut, where today a towering maple shelters his gravesite. Henry's second wife contested his will and, after much legal wrangling, the Plant heirs sold the railroad empire (no hotels or steamship lines) to the Atlantic Coast Line Railroad for $46.5 million. During the nineteenth century, no other Florida railroad firm surpassed Henry's in size—a remarkable achievement for a man who started his career as a captain's boy.

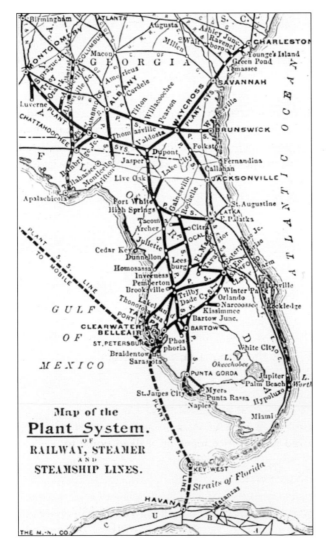

The Plant System of railroads was sold to the Atlantic Coast Line Railroad in 1902.

6. FLAGLER

These railway kings are among the greatest men in all of America. They have wealth, else they could not hold the position. They have fame, for every one has heard of their achievements. They have power, more power than perhaps any one in political life, except the President and the Speaker, who after all hold theirs for only four years and two years, while the railroad monarch may keep his for life.

~ James Bryce, *The American Commonwealth*, 1888

Henry Morrison Flagler was born in 1830 near Rochester, New York, the son of a poor Presbyterian minister. At age 14, he quit school and worked in a general store in Ohio for $5 a month. Around 1850, he became a commissioned grain merchant, and among his contacts was Cleveland produce dealer John D. Rockefeller. Flagler's first wife, Mary, was a niece of Stephen V. Harkness, the whiskey-distilling king of the Buckeye State. Henry Flagler also wanted to make a business fortune, but according to one historian, he was in too much of a hurry. After accumulating about $50,000, Flagler moved his family to Saginaw, Michigan, where he tried his hand at the salt business. Unfortunately, the venture proved disastrous when prices collapsed at the close of the Civil War. Not only did Flagler loose his capital, but he incurred debts of a like amount.

The Flagler family returned to Ohio and Henry reentered the grain business. He also renewed his friendship with Rockefeller, who by then had discovered a new field of interest: oil. Rockefeller had opened a refinery and in 1867, he invited Flagler to join his partnership. Flagler did, after a family member advanced his $100,000 contribution. Rockefeller later recalled:

> For years this early partner and I worked shoulder to shoulder. Our desks were in the same room. We both lived on Euclid Avenue, a few rods apart. We met and walked to the office together, walked home to luncheon, and home again at night. On these walks . . . we did our thinking, talking, and planning together.

Flagler quickly became Rockefeller's marketing expert and contract-maker. Because transportation costs greatly affected the refinery's profits, Henry took

Standard Oil kingpin Henry Morrison Flagler developed the east coast of Florida and integrated his hotels with rail lines. His empire also included steamships, land firms, utility companies, and other enterprises. (Courtesy Florida State Photo Archives.)

a special interest in railroad freight rates, which he felt had to be lowered if the partnership were to truly prosper. Although Flagler himself could not change the published tariffs, he decided to extract rebates, or kickbacks, from the railroads for each barrel of oil they transported. The more barrels conveyed, the greater the rebate. In exchange for these concessions, Flagler directed all of his refinery's needs to that one railroad. More importantly, he guaranteed a minimum number of daily carloads. The minister's son had no problem selling the plan, for the railroads of the day were deeply interested in any customer that could make such a guarantee. Rockefeller's crafty partner took the scheme one step further: after entering into an agreement with one railroad, Flagler disclosed those terms to another, hoping its officials would offer even greater concessions. The ploy worked. Transportation costs were cut to the bone and before long, the partnership started to make money hand over fist. Other Cleveland-area refineries tried the scheme, but in the end, none could match Flagler's minimum daily shipments. Unable to obtain the rebates, most of Rockefeller's competitors failed. At that point, Flagler appeared on the scene and purchased the distressed firm—naturally at below-market prices.

In 1870, at Flagler's behest, the Rockefeller partnership went public. Standard Oil Company emerged, and the new-found funds allowed Rockefeller to begin his quest for vertical integration. Seven years later, Flagler moved his family to New York City, where Standard maintained its headquarters. But poor health continued to plague Henry's wife. The Flaglers were advised to spend some time in Florida. During the winter of 1877–1878, Mary and her doting husband visited Jacksonville, just as Henry Bradley Plant and his invalid wife had decades before. Unfortunately, though, her condition worsened and she died of tuberculosis in 1881. Two years later, and now possessing a fortune of about $20 million, Flagler married young Ida Shrouds, one of Mary's nurses. The couple spent a belated honeymoon in Florida at St. Augustine in 1883. Henry became infatuated with the historic setting, along with its beautiful palm trees, tropical flowers, and warm weather.

The Flaglers revisited America's oldest city in February 1885. At Jacksonville, the couple detrained from Henry's private rail car and made their way across the St. Johns River in a ferry boat to south Jacksonville. There, they boarded a train of the Jacksonville, St. Augustine & Halifax River Railway. (The 36-mile narrow gauge line had opened in June 1883.) Again, St. Augustine worked its charm on the oil baron. That March, the city celebrated the landing of Spanish explorer Ponce de Leon, whose quest for the fountain of youth further sparked Henry's imagination. Convinced that St. Augustine presented fresh challenges, Flagler purchased some land, left town in April, and reappeared in May with his business advisor and an architect. The subsequent building of the Ponce de Leon Hotel created quite a stir. While architects Thomas Hastings and John Carrere labored over details of the Spanish Renaissance structure, the Jacksonville, St. Augustine & Halifax River Railway conveyed building materials and supplies. Flagler himself made innumerable trips from New York as the work unfolded. When the $2.5 million edifice opened in January 1888, it was hailed as one of the grandest hotels in the world. In another leap of faith, Flagler built a companion hostelry for less-wealthy patrons across the street: the Moorish-inspired Alcazar. When he acquired a third, existing, hotel, his triumvirate was complete.

Flagler was greatly concerned with how his hotel patrons would reach St. Augustine. Although the Jacksonville, St. Augustine & Halifax River Railway proved helpful for conveying construction materials, the line did not meet Flagler's exacting standards. Its narrow gauge track was cheaply built, plus the firm was known to render poor passenger service and experience breakdowns. Flagler's clientele would demand something far better, so Flagler joined the railroad's board on December, 10, 1885. Three weeks later, he purchased the $300,000 interest of President Jerome Green of Utica, New York, thus gaining control of the line. In time, Flagler rehabilitated the firm, purchased new cars, added locomotives, and installed standard gauge rails. To eliminate the time-consuming ferry on the St. Johns River, Flagler incorporated the Jacksonville Bridge Company. Work commenced in 1889. The long steel structure opened to traffic the following year, allowing private rail cars and Pullmans to reach St. Augustine directly. To

celebrate the bridge's opening, the railroad ran special excursion trains between Jacksonville and St. Augustine. Flagler, though, was startled at the low fare that his superintendent established for these trips: a mere 50¢. "It would seem to me," he wrote his adjutant, "that a rate as low as this would induce people . . . to come up out of their graves." The specials were nevertheless run.

Flagler then became interested in two other firms that connected St. Augustine with the St. Johns River. The first was the St. Johns Railway, whose story was recounted in Chapter 2. Around 1870, this 15-mile line was acquired by millionaire William Astor of New York, whose son rebuilt it from Tocoi Landing on the St. Johns River to St. Augustine. Tocoi Junction was about halfway along the route. Astor built the St. Augustine & Palatka Railway from Tocoi Junction down to East Palatka, a busy shipping point for vegetables, fruit, and lumber. The new line was reorganized in the late 1880s, about the time Flagler obtained both Astor properties.

The St. Johns & Halifax River Railway also intrigued Flagler. This narrow gauge line was originally conceived as a logging railroad in the early 1880s. By 1886, it ran 51 miles from the vicinity of East Palatka to Daytona by way of Tomoka and Ormond. In 1892, a 3-mile branch was installed from the main track into San Mateo, to serve that hamlet's fruit and vegetable growers. Utley J. White, a successful area lumberman, was the company's prime mover, while Stephen Van Cullen White—a Wall Street broker, financier, and winter visitor of Ormond—played banker. In 1888, the railroad chartered the Palatka Bridge Company, which erected a span across the St. Johns River that connected East Palatka with Palatka. A handy connection was then made with the Florida Southern and the Jacksonville, Tampa & Key West railways. While the bridge was being constructed, White's firm converted its mainline track from narrow to standard gauge. White then became involved with the Ormond Bridge Company, which installed a wooden span over the Halifax River. In exchange for maintaining that structure, the railroad was allowed to install rails upon it to reach Ormond Beach, where the 75-room Ormond Hotel had been built. Henry Flagler gained control of White's fiefdom in May 1888 and, two years later, he obtained a financial interest in the hotel.

In a curious turn of events, Flagler allowed his rail lines to be affiliated with the Jacksonville, Tampa & Key West Railway, whose story was recounted in the previous chapter. However, Flagler's relationship with the "Tropical Trunk Line" was short-lived, as that firm was deeply mired in debt. Flagler then decided to forge his own railroad empire. In 1892, using the charter of the Florida Coast & Gulf Railway, Flagler's contractor started to install rails south of Daytona using leased convict labor. In October, the Florida Coast & Gulf became the Jacksonville, St. Augustine & Indian River Railway—primarily to take advantage of the state's new land grant policy of 8,000 free acres for each mile of railroad constructed. The village of New Smyrna was reached the next month. Flagler's sketchy plan to build across the peninsula to Tampa was dropped, likely because that region of the state was the domain of Henry Bradley Plant. Nevertheless, Flagler hired away two of

Henry Flagler's Jacksonville, St. Augustine & Indian River Railway gathered in all of the master's rail acquisitions. By February 1893, the ribbons of steel had reached Rock Ledge.

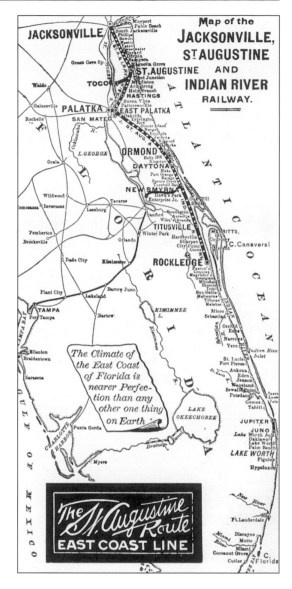

Plant's top lieutenants, railroader James Ingraham and attorney Joseph Parrott. Interestingly, Ingraham had just scouted a rail route for Plant from Fort Myers to Miami by way of the Everglades. Even though he found the route impracticable (the Ingraham party became lost), Flagler knew that Miami, primitive as it was, would have to one day be reached or be lost to a competitor.

The newly formed Jacksonville, St. Augustine & Indian River Railway became a holding tank for Flagler's properties. It gathered up the Jacksonville, St. Augustine & Halifax River Railway (from Jacksonville to St. Augustine), the St. Johns Railway (from St. Augustine to Tocoi Landing), the St. Augustine & Halifax River Railway (from Tocoi Junction to East Palatka), the St. Johns &

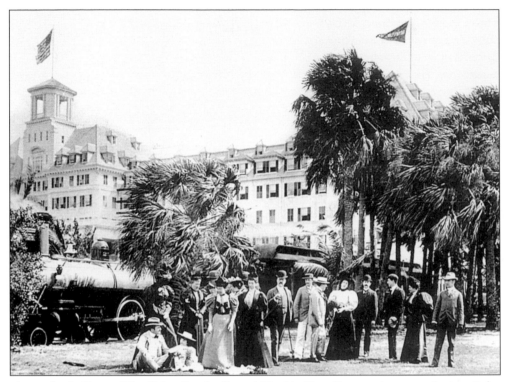

A wooden bridge at West Palm Beach allowed Florida East Coast trains to reach ritzy Palm Beach. This 1896 scene was composed at the Royal Poinciana Hotel. (Courtesy Florida State Photo Archives.)

Halifax River Railway (from East Palatka to Daytona), and the bridge companies at Jacksonville and East Palatka. In essence, it operated a nearly 110-mile-long line from Jacksonville to Daytona.

Flagler's next conquest was the rich agricultural traffic of the Indian River. Workers continued to lay rail past New Smyrna to Titusville—head of Indian River navigation—and on to Rock Ledge, where the Iron Horse arrived in February 1893. Eau Gallie got railroad service in June, while Fort Pierce—242 miles south of Jacksonville—was reached in January 1894. Two months later, rails were spiked to what became West Palm Beach. Flagler, however, arrived there long before his railroad did. In fact, he personally investigated the palm-covered island on the opposite shore of Lake Worth and envisioned the resort community of Palm Beach on its northern tip. To that end, he acquired acreage, laid out the posh enclave, and erected two spectacular hotels: the Royal Poinciana and (what became) the Breakers. Because the railroad had not yet arrived, hotel construction materials were shipped by steamer down the Indian River from Eau Gallie to Jupiter, carried for 8 miles across land on the Jupiter & Lake Worth Railroad to Juno, and reloaded into vessels to reach Lake Worth. Hotel patrons were ferried across the lake from West Palm Beach. In 1895, Flagler installed a wooden bridge

connecting the island with the mainland, which allowed trains to reach the hotels directly. During the busy winter season, private rail cars crowded area side tracks. Servants remained aboard while their wealthy masters passed a few weeks, a month, or the entire season in a sumptuous hotel suite.

Although Flagler could advance his railroad south from West Palm Beach, he was hesitant to do so because the region was so sparsely populated. Regardless, a plucky widow and large landowner named Julia Tuttle, who lived in the confines of old Fort Dallas near the Miami River, repeatedly asked Flagler to build down to Biscayne Bay. She even offered to share her land holdings, but her invitations went unheeded until the disastrous winter freezes of 1894–1895. The thermometer plunged to near zero and countless citrus groves along Flagler's railway were completely destroyed. However, Biscayne Bay escaped the ravages and Tuttle proved it by sending Flagler a box of orange, lime, and lemon blossoms. Flagler met Tuttle and neighbor William Brickell on June 1, 1895. By nightfall, he was convinced that the Miami River area was indeed ripe for development. The parties agreed that—in exchange for receiving free land parcels—Flagler would extend his railroad to the Miami River, help establish a city, and erect a luxury hotel.

The Army Corp of Engineers surveyed the extension from West Palm Beach that summer and construction started in September. Laborers were housed in

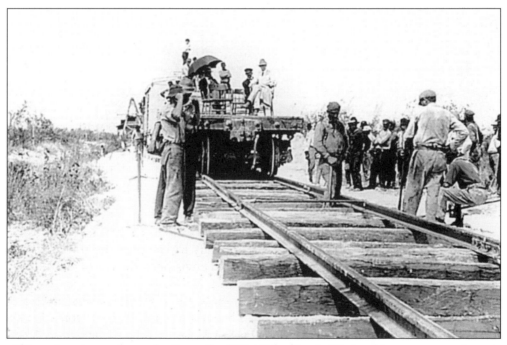

African Americans advanced rails south of West Palm Beach. Their white overseers and guests watch from a flatcar. Ballast has yet to be installed between the crossties. (Courtesy Railway & Locomotive Historical Society.)

several camps along the route. Where possible, steamboats delivered supplies to the work camps via inland waterways. Heavy vegetation was cleared and numerous bridges were constructed. The 70-mile extension to the Miami River opened on April 15, 1896. A few months before, Flagler's contractors began building a luxury hotel, the Royal Palm, which arose where the Miami River empties into Biscayne Bay. Miami itself was incorporated as a city that July. Flagler was the city's first benefactor and arranged to have several streets paved, sidewalks installed, and sewage and water lines built. He also had the city wired for electricity and donated land for churches and municipal buildings.

Just as the railroad commenced construction south of West Palm Beach, Flagler changed the name of his firm to the Florida East Coast Railway. Again, the company expanded. In 1896, the FEC acquired the 28-mile Atlantic & Western Railroad, which ran from New Smyrna inland to Lake Helen, Orange City, and Blue Spring. Four years later, Flagler purchased the 16-mile Jacksonville and Atlantic Railway, which operated between south Jacksonville and the beach community of Pablo, site of the Murray Hotel. (The FEC rehabilitated and

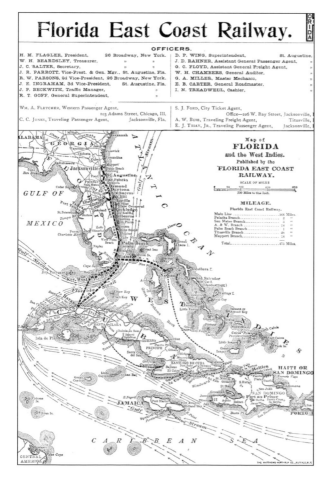

This corporate map was prepared before the Key West Extension was completed in 1912.

Miami's first train station, at Sixth Street and Biscayne Boulevard, featured a horseshoe drive-up for carriages. (Courtesy Florida State Photo Archives.)

eventually extended the line for another 8 miles to Mayport, where it erected substantial docks and wharves.) The Southeastern Railway, a 41-mile line connecting Titusville with Enterprise by way of Maytown, was acquired in 1902. A year later, the FEC extended its mainline south of Miami for an additional 12 miles along the rich lowlands of Cutler Ridge. In 1904, the line was extended again to what became Homestead—another area that Flagler felt had great potential for agricultural pursuits.

The Florida East Coast Railway was just one of several endeavors that commanded Flagler's attention. There were also the affairs of his various land companies, his chain of hotels, his steamship line from Miami, several utility companies, and a trio of newspapers including the Florida *Times-Union*. Flagler's personal life also underwent changes. In 1901, he divorced his second wife on grounds of incurable insanity—a law that he had promulgated. A few weeks after this dissolution, the 71-year-old Flagler married the elegant 34-year-old Mary Kenan. He built her a marble estate in Palm Beach named Whitehall, which is today a national treasure and museum. But Flagler's greatest career achievement did not manifest until 1905. As Seth Bramson, America's foremost authority on the Florida East Coast Railway, stated, "the Key West Extension was a railroad construction feat unequalled, unparalleled in U.S. and possibly world history."

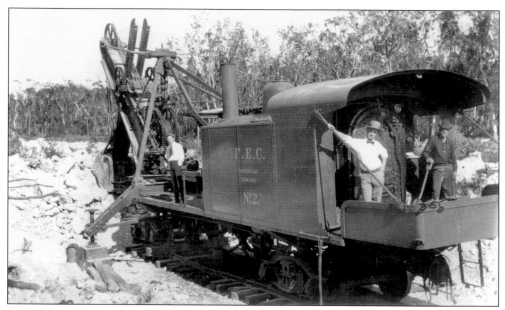

Building the Key West Extension required lots of earth-moving equipment. Here, a steam shovel scoops away limestone on Key Largo in March 1907. (Courtesy Museum of Southern Florida.)

The idea of building a railroad from the Florida mainland to Key West had been discussed since territorial days. In fact, the legislature had chartered several firms during the nineteenth century to construct such a route, but lack of funds or engineering knowledge thwarted each attempt. Nevertheless, establishing rail service to Key West tantalized Flagler because of the latter's proximity to Cuba, Caribbean markets, Mexico, South America, and—most importantly—the Panama Canal. If this "Path Between the Seas" was built, Key West would become the closest American deep water port to the canal and the Florida East Coast Railway an important conduit for its traffic—or so Flagler believed. Several possible routes were examined by Flagler's forces, who concluded that the most feasible solution was to extend the railway south of Homestead to Jewfish Creek and Key Largo. Then, rails would turn in a southwesterly direction and hopscotch over intervening keys and open water to reach the island city. In January 1905, Flagler toured the proposed route in a steamboat, and in May the legislature gave his FEC the green light. (Even before legislative approval was received, laborers had begun hacking their way through the tropical wilderness south of Homestead.) Flagler—now age 75—confidently, but wrongly, predicted that the 128-mile extension would be finished in 2.5 years.

Building the near-$30 million project proved to be a formidable undertaking filled with engineering feats, heartaches, jubilation, and grief. At first, Flagler put the entire project out to bid, but when only one contractor responded (on a cost-plus basis), he decided to have it built "in house." Joseph Parrott, Flagler's legal counsel and general manager, oversaw the immense undertaking, but both he and

Flagler realized that the day-to-day affairs had to be guided by a highly competent construction engineer. Flagler found one in the person of Joseph C. Meredith, an Iowa State graduate who had considerable bridge-building experience and an exceptional knowledge of reinforced concrete. Assisting Meredith was a cadre of engineers, including William J. Krome, a young Cornell graduate who had previously explored for Flagler a Key West route by way of the Everglades and Cape Sable. At the project's high point, some 4,000 workers were employed on the Key West Extension. As one company brochure stated, "men of almost every nation and every shade of color were gathered for the labor." Most were immigrants, many of whom had been hired by padrones, or labor "middlemen," in cities like New York and Philadelphia. (Flagler's firm was later accused of labor brutality and peonage, but the charges were dismissed in 1909.) Virtually every building and construction trade was represented: carpenters, plumbers, electricians, welders, hard-hat divers, bridge workers, riggers, masons, stevedores, pile drivers, concrete mixers, and derrick operators. The pay was modest, only because Flagler provided housing, meals, and medical services. Workers lived in labor camps staggered along the extension or were assigned to floating dormitories called "quarter boats." Life in the camps often proved fractious.

Purchasing, storing, and delivering materials and supplies to the men and work sites was a logistical nightmare. Enormous quantities of lumber and pilings were needed for the project, along with countless barrels of domestic and foreign cement. Steel bridge trusses were ordered by the hundreds, and tons of coal were consumed by the steam machinery that manipulated them. Thousands of railroad ties were purchased along with rails, spikes, bolting hardware, and barge loads of gravel and crushed rock. Foodstuffs were brought down from the mainland together with potable drinking water. A huge supplies complex and command center was established at Marathon. Machine shops, a saw mill, and welding facility-arose at Boot Key, along with a complete marine yard to service the flotilla of vessels that shuttled men and material to the various construction sites. Even Mississippi River sternwheelers were pressed into service.

While laborers toiled south of Homestead, other gangs prepared the right-of-way down Key Largo to Tavernier Creek. The work became more complex as wider expanses of ocean water were encountered. Meredith's forces, however, rose to the occasion and slowly advanced rails across Long Island, Windley's Island, the Matecumbe Keys, and Long Key. To link the latter with Grassy Key, bridge engineers and crews constructed the magnificent Long Key Viaduct, which opened in January 1908. Comprised of 180 concrete arches, the 2.6-mile structure resembled a Roman aqueduct and was later pictured in the railway's promotional pieces. In the end, some 42 bridges were constructed on the Key West Extension to span nearly 18 miles of water.

While preliminary work proceeded on Long Key Viaduct, the October 1906 hurricane struck the Keys, killing nearly 150 workers. Thousands of workers were laid off and the extension was halted for almost a year while clean-up efforts went forward. (Other hurricanes occurred in 1909 and 1910.) Eventually, laborers

were rehired and the ribbons of steel proceeded across Grassy Key, Key Vaca, and mile-long Knights Key. At Knights's southern tip—83 miles below Homestead—Meredith's crews installed a 4,000-foot trestle and dock, enabling the railway to run passenger trains down from Miami. Patrons could then board one of Flagler's Peninsular & Occidental steamships and proceed to Key West or Havana. On January 22, 1908, the first train arrived at Knights and passenger service began the following month. Because of construction delays elsewhere, the Knights Key dock remained the southern terminus of the Key West Extension for several years.

Joseph Meredith died in April 1909 and was succeeded by 32-year-old William Krome. Krome's biggest engineering challenge was bridging the huge expanse of water between Knights and Little Duck Keys. To expedite the work, it was decided to build "Seven Mile Bridge" in four sections. Knights Key Trestle, Pigeon Key Trestle, and Moser Channel Trestle—with its 253-foot drawbridge—were all constructed with steel girder spans placed atop concrete foundations. Pacet Channel Viaduct, however, was comprised of concrete arches. While Seven Mile Bridge was being completed, other gangs toiled on Big Pine Key and the deep waters of Bahia Honda Channel, where yet another major bridge was built to link Bahia Honda Key with Spanish Harbor Key. Once completed, the final constructions' push to Key West was made.

For some time, Krome knew that Key West lacked sufficient land for the railway's terminal and dock. He communicated this fact to Flagler, who tersely wired back, "then make some." Krome decided to dredge Key West harbor and use

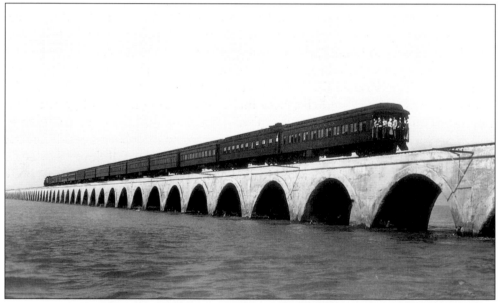

The majestic Long Key Viaduct was the setting of many publicity photographs, such as this one featuring the Havana Special. *(Courtesy Florida State Photo Archives.)*

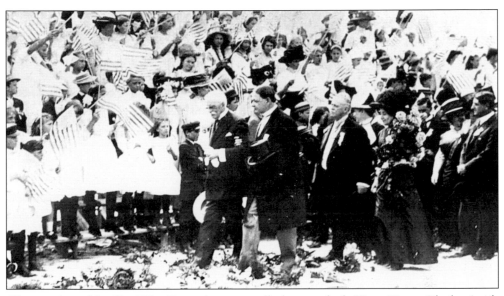

The opening of the Key West Extension was well photographed. Here, Henry Flagler (with boater in hand) is escorted past singing school children waving flags. Flagler's footpath was lined with flower bouquets. (Courtesy Florida State Photo Archives.)

the fill to create an island. But the U.S. Navy refused to sanction the work, fearing it would impact the channel itself. A nasty battle ensued, but the objections were overcome when Krome and project manager Howard Trumbo opted to dredge just the neighboring flatlands. Bulkheads soon appeared, and a 134-acre parcel named Trumbo Island was created. Next, a 1,700-foot dock and terminal buildings were constructed. Nearly 300 employees eventually manned the important facility, from which steamboats and huge railway car ferries departed for Havana.

On January 22, 1912, almost seven years after the project began, the first passenger train arrived in Key West with Henry Flagler on board. Over 10,000 people greeted the infirmed chairman that day, including a bevy of government officials, politicians, and dignitaries from as far away as Europe. The Fifth American Fleet was also on hand, plus a thousand singing school children. About a year after the tumultuous event, Henry Morrison Flagler fell down a staircase in his palatial estate at Palm Beach. He died May 20, 1913 at age 83, and his body was interred at Memorial Presbyterian Church in St. Augustine, which Flagler monies had built. The Key West Extension remained a colorful operation of the Florida East Coast Railway, although it never obtained the freight and passenger traffic that Flagler first envisioned. As related in Chapter 11, the extension was hopelessly decimated by the Labor Day Hurricane of 1935. Later, the railroad right-of-way was sold for the Overseas Highway project.

Three noteworthy events occurred to the FEC prior to the great land boom of the 1920s. The first centered around the rich mucklands near Lake Okeechobee, where sugar and vegetable growing reigned supreme. To tap the region's traffic,

the railway constructed a branch from Maytown down to Okeechobee between 1911 and 1915. This route passed through remote cattle and timber lands, linking several ancient Native American settings, such as Bithlo, Holopaw, Yeehaw, Nittaw, Ilahaw, and Solofka. (Around 1917, the line was extended northeast of Maytown to New Smyrna Beach.) The second event of note took place in 1915, when oil-burning steam locomotives started to haul FEC passenger trains. Contemporary literature proudly proclaimed that passengers no longer had to endure coal dust or cinders. The third event involved World War I. Once America entered the war, the U.S. government took control of the nation's railroads. Florida East Coast Railway officials remained at their posts during the takeover, performing yeoman service. Then on March 1, 1920, the company was returned to its stockholders.

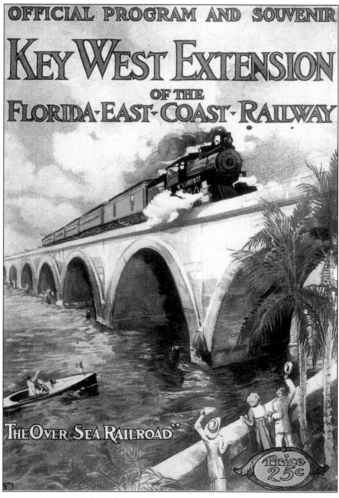

This souvenir booklet of the Key West Extension appeared in 1912.

7. Doings in West Florida

Look here Major Octopus, you can't talk politics, run the State of Florida, do a general land office business, and run a railroad at the same time. Your tentacles will get tangled and suckers exhausted by too much labor.

<div align="right">~ Pensacola Commercial newspaper commenting on railroader
William D. Chipley, 1887</div>

For many decades of the nineteenth century, citizens of west Florida felt isolated from the rest of the state. While tourist literature extolled the attractions of central Florida, Tampa, and the east coast, little was ever mentioned about the western Panhandle, which possessed fabulous stands of timber, the capital city, sugar-like beaches, and the unrivaled port of Pensacola—the largest inland deep water harbor in all of Florida. To end the isolation, railroads were widely discussed and chartered. Although some local lines were built, a huge gap remained between Pensacola and Chattahoochee—a project that the infamous Jacksonville, Pensacola & Mobile Railroad was to have completed. All of this heightened west Florida's desire to annex to Alabama, whose leaders promised a speedy resolution to the transportation problem. As the Marianna *Courier* stated in 1879, "we have waited long enough for help." Just as the dilemma reached a fevered pitch, Colonel William Dudley Chipley and the Louisville and Nashville Railroad entered the scene.

Chipley, a graduate of the Kentucky Military Institute and Transylvania University, had been wounded at the battle of Shiloh. After the rebellion, he worked for the North & South Railroad of Georgia and the Baltimore & Ohio. In 1877, Chipley was appointed general manager of the Pensacola Railroad, a firm owned by Pensacola businessman Daniel Sullivan. (Sullivan's railroad ran north from Pensacola to Alabama near Pollard.) Chipley knew that Sullivan's line could easily become an important feeder for a larger concern, especially since its southern terminal was situated at a strategic port. With Sullivan's approval, Chipley began discussing the matter with Victor Newcomb, president of the Louisville and Nashville Railroad. The L&N had been experiencing good times of late and its solid finances allowed Newcomb to acquire or build many new lines. Realizing that an unusual opportunity was at hand, Newcomb quickly got

<div align="right">81</div>

Colonel William D. Chipley became known as "West Florida's Mr. Railroad." (Courtesy Florida State Photo Archives.)

board approval to purchase Sullivan's firm, "upon what was deemed at the time very favorable terms." After the sale was consummated, the L&N issued $600,000 of bonds to completely upgrade the route. Newcomb also organized the Havana Steamship Company, which offered export services from Pensacola to Cuba. Chipley, in turn, became the L&N's superintendent of area rail and steamship operations. The 1880 L&N annual report boasted that business on the newly-acquired feeder had "exceeded all expectations."

At Chipley's behest, the L&N then cast its eye on the territory east of Pensacola to Chattahoochee. To penetrate the rich timberlands, the L&N chartered the Pensacola and Atlantic Railroad, which the Florida legislature approved in 1881. Colonel Frederick DeFuniak, general manager of the L&N, became president of the P&A, while Chipley was named vice president and general superintendent. State and federal authorities extended a generous land grant to the new firm, which in the end amounted to 2.2 million acres—practically one-fifteenth of the entire state. (Not all parcels were located near the railroad.) To finance the project, the P&A issued $3 million in stock and a like amount in bonds. The L&N, in turn, acquired a majority of the stock issue and all of the bonds. The parent firm

regarded the new subsidiary with considerable enthusiasm, realizing that—in time—the virgin territory would produce a considerable traffic of lumber, naval stores, livestock, and farm products. Additional revenues would also be generated from the sale of land.

Construction of the 161-mile P&A was divided into several sections and performed by both local and out-of-state contractors. Laborers were recruited from the Panhandle, southern Alabama, and southwest Georgia. As was so often the case, African Americans eagerly responded to the call, but problems ensued when fellow workers from Alabama were willing to accept lower wages than their Florida counterparts. An armed delegation of Florida workers scurried to the state line to meet the Alabama workers. Fortunately, a confrontation was avoided when labor negotiators fixed a daily rate of $1.50 for all employees.

At Pensacola, the P&A built a Victorian-style station at the corner of Tarragona and Wright Streets. A freight depot was constructed three blocks south of the passenger facility, at the corner of Garden and Alcaniz Streets. The railroad's engine house, turntable, and shop buildings were erected east of the passenger facility. The P&A mainline continued its way further east to Bayou Texar and Yniestra. There, the P&A faced its biggest engineering challenge: bridging Escambia Bay. The road's engineers overcame the wide expanse of water by building a 2.5-mile bridge with a

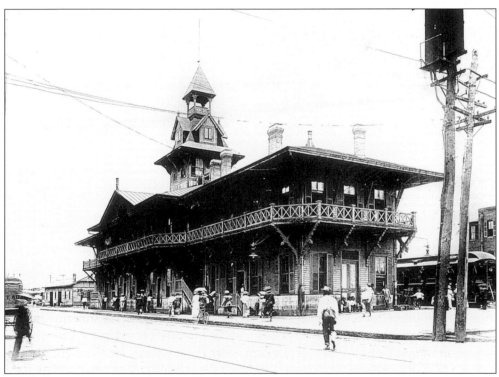

The Pensacola and Atlantic Railroad erected a Victorian passenger depot in Pensacola at the corner of Tarragona and Wright Streets. (Courtesy Florida State Photo Archives.)

drawspan. The big structure opened for service in August 1882. That same year, the P&A acquired the Pensacola and Barrancas Railroad, which ran from the Gulf port to Fort Barrancas by way of Woolsey and Warrington.

Milton and Marianna were the only towns that existed when the work began. Since stations were not immediately required at intermediate settlements, the railroad installed side tracks and allowed box cars to serve as temporary station buildings. Later, wood frame depots went up at Crestview, DeFuniak Springs, Bonifay, Chipley, and Cottondale. J.D. Smith was among the many workers hired for the construction work between Marianna and the Choctawhatchee River. Years later, as an employee of the Louisville and Nashville Railroad, he wrote about his early experiences in the company's magazine:

> I was only 19 years of age, starting in life without a dollar and expecting to be a railroad man. I was surprised to find in Jackson County fertile land, and the country around Marianna inhabited with old-line Southern farmers operating many large plantations, at that time snow white in cotton fields for miles and miles along the public roads with hundreds of Negroes picking and ginning it for market. The banks of the Chattahoochee River were covered with hundreds of bales of cotton that could not be moved by steamboats as the water was very low. Anyone seeing such a productive section would wonder why a railroad

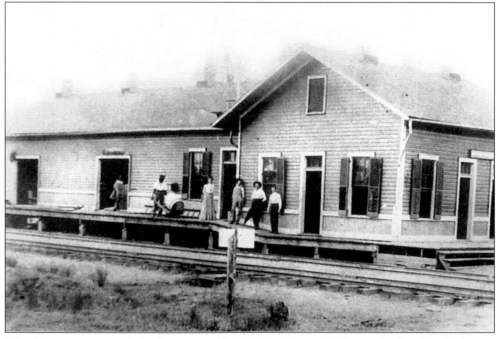

The first passenger and freight station of the Pensacola and Atlantic Railroad at Milton is pictured here. (Courtesy Florida State Photo Archives.)

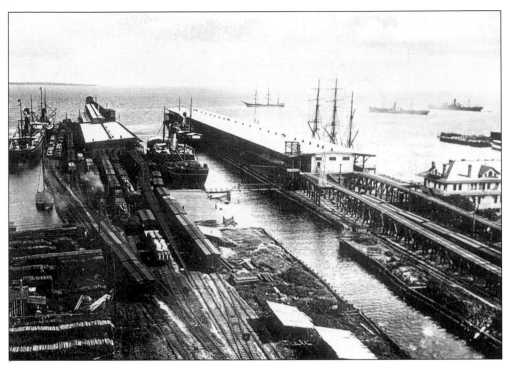

Wharves of the Louisville and Nashville Railroad are seen in Pensacola c. 1910. (Courtesy Florida State Photo Archives.)

had not been built before this time. The people came out to question us about the railroad. They had been fooled for so many years by promises made to give them a railroad, that they seemed to have no confidence in the project being carried out. I assured them, though, that the L&N was behind the move and we would build the railroad very quickly. People were rejoicing everywhere at the thought of this wonderful improvement. It was amusing to see the people coming from distant shacks to see the construction going on. The majority of these people had no conception of what a train even looked like. Some thought it had life. *They even asked me if a train could get in the door of a man's house.*

The P&A was completed to the Apalachicola River in January 1883. Three months later, the bridge over that famed stream was finished and trains entered Chattahoochee, or River Junction. From there, the P&A connected with Henry Plant's Florida, Savannah & Western and Sir Edward Reed's Florida Central & Western Railroad. During its first fiscal year (1884), the P&A generated revenues of $189,098, incurred expenses of $163,796, and showed a profit of $25,301. After land sales of $58,000 were added, its total net income was $75,391. However, this figure did not cover the $180,000 owed in bond interest, which the L&N cheerfully advanced. In fact, for many years afterwards, the P&A compiled losses,

but they were always covered by the parent firm. In 1891, the P&A "corporation" vanished and its lines in west Florida were simply referred to as the Louisville and Nashville Railroad.

In its quest to ship Alabama coal from Pensacola, the L&N eventually dredged the harbor at Pensacola, extended its Muscogee Wharf, and purchased several ocean-going tugs and coal barges. It also organized Export Coal Company. Before long, manifests of coal, lumber, pig iron, rice, sugar, tobacco, grain, wheat, bricks, and manufactured goods were being exported to Cuba, the West Indies, and South America. In 1895, Export Coal was succeeded by the Gulf Transit Company. The latter gained control of the Pensacola Trading Company, a British concern, and ordered two steel steamers: the *August Belmont* and the *E.O. Saltmarsh.* (Both vessels ran to Mexico, Latin America, and later to Liverpool.) The L&N also built the huge Tarragona Street Wharf in Pensacola. Grain was handled on one side of the wharf, while bulk cargo—such as lumber—was accommodated on the opposite side. Three railway tracks serviced the wharf's lower level, while inclined trestles allowed two tracks to reach the upper level of the warehouse. West of the big facility was the railroad's Commandancia Street Wharf, which also had a two-story warehouse for bulk cargo. The company's Muscogee Wharf—located a mile east of the Tarragona Street pier—handled shipments of coal. The L&N also built Goulding Yard, a large switching and marshalling facility, on a 100-acre site north of the city in 1896. Colonel William Chipley became the L&N's land commissioner and sold the huge inventories of land that had been granted to the Pensacola and Atlantic Railroad. Later, he served as mayor of Pensacola, ran the city's board of trade, became a state senator, and organized the annual Florida Chautauqua event at Lake DeFuniak. Chipley died in 1897.

During the 1890s, the L&N acquired the Alabama & Florida Railroad, a firm that attempted to construct a 100-mile line from Georgiana, Alabama to Graceville, Florida. In 1899, the A&F abandoned that project and conveyed the 28 miles it had constructed to the L&N, which resumed the work. In July 1902, the Iron Horse finally arrived in Graceville, a town that became the largest watermelon shipping point in the world. About halfway along the Graceville line was the town of Duvall, Alabama. Here, the L&N installed rails down to the Florida state line near Florala, where a handy connection was made with the Yellow River Railroad for Crestview.

Many railway companies were built in west Florida after the L&N came to the region. Among them was the Escambia Railroad, a logging line situated in the state's northwest corner. The lined opened in 1901 as a subsidiary of the Alger-Sullivan Lumber Company. Although most of the company's mileage was located in Alabama, the line's southern terminal was situated at Century, Florida, where the company operated a huge saw mill complex and made connections with the L&N. The Pensacola and Andulusia Railroad, chartered in 1883, was owned by the logging firm of Skinner & McDavid. This 22-mile narrow gauge line ran northeast of the Escambia River in Santa Rosa County to the Alabama border. After local timber lands played out in the early 1920s, the railroad was taken up.

As noted in Chapter 3, the Pensacola and Perdido Railroad ran between Pensacola and the company town of Millview. Pensacola contractor Henry McLaughlin owned the firm and combined it with his Pensacola, Alabama & Tennessee Railroad—a project he created in 1892 to connect Pensacola with Memphis. A year later, McLaughlin extended the PA&T north of Millview to Muscogee. Although the firm primarily hauled logs and lumber, passenger trains were also run. Another McLaughlin dream was the Pensacola, Mobile, & New Orleans, which built 23 miles of track from Parker (midway between Millview and Muscogee) to Pomona, Alabama. In 1916, McLauglin organized the Gulf Ports Terminal Railway, which became an umbrella for his rail holdings. After McLaughlin died, his nephew Elwood McLaughlin assumed ownership. In 1925, Elwood petitioned the Interstate Commerce Commission to abandon all of Gulf Port's holdings except those in the immediate Pensacola area. The ICC approved the application, provided the unneeded properties would be offered for sale. No purchaser immediately appeared. However, during Florida's land boom, Gulf Port's holdings were sold to the Muscle Shoals, Birmingham & Pensacola Railroad—a proprietary company of the St. Louis–San Francisco Railway—along with an industrial shortline connecting Pensacola with Bayou Grande and the Gulf, Florida & Alabama Railroad. The latter—nicknamed the "Deep Water Route"—linked Pensacola with Jonesville, Alabama via West Pensacola, Gonzalez, Cantonment, Muscogee, Barrineau Park, and Pine Forest. (That portion between Cantonment and Muscogee originally had been built by the Pensacola & Mobile Railroad and

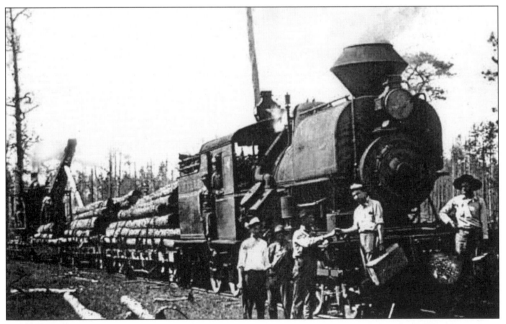

This logging train is of the Bagdad Lumber Company. (Courtesy Florida State Photo Archives.)

Manufacturing Company which, in 1906, sold the 5-mile section to Southern States Lumber. The latter later sold out to the Gulf, Florida & Alabama.)

The Bagdad [Florida] Land and Lumber Company operated the Florida and Alabama Railroad, a logging line that connected Bagdad with Milton, Red Rock, Munson, and Whitey, Alabama. The 44-mile route was partially constructed by Stearns & Culver Lumber and finished by the Bagdad concern around 1914. At Milton, connections were made with the L&N. At Munson, railroad headquarters, a 19-mile branch departed the mainline for logging and turpentine camps in Alabama. The Florida & Alabama conveyed pine logs and occasionally ran passenger train service. After the Bagdad mill closed in 1939, the F&A was abandoned.

The town of Galliver was situated a few miles east of Milton. The Falco Lumber Company constructed the Florida, Alabama & Gulf Railroad from Galliver north to their mill complex and headquarters in Falco, Alabama. The 25-mile line was completed in 1911 and served the Florida hamlets of Baker, Blackman, and Good Hope. Rails for the route were leased from the L&N, which the firm met at Galliver. Four steam locomotives once graced the property, plus the Florida, Alabama & Gulf owned a fair number of freight and lumber cars as well as two passenger cars. The latter were divided into three sections: one compartment for white patrons, another for baggage, and a section for African Americans. The passenger fare was fixed at 5¢ a mile. Mail was also carried on the route, generating an extra $165 of monthly revenue. Several section crews maintained the railroad's right-of-way between Galliver and Falco. Typically, such a "gang" consisted of five African Americans and a white foreman. The foreman received $50 per month, the workers $1 per day. The railroad itself was owned by the Florida and Alabama Land Company ("Falco"), which went bankrupt in 1914. A receiver operated the railroad for a few years, then the McGowin-Foshee lumber firm acquired the line in 1919, renaming it the Andalusia, Florida & Gulf Railway. Operations continued for a few more years until area forest lands were depleted. In 1925, the railroad vanished.

At Crestview, east of Galliver, sawmill operator W.B. Wright built the Yellow River Railroad to Florala, Alabama. Incorporated in 1887, the 26-mile line opened in 1894 and served the Florida communities of Auburn, Campton, and Laurel Hill. At Florala, short spurs were built back into the Florida lumbering towns of Lakewood and Paxton. (The Central of Georgia Railway also operated a line from Florala to Lakewood, which was home to the Britton Lumber Company.) Wright's company also built a branch from Laurel Hill to Wing, Alabama, where the line connected with the previously discussed Florida, Alabama & Gulf. Freight cars for the Yellow River firm were supplied by the Louisville and Nashville Railroad, which purchased the logging line in 1906.

Chipley, Florida was named for railway promoter Colonel William Dudley Chipley. In 1903, the Birmingham, Columbus & St. Andrews Railroad attempted to construct a rail line south of Chipley to Southport, an arm on St. Andrews Bay. Only 15 miles of track were constructed by 1907. Five years later, service was extended to Greenhead and Southport. The 18-mile portion between Greenhead

and Southport was actually completed by the Southport Lumber Company, which operated a big mill complex at Southport. Unfortunately, both Southport Lumber and the Birmingham, Columbus & St. Andrews went bankrupt. The former was acquired by Sale-Davis Lumber Company, while the latter was run by a receiver. The receiver leased the lumber firm's rail line and operated the entire railroad from Chipley to Southport as a single enterprise. At a special masters sale in 1926, that portion of the railroad between Chipley and Greenhead was sold to Alfred DeMayo, who reincorporated it as the Alabama & Western Florida Railroad. (DeMayo also operated the lower half of the railroad to Southport, but never obtained ownership of that piece.) In the late 1930s, after the area's rich forest lands had been depleted, the life of the Alabama & Western Florida Railroad came to a close.

Another project that pierced West Florida—and withstood the test of time— was the Atlanta & St. Andrews Bay Railway. The firm's prime mover was A.B. Steele, who owned the Enterprise Lumber Company in Dothan, Alabama. Steele started constructing a logging line towards Florida in the early 1900s. In 1906, his logging line became a common carrier with a twofold purpose: linking Dothan with a Gulf coast port and conveying traffic between Atlanta, Georgia and the future Panama Canal. Steele's workers advanced rails over the Florida state line to Campbellton then down to Cottondale, where the "Bay Line" intersected the Louisville and Nashville Railroad. Here, the project momentarily halted while a southern terminus was selected. A real estate syndicate helped convince Steele that the town of Harrison (later renamed Panama City) had port potential. Steele

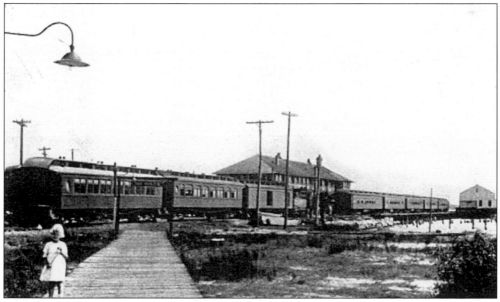

Two trains stand in readiness at the Panama City station of the Atlanta & St. Andrews Bay Railroad. (Courtesy Florida State Photo Archives.)

agreed, and construction resumed via Alford, Saunders, and Youngstown. The Bay Line's first passenger train departed Dothan for Panama City on June 29, 1908. However, the cost of constructing the line south of Cottondale forced Steele to borrow funds from Atlanta investor Asa Candler, of Coca-Cola fame. In 1914, the Bay Line track at Panama City was extended over to the pier at St. Andrews. In the previous year, the railroad constructed a spur to Lynn Haven. Eventually the Bay Line was sold to Minor Keith, an executive of the United Fruit Company. Keith regarded Panama City as a possible banana terminal, but in the end his company selected Port Tampa. In 1930, the Southern Kraft Division of International Paper announced that it would build a $10-million mill at Bay Harbor in Panama City. The firm formed the St. Andrews Bay Holding Company, which in 1931 purchased and rehabilitated the Bay Line railroad. Passenger service ended in July 1956, but a branch from Campbellton into Graceville was completed in 1971. Later, in 1987, Stone Container Corporation acquired ownership of the railroad.

The pride and joy of Calhoun County was the Marianna & Blountstown Railroad. Nicknamed the "Rich Uncle Railroad" or the "Meat & Bread," the company was incorporated in 1909 with a variety of purposes: to build a railroad, buy and sell real estate, own a mercantile business, operate hotels and telephone lines, and broker timber lands. Its real purpose, however, was to convey lumber and logs between the Pennington-Evans sawmill at Blountstown to Marianna, where the M&B met the Louisville and Nashville Railroad. The 29-mile line opened for business in January 1910. Two years later, the Blountstown Manufacturing Company completed a 13-mile railway from Blountstown south to Scotts Ferry, where connections were made with steamboats plying the Chipola River. An agreement was eventually signed allowing the M&B to run the lumber line. In 1924, the latter was extended past Scotts Ferry and across the Chipola River to Myron, where a large sawmill was located. (The Blountstown Manufacturing Company sold its rail line to the M&B in 1927.) Better roads and more truckers, however, diminished traffic south of Blountstown to the extent that tracks were abandoned in 1936. Over the years, the Marianna & Blountstown conducted its affairs in a relaxed, easy going manner. In fact, it was not uncommon for crews to stop their trains and take their noon-time meals with passengers. Operations ceased in 1972.

Among those logging firms that penetrated West Florida from Alabama was E.L. Marbury Lumber Company of Dothan, Alabama. Its railroad meandered down from Ardilla and terminated at Malone, Florida, where the firm had purchased some 50,000 acres of timber land and erected a sawmill. In August 1910, the company incorporated its pike as the Alabama, Florida & Southern. Years later, W.S. Wilson acquired control of the firm, extended the line south of Malone to Greenwood, and changed the firm's name to the Alabama, Florida & Gulf Railroad. Wilson's goal of reaching Marianna never materialized, nor did his railroad achieve financial success. A receiver began running the firm in 1924, and two years later it was sold at foreclosure to the Dothan National Bank, which

later failed. The U.S. Comptroller of Currency appointed a receiver to the bank, who also ran the railroad. In 1931, the Marianna & Blountstown Railroad made overtures about buying the ailing firm. The Interstate Commerce Commission approved the purchase, but the marriage was never consummated for lack of funds. In 1936, the line was sold for $10,000 to a new owner, who incorporated it as the Alabama & Florida Railroad. The company's only steam engine was relegated to emergency use and a diesel-powered motor coach operated over the line. The firm was sold for scrap in the 1940s.

Our brief look at some of West Florida's railroads concludes with another longtime survivor—the Apalachicola Northern. Incorporated in 1903, this line's promoters wished to connect Apalachicola with Chattahoochee, the easternmost point of the Louisville and Nashville Railroad. Construction began in 1905 and was completed two years later by way of Sumatra, Elmira, and Greensboro. Several oyster, shrimp, and fish canneries were served by the Apalachicola Northern, plus the short line carried products of area sawmills and turpentine stills. In 1910, a 20-mile extension opened between Franklin and Port St. Joe that could more easily handle ocean-going vessels. In 1938, the huge Port St. Joe Paper Mill opened, furnishing the railroad with considerable pulpwood traffic. The mill's owners purchased the Apalachicola Northern in the 1940s.

The Marianna & Blountstown Railroad maintained a locomotive shed, yard, and station at Blountstown. Engine No. 444, built by the Baldwin Locomotive Works, approaches the camera. (Courtesy Florida State Photo Archives.)

Space limitations preclude a cameo of every railroad that operated in West Florida. Among those not to be forgotten were the logging line operated by Grand Ridge Manufacturing near Sneads; the Caryville and Geneva Railroad, which ran a 20-mile tram in Washington County; the endeavors of Harbeson Lumber and Beach-Rogers in DeFuniak Springs; the German-American Lumber Company in Panama City; and the network of spurs that the St. Joe Lumber & Export Company built into the region's forest lands near Port St. Joe. Alas, all have vanished.

On April 30, 1907, the first train of the Apalachicola Northern Railroad arrived in old Apalach. Flatcars were both pulled and pushed, and some celebrants sat on the tender's woodpile. (Courtesy Florida State Photo Archives.)

8. TWO RIVALS: THE COAST LINE AND THE SEABOARD

War is the natural state of an American railway towards all other authorities and its own fellows. The president of a great railroad needs gifts for strategic combinations scarcely inferior to those of a great war minister. He must so throw out his branches as not only to occupy promising tracts, but keep his competing enemies at a distance. He must also annex small lines when he sees a good chance, damaging them first so as to get them cheaper.
~ James Bryce, *The American Commonwealth*, 1888

The Atlantic Coast Line Railroad and Seaboard Air Line Railway began serving Florida in the wee hours of the twentieth century. For nearly seven decades thereafter, these two rivals vigorously competed for the freight and passenger traffic of the state. Many Florida towns, cities, and industries were served by both firms, and in numerous locations their respective tracks paralleled or crossed one another. In 1967, the "Coast Line" and the "Seaboard" merged as the Seaboard Coast Line Railroad. This chapter briefly recounts their story in the Sunshine State prior to the great land boom of the 1920s.

The Atlantic Coast Line Railroad was created from over 100 railroads that stretched southward along the Atlantic seaboard from Richmond, Virginia. The company's founder was William Walters, a Confederate sympathizer and Baltimore produce merchant. Walters started assembling his empire during Reconstruction and was aided by Baltimore banker and flour merchant Benjamin Newcomer. Newcomer's bank, the Safe Deposit & Trust, financed many of the railroad company's endeavors. Walters was convinced that the railroad industry of the South would be revived after the Civil War. Moreover, it would play an important role in transporting agriculture products to Northern markets as well as through passenger traffic. In 1869, Walters acquired the first of many firms that helped to forge the Atlantic Coast Line system: the Wilmington and Weldon Railroad, which ran between Richmond and Wilmington—the "Breadline of the Confederacy." Later, Walters established the Atlantic Coast Line Despatch, a fast freight service that utilized refrigerated and ventilated box cars. By 1900, the Walter's syndicate owned or controlled some 2,000 miles of railroad lines.

Henry Walters joined his father's firm as general manager in 1884. Like his father, Henry was an intensely private person, shunned publicity, and possessed an uncanny flair for business. He also shared his father's love of art and European travel. After being hired, Henry immediately immersed himself in the Coast Line's affairs and undertook several projects, such as purchasing more powerful locomotives and installing heavier rail on its mainline tracks. He also persuaded the company's board to purchase two new train sets from the Pullman Palace Car Company. The *New York & Florida Special*—which ran the 1,074 miles between New York and Jacksonville in 30 hours—had vestibules, steam heat, electric lights, pale blue upholstered seats, and wood appointments of Spanish mahogany and birds-eye maple. Service began on January 9, 1888. At Jacksonville, the train was handed over to the Florida East Coast Railway for the trip to Miami.

The Coast Line was based in Wilmington, North Carolina, and when that state began taxing railroads in 1891, Henry Walters suggested that an out-of-state holding company be formed. The unused charter of the American Improvement and Construction Company—which had been formed in Connecticut under the most liberal of terms—was subsequently purchased. In January 1893, the firm was renamed the Atlantic Coast Line Company and Henry Walters became its president. The holding company then issued $10 million of stock, $8 million of which was taken by William and Henry Walters and their closest associates. In April 1900, the Atlantic Coast Line Railroad Company was formed in Virginia to oversee the multitude of railway lines that William Walters had assembled. The Connecticut holding company, in turn, owned 70 percent of the Virginia corporation.

After William Walters died in 1894, Henry inherited his father's share of the Atlantic Coast Line fortune together with his art collection, which today forms the magnificent Walters Art Museum in Baltimore. Preferring to reside in a major cosmopolitan center, Henry Walters left Wilmington and moved to New York City, where he established friendships with many captains of industry, including banker J. Pierpont Morgan, a fellow art devotee, yachtsman, philanthropist, and world traveler. Meanwhile, Michael Jenkins became the new head of Safe Deposit & Trust in Baltimore. Henry's close relationship with that financial institution continued, and both men served each other's corporation.

In the fall of 1898, one of the South's richest and most powerful railroad kings, Henry Bradley Plant (whose Florida endeavors were recounted in Chapter 5) directed his personal attorney to form an investment company that would perpetuate his name and protect his career holdings. Further, he wanted a codicil prepared that would prohibit any assets of his trust from being distributed until his grandson reached majority age. Curiously, the self-made millionaire shielded these instructions from his wife and son. Plant's attorney discovered that the laws of New York, where Plant resided, did not allow for the delayed distribution that the empire builder sought, but the laws of Connecticut did. Thus, the solution lay in Plant becoming once again a Connecticut resident. In June 1899, Plant visited his hometown of Branford, called on friends and relatives, and finalized details on buying a home in nearby New Haven. He also executed the codicil and filed

Henry Walters (1848–1931) was president of the Atlantic Coast Line Railroad for several decades. The reticent master was professionally photographed twice in his life, this being the second. (Courtesy Walters Art Museum, Baltimore.)

an address change whereupon he returned to his home in New York City where he died a few days later. Later that month, Plant's second wife Margaret learned that she was to receive a paltry $30,000 annuity from an estate that was worth over $50 million. Margaret sued. After several years of legal wrangling, the New York Supreme Court determined that Henry Bradley Plant had indeed died as a resident of New York and not Connecticut. The decision paved the way for Margaret to claim her share of the estate.

Robert G. Erwin, Henry Plant's trusted confidant, became president of the Plant Investment Company. Erwin attempted to fold all the estate's railroad properties into Plant's Savannah, Florida & Western Railroad. After the New York Supreme Court rendered its decision, Erwin contacted Henry Walters as to how the Atlantic Coast Line might acquire the Plant System of rails. Interestingly, Plant's relationship with both William and Henry Walters went back many years. Both had invested in the other's lines. From every perspective, the Plant System was a natural addition to the Coast Line, especially since it would permit the latter to tap an unserved market: Florida. After contemplating Erwin's offer, Henry Walters decided to purchase the Plant System (no hotels or steamship lines included) using Coast Line stock.

Margaret Plant learned of Walter's offer in March 1902. She did not disapprove of selling her interest to the Coast Line, but she insisted that the sale be premised

on her receiving cash. Walters, in turn, was somewhat taken back, for Coast Line stock was indeed "blue chip" and had every indication of increasing value in the years ahead and paying good dividends. Walters discussed the matter with his banking confidant, Michael Jenkins of Safe Deposit and Trust in Baltimore, who was convinced that the cash could be raised. With that confirmed, on July 1, 1902, the Plant System of railroads—totaling 2,235 miles—was purchased by the Coast Line for $46,563,898, or roughly $20,800 per mile. Margaret received Coast Line stock at the closing, which she immediately exchanged for a check. The Plant System acquisition practically doubled the size of the Atlantic Coast Line Railroad. Robert Erwin was named president of the latter, Henry Plant's son Morton became a director, and Henry Walters was elevated to board chairman. Interestingly, Walters made another historic purchase that same year. On September 27, the Coast Line purchased a controlling interest in the Louisville and Nashville Railroad. Safe Deposit & Trust again played banker to the $47.7 million transaction. The L&N (whose Florida operations were recounted in the previous chapter) increased the Coast Line's presence in the South to some 9,000 miles.

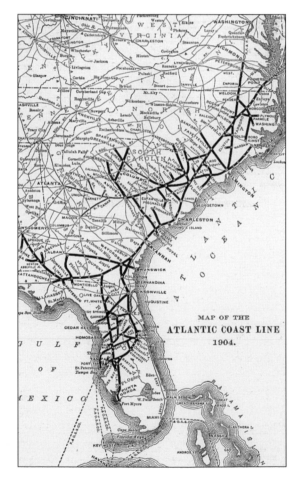

The Atlantic Coast Line Railroad wasted no time in expanding the Plant System. Its extension from Punta Gorda down to Fort Myers is visible in this 1904 map.

Without question, Henry Walters now operated the biggest railroad entity in the Sunshine State, yet the master hardly was ever seen publicly, much less known, by Floridians. Despite his reticence, Walters periodically visited Florida to inspect his holdings. The trips always confirmed that Florida was growing rapidly, and that the Coast Line had to expand and improve to meet demands. One of the first acts Walters ordered was extending the railroad at Punta Gorda down to Fort Myers. The 28-mile extension opened for service on May 10, 1904 and sparked an economic renaissance in the old cattle town. Another project replaced four antiquated drawbridges on the Coast Line route between Jacksonville and Sanford. Further, the old Orange Belt Railroad between Trilby and St. Petersburg was converted from narrow to standard gauge rails. New yard and building facilities also arose at St. Petersburg. Walters insisted that phosphate spurs be built, especially in the Bone Valley of central Florida, where the Seaboard Air Line Railway had already taken the lead. New switching yards were started at Jacksonville and Lakeland, and all mainline tracks in Florida were fitted with new 85-pound steel rails. The Coast Line also purchased some 1,600 new freight cars, as well as 20 passenger coaches and 30 Baldwin steam locomotives. Unfortunately, some of the Florida projects were delayed due to the national financial panic of 1903.

Having appropriate passenger station and freight facilities in Florida also weighed on the Walters administration. Consequently, in 1905, new passenger depots appeared at DeLeon Springs, Wauchula, Punta Gorda, Alligator Creek, Tice, Samville, Fort Myers, Wallkill, and Moffets. The following year, a substantial terminal facility opened in St. Petersburg and new combination freight and passenger buildings were completed at Pine Mount, Tarpon Springs, Winter Garden, Kathleen, and Juliette. During 1907, the Coast Line policy continued as new, wood-frame depots appeared in Leesburg, Dunnellon, Doctors Inlet, Apopka, Newberry, Satsuma, Duke, Edgar, and Homeland. A substantial brick structure was completed at Palatka. Unfortunately, another financial panic gripped the country that same year, prompting the Coast Line to dismiss workers and lower wages.

The Plant System purchase not only included railroads, but all the real estate that each constituent line owned. To manage the land parcels, in 1904, the Coast Line organized the Atlantic Land and Improvement Company, nicknamed Alico. Alico also oversaw many construction projects in Florida, including that of a huge phosphate loading elevator at Port Tampa. (Completed in 1922, it could load 300 tons of phosphate in one hour.) Phosphate, of course, was a major commodity transported by the Coast Line, and Walters allowed Alico to invest directly in several Florida firms, such as Dutton Phosphate, Prairie Pebble Phosphate, and the Atlas Phosphate Company. In return, the Coast Line obtained exclusive traffic agreements.

Concurrent with improvement projects, the Coast Line purchased several non-Plant railroads in Florida and built new lines. For example, the Jacksonville & Southwestern Railway was acquired in 1904. This 86-mile line, built by the

810

JACKSONVILLE & SOUTHWESTERN RAILROAD.

J. M. BARNETT, President, Grand Rapids, Mich.	A. G. CUMMER, Secretary, Jacksonville, Fla.
J. CUMMER, Vice-President, Cadillac, Mich.	W. E. CUMMER, Assistant General Manager, "
H. J. HOLLISTER, Treasurer, Grand Rapids, Mich.	E. S. SPENCER, Gen. Superintendent and Traffic Manager, "
W. W. CUMMER, Second Vice-President and General Manager, Jacksonville, Fla.	M. H. HAUGHTON, Auditor, "
	A. R. CHAPPELL, Train Master and Car Accountant, "

No. 3	No. 9	Mls	January 13, 1901	Mls	No. 10	No. 2
†5 10 P M	†3 45 P M	0	lve......Milldale...arr	85.6	12 00 Noon	†9 30 A M
5 30 P M	4 05 P M	4.8	arr.Grand Crossing ◊ lve	80.8	11 45 A M	9 11 A M
	4 40 P M	arr...Jacksonville¹..lve	11 10 A M	
	5 15 P M	lve...Jacksonville..arr	11 00 A M	
5 50 P M	5 40 P M	4.8	lve. Grand Crossing ..arr	80.8	10 35 A M	9 10 A M
6 07 "	5 55 "	10.5	Cambon	75.1	10 21 "	8 45 "
6 50 "	6 24 "	20.4	Baldwin ◊	65.2	9 57 "	8 00 "
7 06 "	6 36 "	25.0	Mattox	60.6	9 45 "	7 35 "
7 20 "	6 44 "	28.0	McPherson ◊	57.6	9 38 "	7 20 "
7 27 "	6 50 "	30.0	Griffing	55.6	9 32 "	6 48 "
– –	7 10 "	38.0	Cummer	47.6	9 12 "	– –
– –	7 20 "	42.0	Britt	43.6	9 02 "	– –
8 30 "	7 32 "	46.0	Raiford ◊	39.6	8 52 "	5 20 "
8 40 "	7 38 "	48.0	Stewarts	37.6	8 46 "	5 10 "
– –	7 45 "	50.4	Varnes	35.2	8 39 "	– –
9 10 "	8 30 "	54.0	Lake Butler² ◊	31.6	8 30 "	4 30 A M
	8 45 "	59.5	Dukes	26.1	7 44 "	– –
	8 55 "	62.2	Worthington	23.4	7 36 "	– –
	9 03 "	65.0	Santa Fe	20.6	7 28 "	– –
	9 17 "	69.5	Haynesworth ◊	16.1	7 15 "	– –
	9 25 "	72.0	Burnetts Lake	13.6	7 07 "	– –
	9 40 "	74.0	Alachua ◊	11.6	7 00 "	– –
	9 54 "	78.5	Cadillac	7.1	6 40 "	– –
11 00 P M	9 59 "	80.0	Haile ◊	5.6	6 33 "	††12 30 Night
	10 11 "	84.0	Komoka ◊	1.6	6 20 "	– –
	10 15 P M	85.6	arr....Newberry ◊...lve	0	†6 15 A M	

Connections.—At Jacksonville—1 With Atlantic, Valdosta & Western Ry.; Seaboard Air Line Ry.; Florida East Coast Ry.; Plant System; also with steamers for New York and Atlantic coast ports. At Lake Butler—2 With Georgia Southern & Florida Ry.

† Daily, except Sunday; ‡ daily, except Monday; ◊ Telegraph stations. STANDARD—Central time.

In 1904, the Coast Line acquired the Jacksonville & Southwestern Railway. The Cummer family of Michigan built the logging line, which also ran passenger trains.

Cummer lumbering family, had opened in 1899 and connected Milldale (near Jacksonville, where the Cummer sawmill was located) with Newberry by way of Baldwin, Raiford, Lake Butler, and Burnetts Lake. The Coast Line extended the line past Newberry to Wilcox in 1907. Perry, a major lumbering center, was reached two years later. (Cummer also operated a cypress mill and logging line at Lacoochee.) Another Coast Line acquisition with logging roots was the Florida Central Railroad, which was purchased in 1913. Opened in 1908 by J.L. Philips, this 47-mile line ran from Thomasville, Georgia down to the Florida towns of Fincher, Capitola, Cody, and Fanlew.

In the fall of 1910, the Coast Line began constructing its Haines City Branch from Haines City south to Lake Hare and Sebring, a region that became known as the "Scenic Highlands." The 47-mile taproot, which ultimately served citrus and vegetable growers, opened in June 1912. The Sanford & Everglades Railroad, a 12-mile line connecting Sanford with Mecca Junction, was also purchased during this period. Meanwhile, in the phosphate-rich Bone Valley, the Coast Line extended the old Winston and Bone Valley Railroad beyond Tiger Bay to Fort Meade. Archer was connected with Morriston in 1913 and Dunnellon with Wilcox in 1914. During the prosperity of 1916, the Coast Line resumed work on the Haines City Branch past Sebring to Harrisburg and Goodno. At Harrisburg, a branch was installed to Moore Haven to tap the productive mucklands near Lake Okeechobee. (Both projects were completed in April 1918.) The branch to Moore Haven was built at the behest of Marian O'Brien, the town's mayor, herself the daughter of a wealthy railroad executive. For some reason, late train arrivals were quite common on the Moore Haven Branch, and two trains gained the monikers the "Muck City Express" and the "Hinky Dink." A local newspaper quipped that a middle-aged man who got off in Moore Haven on the Hinky Dink had left

Haines City as a young boy. The editor of the Moore Haven *Times* also said that riding on the "Muck City Express" was like "being with a shy young girl afflicted with the St. Vitus Dance [a disorder involving continuous jerking movements]."

On December 26, 1917, President Woodrow Wilson announced that the Atlantic Coast Line Railroad (and 384 other firms in America) would fall under federal control during World War I. The United States Railroad Administration (USRA) oversaw the carriers from December 28, 1917 to March 1, 1920, at which time they were returned to stockholders. Lyman Delano, a nephew of Henry Walters and a future Coast Line president, was named the company's federal manager. In exchange for using the railroads, the government paid each firm a usage fee called a "standard return." The Coast Line also received monies to cover certain maintenance issues and special projects such as constructing a 7-mile branch from Arcadia to Carlstrom Field, where a U.S. aviation camp was located. (Another branch was built from that same "Aviation Spur" for several miles to reach a similar facility at Dorr Field.) Prior to the federal takeover, the Coast Line started to construct its Tampa Southern subsidiary. The considerable number of fruit and vegetable growers operating in Manatee County prompted the line's construction. David Gillett, a former Tampa mayor and owner of Buckeye Nurseries, was the line's president. Nicknamed "The Ghost Line," because at first its true owner was unknown, the Tampa Southern route began at Uceta 3 miles east of Tampa's union station and headed south to Ruskin, Gillett, and Palmetto, where rails arrived in 1919. Bradenton was reached the following year, and further additions took place during the boom years. In 1920, the Interstate Commerce Commission granted the Coast Line (and other Southern railroads) a rate increase of almost 25

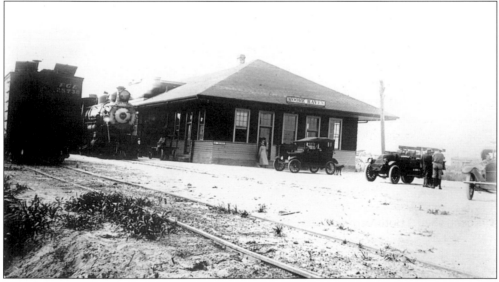

The Coast Line began serving Moore Haven in 1918. Area mucklands produced large quantities of vegetables, which the railroad took to Northern markets.

percent. However, the good news was tempered when the Railway Labor Board ordered Coast Line wages increased. Despite its manifold accomplishments in Florida, the Atlantic Coast Line Railroad was under-prepared for the surge in traffic that would soon occur during the land boom years.

The Seaboard Air Line Railway began as an alliance of several post–Civil War railroads that connected Portsmouth and Norfolk, Virginia with Atlanta, Georgia. In 1898, the confederation was acquired by the Richmond banking firm of John L. Williams & Sons and the Baltimore investment house of Middendorf, Oliver, & Company. (Previously the duo had purchased the Georgia & Alabama Railway from Savannah to Montgomery.) John Skelton Williams, son of the banking firm's founder, headed the alliance that, in February 1899, purchased a controlling interest in the 940-mile Florida Central & Peninsular Railroad, whose story was taken up in Chapter 4. Williams then launched several construction projects that physically connected the various firms. On April 14, 1900, the Seaboard Air Line Railway came into existence, and in the following month two celebratory trains departed Richmond, Virginia for Tampa, Florida. A 32-piece band accompanied Williams and his entourage, a steamboat tour was made of Tampa Bay, and a 21-gun salute greeted guests when they returned home. Service on the new route immediately began. Williams was so optimistic about the Seaboard's future traffic that he placed orders for some 2,000 freight cars.

One of Seaboard's first projects in Florida involved the ponderously named United States and West Indies Railroad & Steamship Company. Construction of the 51-mile subsidiary, running from Durant down to Sarasota, began in August

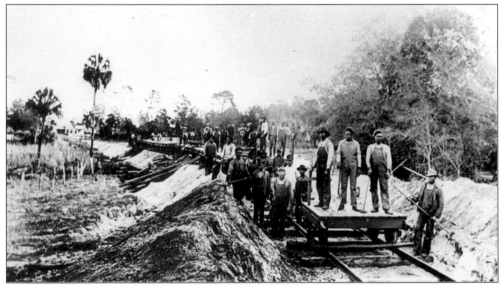

The vegetable and produce traffic of the lower Gulf coast prompted the Seaboard to acquire the United States and West Indies Railroad & Steamship Company. A track gang is seen here installing rails near Sarasota. A noted area photographer, Felix Pinard, composed the setting.

1901. The Seaboard supervised construction, supplied the firm with cars and engines, and in return extracted an exclusive traffic agreement. By May 1902, the track was finished to Palmetto with a branch to Terra Ceia, a rich vegetable and citrus growing area. On March 23, 1903, Sarasota received rail service, the first train consisting of a baggage car, day coach, and Pullman. "There was no office furniture in the Sarasota depot when I got there," remarked station agent Harnden Smith, "only a telegraph table built in the bay window with instruments installed thereon. I borrowed a nail keg from the carpenters for an office chair, and used a bacon box for a desk!" The company was reorganized in May 1903 as the Florida West Shore Railway. As the Seaboard's 1903 annual report noted, "the country traversed by the Florida West Shore is exempt from frost and is admirably adapted for the growing of oranges, lemons, grapefruit, pineapples, bananas, and early fruits and vegetables of every kind." The reorganized firm built spurs to Ellenton and Manatee and extended its mainline from Sarasota to Fruitville. Previously, the Bradenton-Sarasota corridor had been served by the Arcadia, Gulf Coast & Lakeland—a somewhat comical railroad operation that was nicknamed the "Slow & Wobbly" because of poor track conditions. It opened in 1892. A reorganization took place a year later, but the Florida, Peninsular & Gulf fared no better and it, too, flickered out of existence.

Two other Florida railroads that the Seaboard acquired in the early twentieth century were the Plant City, Arcadia & Gulf and the Tallahassee, Perry & Southeastern. The former, which ran from Plant City south to Welcome, was built as a logging line in 1898 by the Warnell Lumber & Veneer Company. The Seaboard bought it in 1905 and rebuilt it the following year to tap the phosphate-rich Bone Valley region of central Florida. Spur tracks later emanated from the mainline to the mining towns of Nichols and Coronet. The Tallahassee line was started in 1891. The Florida, Georgia & Western constructed about 6 miles of railroad from Tallahassee to the southeast, whereupon the track halted in the middle of nowhere. Lumber and logs were carried over the route and in May 1895, the little concern was reorganized as the Tallahassee Southeastern. Rails were advanced towards Wacissa four years later. A third reincarnation involving the Seaboard occurred in 1905, when the Tallahassee, Perry & Southeastern emerged. The latter pushed the stub line to Covington and Waylonzo in April 1907. In fact, the line was graded to the busy lumbering town of Perry, but rails—for some reason—were never installed.

In early 1908, the Seaboard Air Line Railway entered into a brief receivership. Competition from other carriers had contributed to its problems, as had high expenses and heavy fixed charges. Baltimore banker Solomon Davies Warfield (1859–1927), one of the Seaboard's original directors, was named a co-receiver. No liquidation sale occurred and a year later the company was returned to stockholders. In 1912, Warfield purchased a majority of Seaboard stock from investor Thomas Ryan, thus the head of the Continental Trust Company got control of the carrier. Once finances were restored, the Seaboard embarked on several projects in Florida that filled in gaps or developed new traffic. A branch

was installed from Buda to Norwills on the Atlantic, Suwannee River & Gulf, a firm that the Seaboard had leased in July 1900. The Seaboard's existing line between Archer and Early Bird was now pushed further south to the burgeoning phosphate and limestone region of Dunnellon, Hernando, and Inverness—a project that was opened throughout in 1911. Construction work also took place in the Bone Valley. By 1910, Seaboard rails linked Edison Junction (on the old Wornell tram line) with Agricola, where firms like Swift & Company and Armor had built large phosphate processing plants. Two years later, crews connected Nichols with Mulberry and Bartow. (Mulberry was named for a large mulberry tree that grew beside the Seaboard track where freight was unloaded before a station was built. Bills of lading were often marked "put off at the big mulberry tree.") A branch line from Bartow to Juneau opened in 1914. Two years later, crews completed the 22-mile "Lake Wales Extension" that linked Bartow with Lake Wales, Baynard, and Walinwa. A Seaboard subsidiary called the Kissimmee River Railway, which ran from Walinwa to Nalaca, began operations in 1918.

While the Bone Valley of Florida was being exploited, another project unfolded below Sarasota. At the behest of Bertha Honore Palmer—a wealthy Chicago widow who was developing much of what became Sarasota County—the Seaboard broke ground on a 16-mile extension south of Fruitville to Bee Ridge, Laurel, and Venice, which opened in the fall of 1911. Venice, itself, was still a wilderness, but the Brotherhood of Locomotive Engineers—America's largest and richest union—built a model city there in the 1920s. South of Venice stood huge stands of longleaf pine. The Manasota Land & Timber Company harvested area forests using its own railway. Logs were brought to the company's millhouse in Manasota (later called Woodmere) and finished lumber was sent to Venice for Tampa, where it was loaded into awaiting ships. At Laurel, north of Venice, the J. Ray Arnold Company operated another logging line.

In December 1909, the Seaboard leased the portion of its railway between Ocala and Silver Springs to the Ocala Northern Railroad. Wealthy lumberman E.P. Rentz spearheaded that enterprise, and crews began laying rail from the tourist attraction towards Palatka by way of Daisy, Fort McCoy (location of Rentz's mill), Orange Springs, Kenwood, and Stokely. Other crews installed rails on a sister road (the Ocala Southwestern) between Ocala and Ray. But the cost of building the fiefdom bankrupted Rentz who was succeeded by another lumber mogul. H.S. Cummings reorganized the firm as the Ocklawaha Valley Railroad, completed the project to Palatka, and placed new engines and cars on the line. He also connected his mill town of Rodman to the Ocklawaha Valley mainline. Legend has it that an engineer with Cumming's firm owned a playful goat. One day, "Billy" chewed through his rope leash and wandered to the depot in search of his master. The animal somehow managed to board an outgoing train. Another brought Billy home, but the romps continued to the extent that a marvelous public relations story evolved: "Billy, The Ocklawaha Valley Railroad Goat." Unfortunately, business declined on the Ocklawaha Valley as the years rolled by, and in the early 1920s, the railway vanished.

In 1911, the Seaboard opened its extension from Fruitville to Venice. Here, employees wait at the Venice station while officials talk with the station agent. (Courtesy Venice Archives and Area Historical Collection.)

During 1909, the Seaboard opened a big marine facility at Tampa's Seddon Island. The Tampa Terminal Company managed its activities, including the loading of phosphate and bulk cargo. Three years later, the Seaboard purchased the Tampa Northern Railroad, a 49-mile line that connected Tampa with Fivay and Brooksville. Service to Fivay had begun in 1907. The Seaboard purchased and rebuilt portions of a logging line owned by the Aripeka Saw Mill Company in order to reach Brooksville. The Aripeka line from Brooksville to Tooke Lake was acquired by the Tampa Northern in 1911. Another purchase extended the Seaboard's reach from Tooke Lake into nearby Centralia.

President Warfield allowed the Seaboard to acquire another Tampa firm in 1913: the Tampa & Gulf Coast Railroad. The latter traced its existence to the Gulf Pine Lumber Company, which had constructed a logging line from Lutz (on the Tampa Northern Railroad, 15-miles north of Tampa), west to Lake Fern and Gulf Pine—where the firm's sawmill was located. After buying the firm, the Tampa & Gulf Coast extended rails beyond Gulf Pine to the sponge capital of Tarpon Springs. In 1912, the T&GC absorbed the line of J.M. Weeks, which ran from Tarpon Springs to Port Richey. All these endeavors, however, strained the company's treasury. A year later, a reorganized Tampa & Gulf Coast Railroad emerged with the Seaboard firmly in control. The latter then installed a 47-mile branch from Sulphur Springs (on the Tampa Northern Railroad) to Clearwater and St. Petersburg. Along the route at Tarpon Junction, rails were laid north

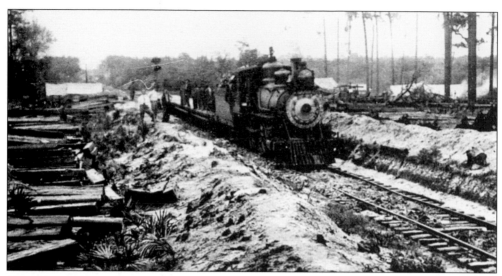

The East & West Coast Railway stretched between Arcadia and Manatee. Workers are preparing the right-of-way in this 1914 scene.

to Lake Fern, allowing the leg coming in from Lutz to be abandoned. Another appendage was built on the Pinellas Peninsula in 1915 to Indian Rocks Beach—greatly favored by Tampa residents due to its proximity. In the end, the so-called "Orange Belt Route" ran from Gulf Coast Junction (near Sulphur Springs) to Clearwater and St. Petersburg, plus operated branches to Port Richey, Tarpon Springs, and Indian Rocks Beach. At Gulf Coast Junction, trains were switched onto the Tampa Northern Railroad so they could reach Tampa proper.

Hardly remembered today is the East & West Coast Railway, a Seaboard subsidiary organized in 1913 and opened two years later. The company served the lumber and turpentine operators that dotted the piney woods between Arcadia and Bradenton. Many remote settings were located along its 48-mile route, such as Myakka City, Lorraine, Alsace, and Verna. The Seaboard supplied engines and cars, and both freight and passenger trains were operated. Logs, turpentine, and milled lumber were the traffic mainstays. The Myakka Lumber Company, King Lumber, R.L. Dowling & Sons, and Manatee Crate were some of the firm's major customers. In fact, each operated its own logging railways and had running rights on the E&WC mainline. Once area forest lands played out however, freight revenues took a serious dip. Passenger traffic also dried up, a mere 93 patrons having been transported in 1932. Shortly afterwards, the line was torn up.

Our brief look at the Seaboard's early years concludes with the Florida Central & Gulf. Organized in 1916, the sole mission of this Seaboard subsidiary was to acquire the 28-mile Standard & Hernando Railroad owned by the Dunnellon Phosphate Company. The S&H mainline connected the various phosphate mines of Hernando with Port Inglis, where a dock on the Withlacoochee River was situated. At Dunnellon, connections were made with the Seaboard. Unfortunately,

the railroad's glory years were few in number, and a lack of traffic prompted the Florida Central & Gulf to be abandoned in 1930.

The Seaboard's annual reports leading up to the land boom years bubbled with optimism. In 1916, for instance, new stations were erected at Manatee, Bee Ridge, and Ocala. Further, spur tracks were installed at Jacksonville to reach the new Commodore Point Terminal. The report—undoubtedly written by President S. Davies Warfield—somewhat exaggerated the company's markets and ability to make money:

> The territory served by the Seaboard is unsurpassed in the United States for traffic producing potentialities, by reason of the mineral resources, water powers, port facilities, lumber reserves, fertile lands, long growing seasons, and the capacity for varied production at all seasons.

Much of the market potential that Warfield referred to was, of course, located in Florida. After World War I, the company was challenged as never before to move traffic there.

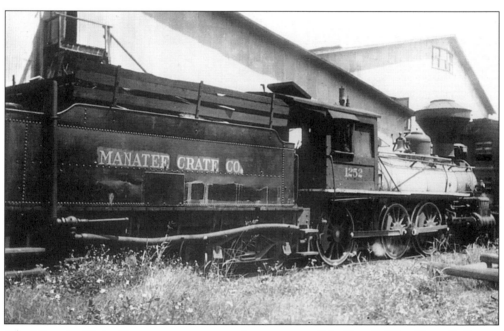

The Manatee Crate Company was among the customers of the East & West Coast Railway. Engine No. 1252 was built by the Baldwin Locomotive Works and bought used in 1921. (Courtesy J.W. Swanberg.)

9. HERE AND THERE

The interests of the railroads and the people, of the carriers and shippers, are the same. The bonds that united them are indissoluble, only death can divorce them. A prosperous people make prosperous railroads. They each lay golden eggs for the other, and neither should be killed. They must live and let live. The pioneer railroad and the pioneer settler cast their lot together and expect to grow up with the country.

~ Annual Report of the Florida Railroad Commission, 1889

In 1939, after many months of research, Florida's railroad commission determined that 564 companies had been chartered in the state since railroading began in the 1830s. Of that number, 251 lines had been actually built, although many were subsequently abandoned or broken up. The remainder never got beyond the paper stage. Of the 251 constructed, 154 lines were still operating, but not under their original names. In fact, through sales and consolidations, there existed in 1939 only 22 railroad companies. This brief work cannot recount all 251 entities; however, we devote this chapter to some of the more noteworthy lines that arose before the 1920s land boom.

The Augusta, Tallahassee & Gulf Railroad set a goal of creating a rail line from Carrabelle to the capital. In 1888, rails were installed from the port for 12 miles to the Sopchoppy River. Three years later, a reorganized firm—the Carrabelle, Tallahassee & Georgia, whose bonds were widely sold in Scotland—assumed the work and completed the line to Tallahassee. This 50-mile concern also operated the sidewheeler *Crescent City,* which ran from Carrabelle to Apalachicola. William Clark, the famed thread maker, headed the company. Clark's firm owned four locomotives, several passenger coaches, assorted freight cars, and one logging train. But even with Clark's support, the railroad was a financial disappointment. In 1906, the firm was acquired by the Georgia, Florida & Alabama, based in Bainbridge, Georgia. Previously, in 1902, the GF&A had built 40 miles of railroad from Bainbridge down to Tallahassee by way of Jamieson and Havana. A branch from Havana to Quincy, by way of Freemont and Florence, was installed in 1906. The line extending from the Florida capital to Carrabelle proved to be a natural addition. In 1928, the GF&A was leased to the Seaboard Air Line Railway, furnishing the latter with a direct route from the Panhandle to Columbus, Georgia.

Truckers and cars, however, made inroads on the traffic south of Tallahassee and, in 1942, the line was abandoned for lack of business.

Among the many Panhandle firms with ties to lumbering interests were the Pelham & Havana and the Florida Central. The 25-mile P&H connected Cairo, Georgia with Havana, Florida by way of Darsey. It began life as a logging line serving the Massee-Felton lumber works in Cairo. Havana was reached after 1906, and the firm used the Havana depot of the Georgia, Florida & Alabama Railroad. Business dwindled after area forest lands were stripped, and a receivership took place in the early 1920s. Service to Havana was suspended in July 1923. The P&H was offered for sale the following year. No takers appeared and the line was subsequently abandoned. The Florida Central was owned by the J.L. Phillips Company of Thomasville, Georgia, which constructed 81 miles of railroad from Thomasville to Fanlew, Florida by way of Fincher, Concord, Capitola, El Destino, and Cody. Traffic consisted of logs, pulpwood, and lumber. The firm owned two steam locomotives along with a single passenger coach and twelve freight cars. Profits were slim. A receivership took place in 1912, and that portion of the railroad between Fincher and Fanlew was purchased for $100,000 by the Atlantic Coast Line Railroad in 1914. The little-used line was torn up in 1941.

Another Panhandle carrier of note was the South Georgia Railway, which in 1900 completed a rail line from Quitman, Georgia to Greenville, Florida via Lovett and Maysland. By 1904, a subsidiary of the company, the West Coast Railway, extended rails south of Greenville to Shady Grove, Lady Bird, and the busy lumbering town of Perry in Taylor County. The Interstate Lumber Company built a 5-mile line from Perry west to Hampton Springs, which the West Coast

A Georgia, Florida & Alabama railroad train meets the company-owned steamer, Crescent City, *at Carrabelle. (Courtesy Florida State Photo Archives.)*

Railway acquired in 1915 for $26,343. The Oglesby family—owners of the South Georgia—also bought the famous springs at Hampton, erected a hotel, and advertised the pretty setting far and wide. Passenger trains were run, and a premium was charged to ride in the parlor car named *Hampton Springs*. A self-powered rail car appeared in 1924. Four lumber companies were allowed to run their logging trains over the South Georgia and West Coast Railroads. In 1923, the two firms were merged and, in 1931, the line between Perry and Hampton Springs was abandoned. The Brooks-Scanlon Corporation of Minneapolis purchased what was left in 1946 and sold the property to the Southern Railway in 1954. The latter upgraded the property, although passenger service—which had been reduced to a "doodlebug"—ended two years later.

The Valdosta Southern Railroad connected Valdosta, Georgia with the prosperous agricultural town of Madison. Rails reached Pinetta in 1898, but several years elapsed before Madison was served. In 1909, the Madison Southern Railroad carried the project south of Madison towards Deadman's Bay. Later that year, 7 miles of track were installed to reach Weston and Waco. Forest products were transported over the route from Valdosta, and several sawmills and turpentine stills were located near the railroad. Like so many Panhandle lines, traffic dipped once area timber lands were depleted. Not only did freight revenues diminish, but so did passenger traffic: in 1921, passenger receipts totaled only $37.15. Two years later, the Madison Southern was abandoned.

East of Madison lay the enterprising town of Ellaville, head of navigation on the Suwannee River. Ellaville was also home to the state's largest post–Civil War sawmill,

The mixed trains of the Live Oak & Gulf contained both freight cars and coaches. Here, crew members pose at the Luraville depot. (Courtesy Florida State Photo Archives.)

built by future Florida governor George Drew. The Ellaville, Westlake & Jennings Railroad, owned by the West Brothers Lumber Company, ran north of town and served Grooven, West Lake (site of the company's mill), and Malloy Point. At Grooven, a branch forked northwesterly to Bellville. During its heyday, the EW&J owned 2 locomotives and 34 freight cars. Business declined before World War I and the company's rails were taken up and sold for scrap. The Suwannee River Railroad ran south of Ellaville. Organized around 1888 by lumberman Charles Bucki, this 35-mile logging road served Columbus, San Carlos, Glen Park, Flagler, Bald Hill, Charleston, Hattysburg, and Frederica, where rails arrived in 1891. At Flagler, a branch departed west to Hudson-on-Suwannee (later renamed Dowling Park). The goal of extending the mainline south of Frederica to the Plant System station of O'Brien never materialized. In 1892, Bucki's firm owned 60 freight cars and 4 locomotives; gross revenues amounted to $34,810.

The Florida & Georgia Railway, spearheaded by the lumbering firm of R.J. Camp, aimed to connect Macon, Georgia with Lake City, Florida. Lack of finances, though, reduced the project's scope from Wellborn to White Springs and Thaggard. Interestingly, standard gauge track was utilized on the line south of White Springs, while narrow gauge rails were selected for everything north of town. By 1914, loggers had harvested the virgin forests and the railway was taken up.

Few areas of the state could equal the labyrinth of lumber roads serving such towns as Live Oak, Mayo, Foley, Alton, Perry, and Hampton Springs. Huge stands of timber existed in this region, and numerous firms competed to harvest, transport, and process the forest products. Two of note included the Florida Railway and the Live Oak, Perry & Gulf. The former surfaced in 1905 as the consolidation of the Live Oak & Gulf and the Suwannee & San Pedro Railroads. It operated between Live Oak and Perry, plus ran two branches: one from Wilmarth to Luraville and another from Mayo to Alton. The Live Oak, Perry & Gulf Railroad surfaced about the same time and also operated in the Live Oak–Perry corridor, building further west to Hampton Springs, Waylonzo, Loughridge, Mandalay, and Flintrock. Like its rival, the Live Oak, Perry & Gulf also operated a branch between Mayo and the sawmill town of Alton. Wealthy lumbermen, notably the Dowling and Drew families, figured into these firms. Some of the companies enjoyed a new revenue stream after phosphate was discovered near the Suwannee River at Luraville. (A French company even invaded the region and operated a novel 2-foot narrow gauge railway out of Densler.) But the mainstays of the Florida Railway and the Live Oak, Perry & Gulf were pine logs, milled lumber, wood pulp, naval stores, and to a lesser extent, limestone, bricks, watermelon, corn, and cotton.

In 1915, the aforementioned Florida Railway slipped into receivership. It was sold a year later and largely abandoned by 1919. The Atlantic Coast Line Railroad began purchasing bonds of the Live Oak, Perry & Gulf in 1905, which led to a purchase of the "Loping Gopher" in 1918. A decade later, the Coast Line sold the company to the Brooks-Scanlon Corporation, which operated a huge sawmill complex at Foley. Before Brooks, several lumber companies operated logging trains over the system,

such as Park Lumber, Standard, Taylor County Lumber, Rock Creek Lumber Company, and Burton-Cypress. On September 14, 1954, the Georgia, Southern & Florida (part of the Southern Railway) acquired the Live Oak, Perry & Gulf along with the previously discussed South Georgia Railroad, allowing both to be run as independent shortlines. In 1972, the Southern folded both into a new subsidiary called the Live Oak, Perry & South Georgia Railway.

An entire book could be written about Florida's logging railroads, whose unique and sometimes hair-raising operations are practically unknown to the modern generation. From their mainline tracks, most all installed portable spurs into area forest lands. After an area was "cut-over," the temporary tracks were disassembled then laid elsewhere. The trees, once felled, were fashioned into manageable logs and whisked off to mill houses on special flat cars. The trains themselves were hauled by a variety of steam locomotives. Some were new, many were used, and most clanked, hissed, and groaned. The tracks over which the logging trains ran were often hastily constructed. Many routes were peppered with steep grades and tight curves, not to mention flimsy rails and rickety trestles. Overloaded trains were common. Hotboxes (burned-out axle journals) frequently occurred and most every firm suffered derailments and occasional collisions. Many logging railroads lacked common carrier status with the federal government. Thus, they ignored certain maintenance and safety issues, like car brakes.

One of the more important independent firms to serve the Sunshine State was the Georgia Southern & Florida Railroad. In 1884, the legislature created the Macon & Florida Air Line Railroad to build a line from the Georgia border to Tampa, Charlotte Harbor, or the St. Johns River. A sister firm was formed in Georgia to carry the project into Macon. Four years later, the two projects merged as the Georgia Southern & Florida. Goals were revamped and, in 1890, the Macon Construction Company completed the line from Valdosta to Palatka by way of Jennings, Jasper, Lake City, Lake Butler, Sampson City, and Springside. However, the cost of creating the "Suwannee River Line" (along with some misuse of funds) forced the GS&F into bankruptcy in 1891. In 1895, a good portion of the receiver's certificates (convertible to new stock and bonds) were acquired by the Southern Railway. The latter's 1895 annual report noted that "the control of the Georgia Southern & Florida will be advantageous, as it originates a large lumber, fruit and melon business through its terminus on the St. Johns River at Palatka." In 1902, the GS&F acquired the Atlantic, Valdosta, and Western, which ran from Valdosta into Jacksonville via Sargent, Crawford, and Spaulding. The 107-mile firm had ties to the G.S. Baxter Lumber Company and was regarded as a progressive carrier; it was the first in Florida to use 70-pound steel rail and equip its locomotives with electric headlights. The AV&W also owned the St. Johns River Terminal Company, whose myriad spurs serviced port industries in Jacksonville. The principal commodities carried on both GS&F lines were timber and wood products and to a lesser extent, citrus and vegetables.

The Jacksonville Terminal Company was chartered in 1894 to build and maintain a union station terminal with facilities "to switch, repair, and store trains,

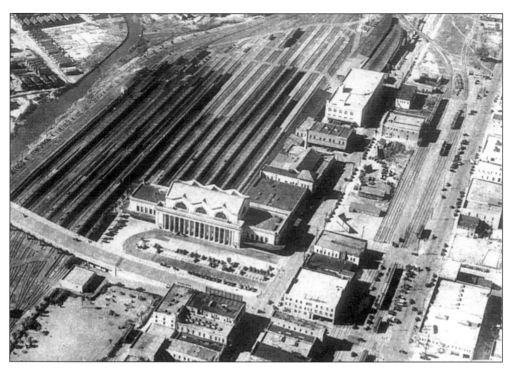

This aerial view depicts the columned Jacksonville union station and yard. (Courtesy Florida State Photo Archives.)

expedite the shipment of freight, and to provide comfort for travelers." It was owned by the area railroads of the day. In 1916, the company began to acquire additional land along West Bay and Lee streets for a new union station, the third such facility. Architect Kenneth Murchison conceived its Beaux Arts design, freely borrowing from New York's Pennsylvania Station. The huge multi-million dollar structure opened to the public on November 18, 1919. Constructed of reinforced concrete with a limestone veneer, the building's colonnade was formed with 14 colossal Doric columns, each measuring 42 feet tall. Granite, marble, and tile were used lavishly inside, and a 75-foot-high barrel-vaulted ceiling graced the waiting area. At its peak, over 100 trains a day arrived at the facility. The Jacksonville Terminal Company was also responsible for shuttling trains in and out of the complex, marshalling express cars, and managing coach yards. The firm operated its own fleet of locomotives and in the 1940s, nearly two dozen switching crews were always on duty. (The JT was Jacksonville's second biggest employer, after King Edward Cigar.) Due to decreased rail travel and high maintenance costs, the building closed in 1974, but was later remodeled and converted into the Prime F. Osborn III Convention Center. The state's other big Beaux Arts structure was built in 1912. The Tampa Union Station Company (jointly owned by the Atlantic Coast Line and Seaboard Air Line railroads) erected a building utilizing reddish-brown brick, terra cotta, and light-colored stone. It, too, fell into disrepair

as passenger rail traffic declined. Fortunately, a nonprofit group purchased the building in 1991 and comprehensively restored it.

Among Florida's many independent railroads was the Jacksonville, Mayport and Pablo Railway & Navigation Company. Nicknamed the "Cash Road" (since construction only advanced as cash funds permitted) this 20-mile line opened in 1888 between Arlington and Mayport, where its founders wanted to create a fish and phosphate business. (Another company goal was to build a seaside resort at Burnside Beach.) Initially, narrow gauge rails were employed, but after grading commenced, the directors wisely selected standard gauge track. Unfortunately, the railroad endured an embarrassing moment on opening day: the locomotive hauling its inaugural train expired 6 miles from Arlington, forcing passengers to walk home. Perhaps this was a bad omen, for the company's fortunes did not materially improve with time. New owners appeared in 1892, and the terminus of Arlington was later moved to south Jacksonville, but once again, finances worsened. A receivership occurred in 1895 and its rails were taken up and sold along with engines and cars. Its roadbed was subsequently purchased by the Mayport Terminal Company, a Flagler subsidiary.

Among the independent firms that operated south of Jacksonville were the St. Augustine & North Beach, running from Baker to the colony of North Beach, and the St. Augustine & South Beach Railway, which installed a narrow gauge line from St. Augustine to Anastasia Island. Green Cove Springs, seat of Clay

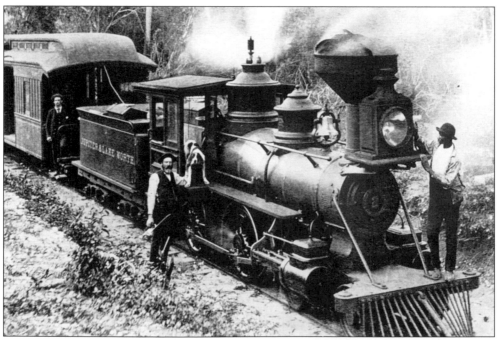

The engineer of this Jupiter & Lake Worth Railroad train holds two trusted items: an oil can and a traveling companion. (Courtesy Florida State Photo Archives.)

County, was the eastern terminus of the Green Cove Springs & Melrose Railroad. Chartered in 1881, this line built a narrow gauge line to Sharon in 1883, while a reorganized firm—the Western Railway of Florida—advanced construction to Melrose on Lake Santa Fe in 1890. Forest products were carried over this route. Operations ceased in 1899 and the railroad was subsequently abandoned.

The "Grits & Gravy" was a sobriquet for the Gainesville & Gulf Railroad. This Florida line surfaced in 1895 and during the next four years, its owners constructed a ribbon of steel from Sampson City to Gainesville and Micanopy. The 48-mile company owned 3 engines, 2 passenger coaches, and 14 freight cars. Like many firms of its era, the Grits & Gravy teetered under construction debt and had to endure a receivership. In 1906, the property emerged as the Tampa & Jacksonville, which extended rails south of Micanopy to Fairfield and Emathla. At that point, the 56-mile firm inherited a new nickname: the "Tug & Jerk." Phosphate was conveyed over the route along with produce and the naturally mined clay, Fuller's earth. In 1915, a self-contained powered rail car began transporting passengers. Many vegetable and produce farmers resided along the Tug & Jerk route, and frequent whistle blasts from the locomotive signalled that a frost was imminent. In 1926, the Seaboard Air Line Railway purchased the carrier and reorganized it as the Jacksonville, Gainesville & Gulf. Passenger service ended in the 1930s and in the next decade, the line was sold for scrap—except for a small portion in Gainesville that was acquired by rival Atlantic Coast Line Railroad.

Vegetables and produce were also the traffic mainstays of the Tavares & Gulf Railway, whose epithet was the "Tug & Grunt." This firm operated from Tavares to Monteverde and Clermont, reaching the latter locale in 1887. Tavares was part of the "Golden Triangle," a prosperous citrus growing region with Mount Dora and Eustis as its other points. In 1891, construction resumed from Waits Junction near Monteverde to Oakland. A receivership occurred in 1892, whereupon the line's new owner, Henry Jackson, reorganized the property. In 1899, the Tug & Grunt restarted construction from Oakland to Winter Garden and in 1914, the line was extended further east to Ocoee. The Seaboard Air Line Railway acquired the T&G in 1926 and operated the firm until the Seaboard merged with the Atlantic Coast Line Railroad in 1967. Previously, in 1962, the Seaboard had abandoned the portion of the T&G between Waits Junction and Clermont. In 1969, the entire line was abandoned.

During the 1920s, the Wilson Cypress Company operated a private logging railroad in Lake County near the St. Johns River. Another such operator was J.M. Griffin, who harvested dense pine and red cypress in northeastern Orange and Osceola Counties. Peavey Wilson Company, a Louisiana-based firm, succeeded Griffin, though connections continued with the Florida East Coast Railway principally at the mill town of Holopaw. Another area firm, albeit short-lived, was the Apopka & Atlantic Railway, a 5-mile protoplasm conceived in 1885 to connect Woodbridge with Forest City. The Fellsmere Farms Company, which came alive in 1909, operated its own line from Sebastian (on the Florida East Coast Railway) west to Fellsmere. It transported cut logs and agricultural products and, in 1924,

the firm was reorganized as the Trans-Florida Central Railroad. Farther down the coast was the Jupiter & Lake Worth Railroad, a narrow gauge outfit that installed tracks across the narrow strip of land between Jupiter on the Atlantic Ocean and Juno on Lake Worth. The 7.5-mile line opened for business in 1889 and became known as the "Celestial Railroad" because of the various locales it served: Jupiter, Neptune, Mars, and Venus. Henry Flagler used this portage firm to transport building supplies for his Palm Beach hotels. In fact, he even expressed an interest in buying the firm, but its owners refused to sell. Unfortunately, after the Florida East Coast Railway arrived in the region, the Celestial Railroad foundered and was abandoned in 1895.

Chartered in 1902, the Brooksville & Hudson Railroad was owned by the Aripeka Sawmill Company. This independent carrier departed Brooksville for Wiscom, where the track forked northwesterly to Tooke Lake and southwesterly to Weeki Wachee and Hudson. The Tooke Lake branch was sold to the Tampa Northern Railroad in 1911, while the branch to Hudson was operated by the lumber firm for several more years. Around 1924, Foshee Lumber began constructing its own standard gauge logging railroad from Willow (southeast of Tampa) to its 11,000-acre tract of timber in Manatee County. The line terminated near the East & West Coast Railway at Verna. Later, the firm became known as McGowin-Foshee Lumber Company. Portable spurs penetrated area timber lands, and longleaf pine logs were brought to the company's mill house in Willow for processing. When the timber deposits played out in the 1930s, the railroad vanished. Another curio was the Palmetto Terminal Company, which connected the Hendrix Dock in Palmetto (at the foot of Central Street) to the so-called Memphis Hammock (today's Memphis Heights), where citrus and vegetables grew in abundance. This railway was really a conduit between the growing fields and the boat dock. A large civic ceremony launched the 2.5-mile project in 1895, but once the United States and West Indies Railroad & Steamship Company was built through Palmetto, the terminal company fell on hard times.

Several railroads served the phosphate-rich Bone Valley district of central Florida. Among them was the Charlotte Harbor & Northern, owned by the American Agricultural Chemicals Company. For years, its chief executive, Peter Bradley, wanted to operate his own railroad from the phosphate mines to some deep water port on Charlotte Harbor. Bradley acquired the charter of the unbuilt Alafia, Manatee & Gulf Coast and in 1905, changed its name to the Charlotte Harbor & Northern Railroad. Workers then built a rail line from Arcadia to South Boca Grande on Gasparilla Island, where a huge phosphate dock was constructed. Company shops were established at Arcadia, where the firm connected with the Atlantic Coast Line Railroad. Bradley's line opened in August 1907. Both freight and passenger trains were operated and by 1911, the railroad was extended north of Arcadia to Mulberry by way of Garwood, Brewster, Bradley, and Achan. That same year, the company built a branch over to Tiger Bay, while in 1913, another spur linked Achan with Ridgewood. Connections were made with the Seaboard Air Line Railway at Bradley and Mulberry. Millions of tons of phosphate were

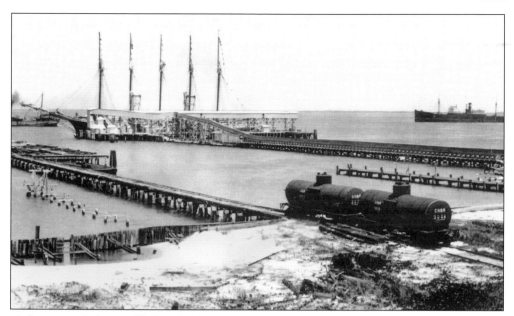

A five-masted ship is filled with phosphate at Port Boca Grande, southern terminus of the Charlotte Harbor & Northern Railroad. (Courtesy U.S. Cleveland, Charlotte Harbor Area Historical Society.)

conveyed over the "Boca Grande Route." Boca Grande itself, located just north of the port area, eventually became a watering hole for the nation's bluebloods. Pullman cars came and went and many visitors stayed at the railroad's Gasparilla Inn, still in operation today. Robert Bradley, Peter's brother, later ran the railroad, but his penny-pinching methods reduced worker morale to the extent that employees called it the "Cold, Hungry & Naked." In 1925, the phosphate hauler was acquired by the Seaboard Air Line Railway.

Our brief look at some of Florida's independent carriers concludes with the regulatory agency that oversaw them, the Florida Railroad Commission. Governor Edward A. Perry proposed in 1887 to establish a railroad commission, primarily because the government had received so many complaints about railroad rate abuses. An act was drawn up based on the commission law existing in Georgia. In short, the governor appointed three commissioners (with Senate approval required) who were given the power to establish reasonable rates, among other rights. Commission members themselves received an annual salary of $2,500. A basement room in the capitol building at Tallahassee served as the commission's office, and George G. McWhorter of Milton, former chief justice of the Florida Supreme Court, was its first chairman.

After its formation, the commissioners discovered that one-third of all railroads within the state were in the hands of receivers and that passes were handed out to politicians when the legislature was is session. More importantly, the trio learned that the railroads "charged tolls at will, high or low, making rates

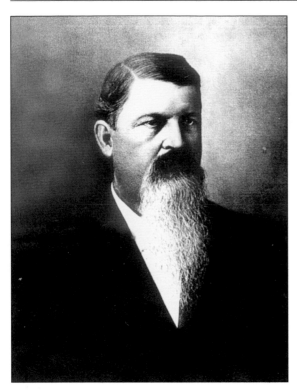

George McWhorter was the Florida Railroad Commission's first chairman. He was also a former chief justice of the Florida Supreme Court. (Courtesy Florida State Photo Archives.)

at discretion whether or not they were uniform or fair." To curb this freedom, Chairman McWhorter issued circulars that reduced rates for the traveling public and shippers. (Local chancery courts adjudicated differences.) Whereas the commissioners squashed many intrastate abuses, they were virtually helpless in regulating interstate rates. After McWhorter's death in 1891 and a rumor that a potential commission appointee had railroad connections, the regulatory body was abolished. Rate abuses renewed, discounts to big shippers resumed, and passes were once again handed out to legislators. The public pleaded for reform and in 1897, a new commission act was passed. This commission was composed of a lawyer, a farmer, and a man of railroad experience. Its powers were also greatly enlarged. Not only could the commissioners set rates, but they could investigate accidents, demand written reports from the railroad companies, and recommend legislation. This recipe worked, and eventually the regulatory body was given jurisdiction over express companies, sleeping car firms, trolley lines, truckers, telephone companies, and bridge commissions. In 1947, the agency became known as the Florida Railroad and Public Utilities Commission. In 1965, it reorganized as the Florida Public Service Commission. When common carriers were deregulated in 1980, the railroad division was eliminated and succeeded by Florida's Department of Transportation.

10. The Boom

Your Company has watched the rapid growth of Florida and, as far as possible, has anticipated the transportation needs of the State by large and substantial improvements. No one, however, could have foreseen the phenomenal growth and development that has taken place in a year's time, thrusting upon the railroads such a volume of business that they were unable to give normal service.

~ Annual Report of the Atlantic Coast Line Railroad, 1925

The 1880s saw the greatest period of railway development in Florida. Forty years later, the second-most prolific era began to unfold in the Sunshine State. During the 1920s, the railway map swelled to its greatest extent: nearly 5,500 miles including all mainline routes, sidings, and leased entities. The variety and frequency of service offered reached an extraordinary level that was never again repeated. This chapter recounts some of the events experienced by the "Big Three:" the Atlantic Coast Line Railroad, the Seaboard Air Line Railway, and the Florida East Coast Railway.

America's railroads were under rigid federal control during the World War I and after the hostilities, the carriers were returned to their stockholders. In Florida, the seasonal flow of traffic changed little during the war years. Freight shipments increased from October to May as citrus and vegetables made their way to Northern markets, while passenger traffic picked up in the early winter months and reached its zenith in February—albeit fewer tourists and vacationers appeared during the war years. In April, the direction of passenger traffic reversed as snowbirds and travelers returned home. Traffic on the Big Three increased beginning in 1920, partly due to the railroads themselves advertising Florida's charms and attractions in radio, newspaper, and magazine ads. New home seekers started to arrive, as did potential fruit growers, business owners, and investors. To accommodate the flux of traffic, new hotels and apartments were built in the state along with many homes and commercial buildings. The bubbling postwar economy also prompted many municipalities to build new roads, bridges, causeways, schools, and public buildings.

With every indication that the good times were going to last, Florida's contractors and merchants ordered inventories and supplies far in excess of their

requirements. As the decade wore on, commodities were often shipped to the "Empire in the Sun" with no specific address, changing hands many times en route and reaching destinations with inadequate or nonexistent service tracks. Bottlenecks resulted and before long, freight was left in thousands of box cars at all Florida points, occupying side tracks and clogging yards. In 1924, bumper crops of citrus and vegetables were harvested, requiring huge numbers of refrigerator cars and further taxing capacity. In the following year, tourists and newcomers descended upon the state as never before. Americans everywhere lusted for Florida, especially since voters had approved a constitutional ban against state income and estate taxes. Although many folks arrived in the family motorcar (thousands came down the Dixie Highway), countless others traveled by train. Pullman space became scarce and was often sold-out months in advance, plus extra sections of trains had to be run and new ones inaugurated. The rise in railroad freight traffic continued and ultimately ended in gridlock, prompting the

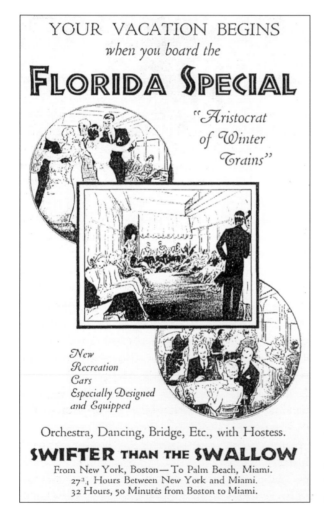

During the boom, the Florida Special continued to be the Atlantic Coast Line's premier winter train between New York and Miami.

Big Three to issue an embargo. (Foodstuffs, perishables, and petroleum products were excepted.) In November 1925, some 4,000 freight cars were tied up in the Jacksonville yards, while an additional 10,000 cars destined for Florida were ordered held at outlying points such as Atlanta; Washington, D.C.; Cincinnati; St. Louis; Montgomery; and New Orleans. Experienced traffic experts were rushed to the state to help untangle the mess. By February 1926, part of the embargo was lifted and on May 15, it was entirely withdrawn.

To increase capacity and expedite movement, the Big Three launched their own expansion and betterment projects. Some had been conceived before the war, but were delayed by the federal takeover. Others were planned in stages as the 1920s unfolded, but instead were rushed to completion. The scope of plans was impressive. New lines were constructed, several routes were shortened, and numerous yard and terminal facilities were built or modernized. Heavier rails were also installed on mainline tracks together with crushed rock ballast. Hundreds of bridges and trestles were strengthened to accommodate the heavier weights of trains. Safer signal systems were integrated too, along with new stations, faster and more powerful locomotives, and new rolling stock. Whereas the Big Three spent a total of $8 million on improvements in 1922, they shelled out more than $43 million in 1926.

The Atlantic Coast Line Railroad operated more miles in Florida than any other carrier. In 1922, the company began double-tracking its 661-mile mainline between Richmond, Virginia and Jacksonville, Florida. Although Chairman Henry Walters had predicted that the huge undertaking would be completed in 1927, the project was hurried along and finished in December 1925. Automatic block signals were installed as well as 100-pound-to-the-yard steel rail. Walter's firm also purchased new steam locomotives, more refrigerator cars for perishables, and specialized hopper cars for phosphate traffic. As the 1920s began, work resumed on the Coast Line's Haines City Branch, from Goodno south to Sears, Felda, and Immokalee, where attractive lumbering and agricultural interests were being developed. Walters then decided to extend the branch all the way to Everglades City, the southernmost point the Coast Line system ever reached. To help achieve this goal, the company purchased the Deep Lake Railroad, a 14-mile independent line owned by millionaire Barron G. Collier, for whom Collier County is named. Collier's line ran from Deep Lake to Everglades City and primarily hauled pine and cypress logs and vast quantities of seedless grapefruit. Walters engaged one of Collier's construction firms to rebuild the flimsy affair, and the first Coast Line train rolled into Everglades City in June 1928.

Another area project embraced was the Moore Haven & Clewiston Railway. (The Coast Line's Moore Haven Branch from Harrisburg connected the firms.) What attracted Walters to Clewiston was the Southern Sugar Company, reorganized in 1931 as the United States Sugar Corporation. This firm planted and harvested huge quantities of sugarcane in the 16,000 acres of muck lands it owned near Lake Okeechobee. The sugar company even operated its own network of rails in and around the cane fields. The Moore Haven & Clewiston

opened in 1921 and the Coast Line supplied the 14-mile line with engines and cars. Four years later, it leased the firm and in 1929, Walters extended its track to Lake Harbor to meet the Florida East Coast Railway.

Another Coast Line subsidiary that was extended during the boom was the Tampa Southern Railroad. In 1921, its "Ellenton Belt Line" was constructed to serve area industry and agricultural growers. The rectangular-like project departed the Tampa Southern main track at Gillett and headed east to Seth, turned south to Nettles, then jogged west to the mainline at Palmetto. (The belt line crossed the Seaboard Air Line Railway at several points.) At Seth, the "Saw Grass Spur" was installed to Senanky. In 1923, the TS also built a branch from Palmetto to Terra Ceia, where huge quantities of citrus and vegetables were grown. The TS also extended its mainline down to Sarasota, where rails arrived on May 17, 1924. No yard or terminal buildings were built at Sarasota except for a brick freight house, but an elegant passenger station opened on October 1, 1925 at Main Street and School Avenue. During the summer of 1925, the Tampa Southern expanded further by building its "Fort Ogden Extension" from Sarasota to Southfort via east Sarasota, Utopia, Honore, and Sidell. At Southfort below Fort Ogden, a physical connection was made with the Coast Line's Lakeland–Fort Myers route. After the Fort Ogden Extension opened for service in August 1927, a pair of daily passenger trains traversed the route from Tampa to Sarasota, Fort Myers, and Naples. Pullman sleeping cars from such famous trains as the *Floridan, Dixie Limited,* and *Palmetto* helped form the consists.

Two other events of note occurred in Sarasota during the boom years. In 1927, the city became the winter headquarters of the Ringling Brothers and Barnum & Bailey Circus. John Ringling built a fabulous mansion in town and invited the Coast Line and the Seaboard to build spurs to his circus grounds. Both obliged. Circus trains were parked on sidings at the complex, which also included repair shops. The Seaboard began serving Sarasota long before the Coast Line. Moreover, it serviced the big Payne Terminal at Hog Creek. In 1928, the Coast Line wanted some of this traffic, but its rival blocked the firm from crossing its tracks. When Sarasota's city fathers discovered that some of the Seaboard's rails were now illegally blocking city property, the Coast Line saw an opportunity. On the night of May 5, 1928—under the glare of torches and flares—Coast Line crews ripped up the illegal ribbons of steel and quickly installed the much-needed crossover. The Coast Line spur to Payne Terminal opened the next day and the Seaboard did nothing more than sulk.

Boom activity on Florida's lower Gulf coast started in 1923, when the Coast Line constructed a substantial new passenger station in Fort Myers—today home of the Fort Myers Historical Museum. The following year, the company extended its line south of the "City of Palms" to Bonita Springs by using the dormant charter of the Fort Myers Southern Railroad. Construction pressed on to the outskirts of Naples, where rails arrived in October 1926. After a drawbridge was installed over the Marco River, the Coast Line then began servicing Collier City (today known as Marco Island) in June 1927. No station was built at the latter

point, but the freight platform easily accommodated shipments from the island's growers and those of the Doxee clam cannery.

The Coast Line tackled many improvement projects during the boom. For example, its freight yards at Jacksonville, High Springs, Palatka, and Lakeland were expanded. In 1926, a major shop was erected at Tampa's Uceta Yard, employing almost 1,000 workers. Electric coaling stations, which speeded the refueling of locomotives, were installed at Moncrief Yard in Jacksonville, High Springs, Wilcox, Palatka, Ocala, Tampa, and St. Petersburg. Several double-tracking projects were also completed at Jacksonville, Sanford, and Tampa. New stations also appeared, including a magnificent structure of Spanish Colonial design on Sligh Avenue in Orlando.

To overcome the frequent and costly delays incurred at Jacksonville, the Coast Line finished an alternate mainline up the peninsula's west coast from Lakeland, a project that had been started years before. In 1926, a contract was let for the famed "Perry Cutoff" between Perry and Monticello. The work was prosecuted with fervor and finished in December 1928. Existing track from Monticello into Georgia was also rehabilitated. As a result, Coast Line trains destined for the Midwest could now completely avoid busy Jacksonville. To eliminate the run from Tampa to Lakeland, the Coast Line rebuilt the Tampa and Thontosassa Railroad from Tampa and extended it to Richland. Then, the 60-mile stretch between Richland and Dunnellon was equipped with a double track.

When the 1920s began, the Coast Line was operating four scheduled passenger trains between the upper east coast and Florida: the *ACL Express*, the *Havana Special*, the *Palmetto Limited*, and the ever-popular *Florida Special*. In the 1920–

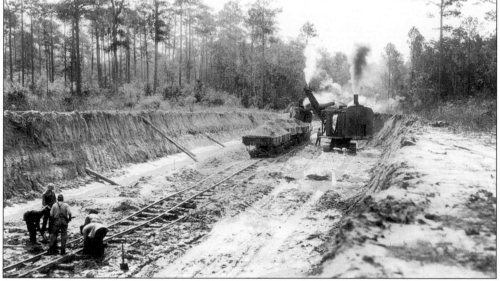

Workers toil on the 40-mile Perry Cutoff between Perry and Monticello. The Coast Line completed the project in December 1928. Its Midwestern trains could then avoid Jacksonville.

Modern-day Venice was created in the 1920s by the Brotherhood of Locomotive Engineers. The Arcadia publication Venice in the 1920s *recounts the fascinating story. (Courtesy Railway & Locomotive Historical Society.)*

1921 winter season, the *Everglades Limited* was added. At the boom's peak in 1926, the passenger department inaugurated three more New York–to-Florida trains: the *Miamian,* the *Florida West Coast Limited,* and the *Florida East Coast Limited.* (The company's old *West Indian Limited* also made periodic appearances as conditions warranted.) The Coast Line's passenger department also released a new publication during the boom entitled *Tropical Trips,* which described the attractions, hotels, and recreational facilities along the Atlantic Coast Line Railroad,especially those in Florida. Pullman trains from the Midwest also operated to Florida in connection with the Coast Line, such as the *Florida Seminole,* the *Southland,* and the *St. Louis–Jacksonville Express.* The triweekly, all-

Pullman *Floridan* from Chicago to Jacksonville appeared in 1923. Other popular trains included the *Dixie Express*, *Dixie Flyer*, and *Southland*. The *Flamingo*, serving several Florida destinations, originated in Detroit. By 1926, eight Midwest trains ran to Florida in cooperation with such railroads as the Illinois Central, Chicago & Eastern Illinois, Louisville and Nashville, Central of Georgia, and Southern. As previously noted, Florida's land boom peaked in 1926. That year, the Coast Line reported record revenues of $97 million. Expenses amounted to $70 million, leaving a net income after all deductions of $14.4 million. Chairman Henry Walters felt confident in declaring a 7 percent dividend on common stock and 5 percent on preferred. But as the real estate and construction mania in Florida receded, so did the Coast Line's revenues, which fell to $80.4 million in 1927 and $71.3 million in 1928.

If Floridians were unsure who S. Davies Warfield was at the boom's start, his name was practically a household word by 1927. As president and chairman of the Seaboard Air Line Railway, his firm constructed more new lines during the boom than any other carrier. Warfield had an unshakable faith in Florida, its people, and its businesses. His enthusiasm never flagged and Governor John Martin was frequently at his side. During the boom, the Seaboard became a major player by spending fistfuls of money on new lines and improvement projects. But with every conquest, the Seaboard incurred more indebtedness that, in the end, brought the

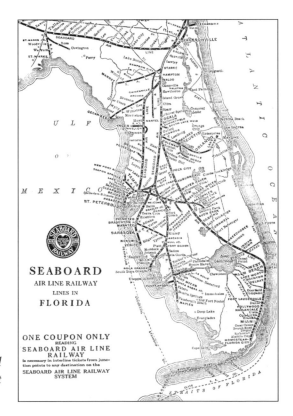

The Seaboard Air Line Railway reached its greatest extent in Florida in 1927, but the cost to do so came at a great price.

123

firm to its knees. That Warfield wanted more market share in Florida was certainly no secret. He noted in the company's 1924 annual report that "the Seaboard is not receiving the share of business originating in the territory for which it was justly entitled, and the development of Florida is retarded because of the lack of railroad facilities between the two coasts of its peninsula." Warfield had investigated a cross-state route in 1913. After World War I, he pursued the dream with fervor, along with several other Florida endeavors, and in 1924 the action began.

In April, the Seaboard chartered a new subsidiary: the Florida, Western & Northern Railroad. This 204-mile project began at Coleman, 6 miles below Wildwood on the Seaboard mainline, and terminated at West Palm Beach by way of Auburndale, West Lake Wales, Sebring, Okeechobee, and Indiantown. Warfield floated a $7 million bond issue to pay for the work and gave the contract to the Jefferson Construction Company of Charleston, South Carolina. From Coleman, the single-track route passed through the live oak hammocks in Sumter County en route to Polk City. Then, rails traversed the famed "Ridge Country" of Florida to Arbuckle Creek, home of countless citrus groves. Prairie lands were encountered south of Arbuckle all the way to Okeechobee, then intermittent stands of longleaf pine were sacrificed to spike rails to West Palm Beach. The work was prosecuted at breakneck speed, as reported by the August 1, 1925 issue of *Railway Review* magazine. Mechanized equipment was brought in, the contractor amassed a mountain of materials and supplies, and all manner of laborers were hired. Once again, the contributions of African-American workers proved indispensable:

> A considerable part of grading the roadbed was performed by that famous institution of our southern country—the "station man." Given a shovel, a wheelbarrow, and a board to run it on, and provided with rations and a contract for one, two, or three station sections, this fellow will build his little thatch hut and live, eat, and sleep on the job. He works in the cool hours of the day and on moonlit nights until his contract is completed, then moves on to another. Hundreds of these faithful workers were employed, and they took great pride in the fact that they were doing their part to have the grading all ready when the track gang came along.

Dragline tractors helped overcome the challenges of ponds, low mucky places, and cypress bays. Steam shovels were also employed in the ridge country, where cuts and embankments were often 30 feet high. Numerous trestles were constructed, such as at Arbuckle Creek and Lake Tulaine. The American Bridge Company fabricated drawbridges over the Kissimmee River and the St. Lucie drainage canal. Some 700,000 crossties were consumed on the extension. Steel rail weighing 100 pounds to the yard was supplied by the Bethlehem Steel Corporation. Several 65,000-gallon water tanks were installed at various points along the new line, all built of California redwood. Harvey & Clarke, a noted architectural firm based in West Palm Beach, designed almost every station on the

route. The striking facility conceived for their own city—today used by Amtrak and Tri-Rail trains—even featured Spanish Baroque details. The last spike on the new line was driven home on January 21, 1925. Four days later, four sections of the Seaboard's *Orange Blossom Special* made their way to West Palm Beach. Warfield and 500 guests were on board for the opening ceremonies, and afterwards the all-Pullman winter train began regular service from the Northeast.

Later that year, two other Warfield projects opened in Florida: the 12-mile Valrico Cutoff and the 13-mile Gross-Callahan Cutoff. The former branched from the Seaboard's mainline at Valrico and headed east for 12 miles to Durant and Welcome Junction. There, Seaboard rails already existed to Mulberry, Bartow, and West Lake Wales. The newly built Coleman–West Palm Beach extension was conveniently intercepted at West Lake Wales, enabling the Seaboard to offer service from Tampa to West Palm Beach, in essence a cross-state connection. The Gross-Callahan Cutoff in Florida—linking its namesake locations—allowed many Seaboard trains, especially fast perishable freights, to bypass the congestion at Jacksonville. Clarence W. Barron, who owned the *Wall Street Journal* newspaper, knew Warfield and became enamored of his boom projects. In fact, Barron wrote an article for the paper on February 26, 1925, entitled "Florida By the Airline." The article heightened nationwide interest in the Seaboard's endeavors, but its title led many readers to think that Warfield was building an airline company. Conveniently, investors acted on Seaboard securities, for airline company investments were much in vogue.

Revenues on the Seaboard jumped to $62.8 million in 1925, compared to $53.3 million the year before. The boom in Florida contributed to the increase and prompted Warfield to continue his expansionary measures. The Seaboard-All Florida Railway was conceived in June 1925 with two goals: to extend the line at West Palm Beach down to Miami and to construct a new west coast extension from Fort Ogden to Fort Myers and Naples. To pay for the additions, the Seaboard floated yet another bond issue, this time for $25 million. After the Interstate Commerce Commission gave its green light, Warfield gave the construction contracts for both coasts to Foley Brothers of St. Paul, Minnesota, reputedly the largest railroad contractor in America. Once again, work proceeded at full throttle. The 66-mile route to Miami via Fort Lauderdale, Pompano, Boca Raton, and Opa Locka was finished in December 1926 along with a 3-mile branch at Hialeah Junction that lead to the new Hialeah yard. A 28-mile extension from Hialeah south to Homestead was completed in April 1927. Interestingly, the line from West Palm Beach pierced a territory that, for years, had been monopolized by the Florida East Coast Railway. Naturally, the incursion caused consternation in FEC circles.

Groundbreaking for the Fort Myers extension was held in that city on February 8, 1926. The 69-mile line began at Hull on the Charlotte Harbor & Northern Railroad and proceeded to Fort Ogden and then down to Fort Myers. At Estero, 15 miles below Fort Myers, the Naples, Seaboard & Gulf (another Seaboard subsidiary) advanced rails to Bonita and Naples. The Seaboard and Warfield

(personally) purchased large land parcels at Naples, regarded by the chairman as "a most attractive place with beautiful beaches, the latitude approximately that of Miami, and one of the best situated winter resorts on the west coast." Additionally, the Seaboard constructed two branches from Fort Myers: one easterly to LaBelle and another westward from south Fort Myers to Punta Rassa. (Warfield envisioned deep water ports at both Naples and Punta Rassa, but neither was built.) The route down the west coast was not through forbidding terrain, although a fair number of swamps, mucklands, and small streams had to be overcome. The greatest challenge was bridging the wide Caloosahatchee River at Fort Myers. A beautiful $75,000 passenger station, which still stands and is commercially occupied, was erected in the "City of Palms" along with a 14 track switching yard and freight terminal. Another Mediterranean Revival station was constructed at Naples. It, too, has been restored and is currently utilized.

The 30-mile branch to LaBelle left Fort Myers near the freight terminal on Michigan Avenue and passed through east Fort Myers, Alva, Buckingham, and Floweree. Several large citrus growers were located near the route and the region also possessed huge stands of longleaf pine. At LaBelle, connections were made with the Brown Lumber Company. The 8.6-mile branch to Punta Rassa served the vegetable growers and truck farmers located in Iona, regarded as the most frost-free region of the continental United States. (Gladioli producers later flourished here.) Freight trains plied the Punta Rassa branch, while mixed trains briefly operated to LaBelle. North of Fort Myers at Tamiami, the west coast extension connected with the McWilliams Lumber Company, which operated its own logging railroad in Lee County. In 1929, the firm was succeeded by Dowling-Camp, whose logging trains were permitted to operate over Seaboard rails to the rich timberlands located in east Fort Myers near Alva at Hickey Creek.

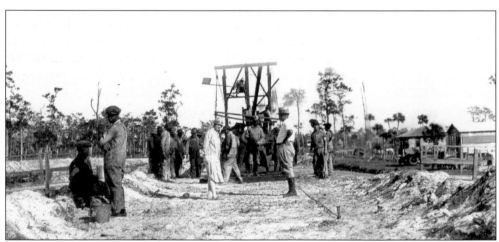

The Seaboard constructed its west coast extension in 1926. Here, crews advance rails past Gordon River Grove in Naples. A splendid station—still standing and used—was erected in the downtown district. (Courtesy Collier County Museum, Naples.)

The Seaboard's east coast extension ran from West Palm Beach to Miami. Opening celebrations were held in January 1927. At Opa Locka, President S. Davis Warfield (right) and Governor John Martin were entertained by theatricals dressed in Arabian costumes. (Courtesy Historical Museum of Southern Florida.)

The Seaboard's west and east coast extensions were also completed in late 1926. Opening ceremonies on both coasts were arranged the following month by Warfield, who personally invited some 600 guests from 90 cities and 18 states. The chairman installed them on no less than five sections of the *Orange Blossom Special* beginning on January 5, 1927. For the next few days, they partook of one of the most remarkable celebrations in American railroad history. The various *Blossom* sections converged at Plant City and proceeded in convoy style down to Arcadia during the early morning hours of January 7. At the latter point, almost 2,000 citizens of DeSoto County were on hand to greet the chairman, although most of Warfield's guests were still slumbering in the Pullman cars. Similar receptions were staged at Fort Myers and Naples. Bands played, flags waved, and often children sang as the trains arrived, and locally grown fruits and vegetables were frequently displayed on freight platforms. At Naples, a superb luncheon was followed by beach visits and boat rides. Both Warfield and Governor John Martin spoke to the crowds, while newsreel companies and representatives from the Associated Press recorded everything. The next day, the *Blossom* sections descended down the east coast, where similar receptions went off at Lake Worth, Boynton, Delray, Boca Raton, Deerfield, Pompano, Fort Lauderdale, Dania, and Hollywood. At Opa Locka, a theatrical group dressed in Arabian garb staged a show aboard Warfield's train and then dashed away on horses and camels. Two thousand persons were on hand when the *Blossom* sections glided into Hialeah.

On the speakers' platform were six Seminole Indians dressed in native costumes. The din of engine bells, the whistles of industries, and the horns of automobiles welcomed the trains in Miami. Afterwards, Warfield delivered a major speech at Royal Palm Park where nearly 5,000 people had gathered. Days were spent in Miami before the *Blossom* sections returned north. It was a fitting conclusion to Warfield's investment in Florida. Regretfully, the master died of a heart attack later that year in a Baltimore hospital.

In addition to building new lines during the boom, the Seaboard also acquired other railways. In 1926, it leased the Charlotte Harbor & Northern, the East & West Coast Railway, and the Tampa Northern. (It extended the last's track from Brooksville to Inverness the following year.) The Tavares & Gulf was purchased in 1926, although it continued to be operated as a separate entity. The Seaboard also leased the Gainesville & Gulf that year and reorganized it as the Jacksonville, Gainesville & Gulf Railway. In 1927, the Tampa & Gulf Coast was picked-up, while the 183-mile Georgia, Florida & Alabama was leased in 1928. To ease traffic congestion during the boom, Warfield also authorized several double-tracking projects: one from Baldwin to Starke, one from Wildwood to Coleman, and one near Tampa. Automatic block signals were installed between Savannah, Georgia and Baldwin, Florida in the spring of 1927. Another signal project followed from Starke to Coleman. At Baldwin, the engine terminal and yard tracks were enlarged, while similar work was undertaken at Wildwood and Indiantown. Of course, the expansion policies of the Seaboard came with a big price tag. Bonds were issued to pay for most of the work, and so long as net income was robust, all was fine. But in 1927, the Seaboard showed a net income of only $31,576 on revenues of $61.7 million. The picture continued to worsen and three years later, the Seaboard was declared bankrupt.

The Florida East Coast Railway also experienced phenomenal growth during the boom years. It, too, ordered new locomotives and cars, built new lines, constructed yard and terminal facilities, and erected new stations. In 1923, the Interstate Commerce Commission authorized the FEC to extend its Okeechobee line down to Lemon City near Miami and approved a branch from Hialeah to Larkin. But only part of the big project was actually undertaken. At Okeechobee, laborers advanced rails around the east side of the "Big Lake" and terminated the line at Belle Glade, where sugar cane and vegetables flourished. At Miami, the FEC constructed an 18-mile "belt line" around that city's north and west sides. It commenced at Little River, proceeded westerly to Hialeah, then turned south to rejoin the mainline at Larkin in South Miami.

The FEC's biggest boom endeavor was double-tracking its 346-mile mainline from Jacksonville to Miami. Construction began on the south end of the railway in December 1924, on the central portion of the project in March 1925, and on the north end in July. Numerous difficulties were encountered, however, including labor shortages, lack of construction materials and supplies, and performing the work in the face of ever-increasing traffic. Automatic block signals were also integrated as part of the big upgrade, as were several new drawbridges, including

a huge new steel structure over the St. Johns River at Jacksonville costing $2,400,000. Another component of the work was the building of the "Moultrie Cutoff." This shortcut began just south of St. Augustine at Moultrie Junction, proceeded for some 29 miles down to Bunnell, and eliminated the mainline swing through East Palatka. During the 1920s, the FEC also constructed its big Bowden Yard near Jacksonville and the Miller Shops at St. Augustine. New yard tracks were also installed at New Smyrna (the first division point south of Jacksonville), while the railway's facilities at Fort Pierce were improved. The company also built a new general office complex at St. Augustine comprised of three interconnected four-story buildings.

In 1926, 12 mainline trains were operating on the FEC between Jacksonville and Miami in each direction. Several serviced Key West, where across-the-platform boat connections were made for Havana. That September, a powerful hurricane devastated south Florida and many parts of the railway. Over 200 souls perished in the catastrophe and some 6,300 persons were injured. Relief agencies aided the destitute and the FEC did everything it could to help the stricken areas. A few days after the storm, the railway provided free transportation for hundreds of people sent out of the area by the Red Cross.

The recently built branch from Okeechobee to Belle Glade was extended in 1929 for an additional 10 miles down to Lake Harbor, where a physical connection was made with the Atlantic Coast Line Railroad. By then, the boom was over and FEC revenues had fallen precipitously. The stock market crash and resulting national depression worsened matters. In fact, the financial condition of the railway became imperiled to the extent that in 1931, the firm was declared bankrupt.

During the boom, the Florida East Coast Railway built a new drawbridge over the St. Johns River in Jacksonville. The massive structure is still used today. (Courtesy Florida State Photo Archives.)

No snapshot of boom events can conclude without mentioning the St. Louis–San Francisco Railway, or "Frisco" for short. For years, this prominent railroad company desired an outlet at Pensacola to export oil and wheat originating on its lines in Oklahoma and Kansas along with products manufactured in St. Louis and Kansas City. The goal crystallized in July 1925, when the Frisco acquired the Muscle Shoals, Birmingham & Pensacola Railroad running from Pensacola to Kimbrough, Alabama. Evolution of the Muscle Shoals firm was recounted in Chapter 7. To connect that entity with the Frisco system, the company built a new rail route from Kimbrough to Aberdeen, Mississippi. The Frisco spent $2.5 million rehabilitating the line into Pensacola, making it completely serviceable for trunk line traffic. Excessive grades were reduced, embankments and cuts were widened, and 80-pound-to-the-yard steel rail was installed. Passenger stations, freight houses, and coaling stations were also rebuilt or remodeled, plus a considerable amount of money was spent on improving the terminal facilities at Pensacola. On June 28, 1928, two special Frisco trains arrived in the Gulf port with upwards of 300 businessmen, bankers, and railway officials. After welcoming speeches, a parade was held, a regatta was staged on Escambia Bay, and an airplane show was performed by officers of the naval air station. The city went out of its way to welcome the Frisco and many storefronts were decorated for the big event. In this way, a prominent western rail carrier came to Florida.

The Havana Special *operated over the Florida East Coast Railway to Key West. Flappers dominate the lounge car in this 1926 scene. (Courtesy Railway & Locomotive Historical Society.)*

11. Pursuing Business

Confusion to the enemy!
 ~ Toast of Edward G. Ball, chairman of the Florida East Coast Railway

Many railway milestones occurred in Florida between 1930 and 1970. The first streamlined passenger trains appeared, diesel engines replaced steam locomotives, piggyback train service was inaugurated, and numerous technological advances such as radio, centralized traffic control, and computers were integrated. When the period began, the state contained about 5,700 miles of lines split among 22 railroad companies. The "Big Three" continued to dominate the scene, controlling more than 80 percent of total rail mileage. This chapter recounts some of the events the trio experienced.

The Atlantic Coast Line Railroad avoided bankruptcy during the Depression by slashing costs, delaying purchases, and reducing its workforce. Revenues stood at $63 million in 1930, as opposed to $72.3 million the previous year. Truckers had captured millions in freight revenues, and passenger travel markedly decreased in favor of private automobiles. A lack of business forced many Florida companies to close or operate with minimal staff, further reducing the railroad's customer base. For example, cheap lumber from the American Northwest was shipped to the eastern seaboard, in turn leading to a sharp decrease in the manufacture and movement of forest products from the Sunshine State.

Henry Walters, the esteemed chairman of the Coast Line, died in 1931 at the age of 83; his nephew, Lyman Delano, became the new chairman. As the railroad's cash position grew weak, Delano was forced to suspend stock dividends and institute economies. Despite these measures, revenues continued to fall. In 1932, a loss of $6.7 million was recorded on revenues of $37.2 million. Freight traffic was down 30 percent from the year before, while passenger revenues decreased by 38 percent. Again, Delano ordered layoffs and reduced the salaries of officers. The company's only bright spot was its *Florida Special,* which set a new time record between New York and Miami: 29 hours and 40 minutes. A recreation car was added to the flyer in 1933 that touted a three-piece band, a small dance floor, bridge tables, a miniature gym, and a hostess.

The Coast Line's financial shape improved as the decade closed, to the extent that Delano felt comfortable in ordering new engines and rolling stock. In 1938, the company's biggest steam locomotives—the famed "Northern" class engines with 4-8-4 wheel arrangements—arrived on the property. They were built by Baldwin, boasted 80-inch drivers, weighed 460,270 pounds, and cost nearly $159,000 apiece. Even though their appetite for coal and water was prodigious, the behemoths could haul 20 heavyweight Pullman cars in excess of 60 miles per hour. After they were broken in, the engines hauled such famous Florida trains as the *Havana Special* and the *Tamiami.*

In 1939, the Coast Line's rival, the Seaboard, introduced an extremely popular streamlined lightweight train named the *Silver Meteor,* powered by a state-of-the-art diesel-electric locomotive. Champion Davis, a respected Coast Line vice president, advised Delano that the company had to purchase one as well, otherwise it would loose its preeminent market position. Delano was reluctant to make the purchase until he learned that the Florida East Coast Railway was going to place such an order with the Budd Manufacturing Company in Philadelphia. Delano then ordered two similar sets plus two diesel-electric engines from the Electro-Motive Corporation. (The cars cost $70,000 each, while an engine was priced at $175,000.) A nationwide contest was held to establish a name for the Coast Line train and over 100,000 people submitted suggestions. The *Champion* started service in early December amidst much fanfare at New York's Pennsylvania Station. When the streamliner arrived at Fort Lauderdale, it was joined by its counterpart on the Florida East Coast Railway, the *Henry M. Flagler.* In a magnificent publicity stunt, the two streamliners then rode side-by-side down the Florida East Coast Railway's double-track to Miami, at times reaching 75 miles per hour. Overhead, two airplanes chased the consists and discharged smoke trails. The decade ended on an auspicious note.

Revenues on the Seaboard reached $61.7 million in 1927, the year in which S. Davies Warfield died. Three years later, they dropped to $49.6 million, while in 1932 they amounted to just $30.7 million. Management wisely began cutting expenses in the late 1920s. They also ordered gas-electric self-propelled cars and placed them into service where the cost of running a steam-hauled passenger train was prohibitive. Despite these and other measures, serious problems arose when the Seaboard failed to earn its fixed charges in 1930. Numerous conferences were held that year with bankers and investment houses, but a resolution proved "impossible of accomplishment" and the company slipped into receivership, the nation's first railroad to do so during the Depression. The federal district court appointed two receivers to operate the property. Among other directives, they were ordered not to pay certain rental monies on leased properties or bond interest until the firm's financial house was put back in order (which did not occur until 1945). During the interlude, the receivers scrapped many little-used lines. In Florida, the branch to Silver Springs vanished, as did tracks between Alcoma and Nalaca and from Gainesville to Sampson City. The Tooke Lake branch was also

taken up, as was the entire Florida Central & Gulf subsidiary between Hernando and Port Inglis.

The temporary pause in paying debt allowed the Seaboard's receivers to fund several projects including a new electric power plant at south Boca Grande and a new phosphate loading bin. Many dangerous highway crossings in Florida also received warning signals. By January 1934, the *Orange Blossom Special* boasted air-conditioned passenger cars, followed by the *Southern States Special* and the *New York–Florida Limited*. New combination freight and passenger stations were erected at Tavares and near the veterans home in St. Petersburg. Refrigerated storage buildings were constructed in Jacksonville to accommodate shipments of fruit and produce, while improvements were made to the Seaboard's repair shops in west Jacksonville. Three rail "buses" were acquired in the 1930s from American Car & Foundry, and two diesel-electric rail motor cars were ordered from the Electro-Motive Corporation. The Seaboard also extended its auto loading platform at Miami.

The company's policy of abandoning little-used rail routes continued. Rails from Archer to Cedar Key were removed, as were those on the Royster Spur near Bartow, from St. Marks Junction to Covington, and between Wannee and Bell. The East & West Coast Railway subsidiary (from Arcadia to Manatee) was completely taken up in 1933. Competition from cars and buses continued to intensify, prompting the Seaboard to cut passenger train fares. Rates on citrus shipments were also reduced, in an attempt to stem the considerable traffic

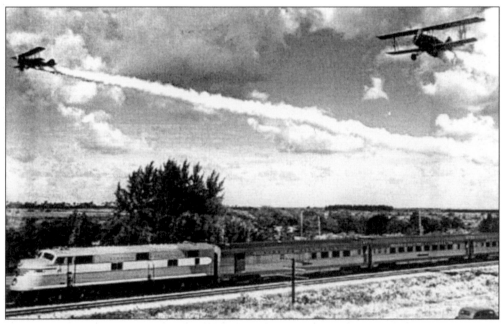

Biplanes discharge smoke trails while chasing the Florida East Coast Railway streamliner Henry M. Flagler. *(Courtesy Florida State Photo Archives.)*

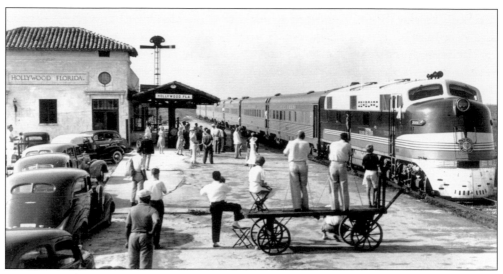

Cameras rolled in Hollywood, Florida, as the Seaboard's new streamlined train, Silver Meteor, *arrived on February 3, 1939. (Courtesy Florida State Photo Archives.)*

being conveyed up the Atlantic seaboard in refrigerated ships. Finally, in 1936, passenger traffic started to increase due to the lower fares and air-conditioned coaches. The *Florida Sunbeam* began running from Chicago and Detroit via the New York Central, Southern, and Seaboard lines. Then, the winter-only *Orange Blossom Special* began operations in two sections from New York to Miami and St. Petersburg. A new bridge was also constructed over the Nassau River near Yulee, while the passenger depot at Sarasota was remodeled. Funds were also found for a new five-stall engine house at Wildwood, while shop facilities at Hialeah were expanded. In 1938, freight revenues surged because of a longshoremen's strike that affected South Atlantic and Gulf ports. New pulp board and box mills opened in Jacksonville and Fernandina, also contributing to freight revenues.

To increase passenger traffic, the Seaboard's receivers purchased a diesel-powered streamlined passenger train, the first in Florida railroad history. Nine 2,000-horsepower diesel locomotives and fourteen stainless steel lightweight coaches went into service the following February. The *Silver Meteor* became an instant success in the New York–Miami corridor. Later, the train split at Wildwood so that service could be offered to the west coast at St. Petersburg.

Like its rivals, the Florida East Coast Railway was profoundly affected by the Great Depression. It, too, instituted cost-cutting measures as the land boom wound down. Train service was reduced on branch lines and obsolete equipment was retired to lower taxes and insurance costs. Nevertheless, the empire that Henry Morrison Flagler had so patiently assembled slipped into receivership in September 1931. Two receivers ran the property until a reorganization plan acceptable to creditors could be found. What precipitated the failure was the company's inability to pay interest on its "First and Refunding Bonds." This $45

million issue had been floated during the land boom for two purposes: to refinance the company's first mortgage bonds and to fund the manifold improvements undertaken during the boom. The testamentary trust that owned the railway's common stock (the so-called Bingham Trust, for Mary Flagler Bingham, the remarried widow and heir of Henry Flagler) advanced several million dollars to cure the interest defaults, but when further payments were skipped, the trust fund lent a deaf ear and the company became a ward of the court. Before long, owners of the First and Refunding Bonds began to wonder if they or the Bingham Trust actually owned the railway. Litigation over this issue arose and was not resolved until the 1950s.

The quest for cutting costs intensified as the receivership continued. In 1932, the receivers halted trains on the Orange City Branch in favor of bus and truck service. Two years later, that 27-mile rail line was ripped up. The Mayport Branch between Spring Glen and Mayport also vanished, as did the spurs to Ormond Beach, to Palm Beach, and from East Palatka to Palatka. The FEC also reduced worker wages. Passenger train fares were cut to attract customers and, like the Coast Line, the railway began offering door-to-door delivery service on LCL (less-than-carload) freight shipments. During the early 1930s, five daily trains operated in each direction between Jacksonville and Miami. In 1934, revenues amounted to $7.6 million, a far cry from the $29.4 million enjoyed in 1926.

A hurricane of enormous proportions struck the Florida Keys on Labor Day weekend in 1935. Nearly 600 men, women, and children perished. Many of

The tidal wave of the Labor Day, 1935 hurricane overturned this Florida East Coast Railway rescue train near Islamorada. (Courtesy Florida State Photo Archives.)

135

the fatalities were World War I veterans who had come to the Keys to build highway bridges at the behest of President Franklin Roosevelt. An FEC rescue train was dispatched from Miami to Lower Matecumbe, where many of the vets huddled. But as the train struggled at Islamorada, the storm's dreaded tidal wave came ashore. The train was immediately engulfed and overturned, except for its locomotive. Within minutes, over 40 miles of rails on the famed Key West Extension were ripped asunder. The cost of rebuilding the railway could not be justified by the receivers, who decided to sell everything south of Florida City to several government and municipal agencies. What had cost Flagler tens of millions to create was sold for the trifling sum of $640,000. In time, the railway line was fashioned into the Overseas Highway.

Passenger traffic on the FEC began to improve in 1936. One of its most popular trains, the *Florida Special*, was brought from New York to Jacksonville via the Atlantic Coast Line, then handed over to the FEC. On February 29, 1937, seven separate sections of the famous train were operated to Miami. A year later, the *Special* celebrated its 50th year of continuous operation.

As previously noted, the FEC purchased two seven-car streamlined coach sets from Budd Manufacturing in Philadelphia and two diesel locomotives from Electro-Motive in Illinois. One of the train sets, the *Champion*, ran in the New York–Miami corridor in conjunction with the pair owned by the Coast Line. The other, christened *Henry M. Flagler*, operated just between Jacksonville and Miami. Seating arrangements, car interiors, and air conditioning apparatus distinguished the Coast Line and FEC cars from those forming the Budd-built *Silver Meteor* belonging to the Seaboard.

World War II sparked a tremendous surge of traffic on the nation's railroads. Revenues and net income rose dramatically and the carriers did everything in their power to expedite the movement of soldiers, munitions, and wartime supplies. As the war unfolded, dozens of military installations opened in Florida, such as ammunition storage facilities, air bases, flexible gunnery schools, glider schools, airfields, and air training bases. Many of Florida's railroads transported supplies and materials for these projects, and frequently spurs were built directly to the installations. Also during the war years, record volumes of phosphate, citrus, sugar, and bananas were conveyed by rail because the submarine menace had halted coastal shipping.

The Atlantic Coast Line Railroad experienced a traffic surge even before the attack on Pearl Harbor. Shipments of phosphate and fertilizer doubled, while the movement of construction rock tripled. Citrus car loadings also dramatically rose, as did those of sugar and petroleum. In 1941, revenues on the Coast Line amounted to $67.4 million. A year later, they had reached $115.1 million, a 70 percent increase. In just one year, freight traffic had increased by 65 percent, while passenger traffic rose by 118 percent. Because of government restrictions, the Coast Line was unable to operate all of its tourist train services during the 1942–1943 winter season. However, it did get approval for one additional section of the *Tamiami-Champion* and the famed *Havana Special*.

During the war, a substantial quantity of forest products emanated from the Coast Line's Immokalee Branch (formerly the Haines City Branch) in southwest Florida. Deep within Collier County existed the largest remaining stand of virgin bald cypress in the United States. Intensive harvesting began in the Big Cypress Swamp in the 1940s and within two decades, its vast deposits—including those in the Fakahatchee Strand—were nearly depleted. Lee Tidewater Cypress Company, located in Copeland, installed temporary logging spurs into the forests and very quickly became the world's largest supplier of cypress lumber. The federal government was the company's sole customer during World War II, purchasing about one million board-feet a month. Operations reached their zenith in the early 1950s. (Life in the logging camps was profiled in the May 29, 1954 issue of *Saturday Evening Post*.) At Copeland, Lee Tidewater maintained a self-contained community with offices, warehouses, repair shops, and a power plant. From there, connections were made with the Atlantic Coast Line Railroad. After the great cypress trees were cut, the logs were sent to Lee Tidewater's millhouse at Perry, some 400 miles distant. The last of the economically harvestable trees were downed in the winter of 1956–1957; then operations ceased. Interestingly, the coal-fired locomotive fleet sat on side tracks for years until collectors acquired them. In March 1987, Engine No. 2—a Prairie-type (2-6-2) Baldwin product—was returned to Collier County courtesy of a train collector. Today, it can be seen at the Collier County Museum in Naples.

In 1943, revenues climbed to $155.9 million, the greatest in Coast Line history. However, the railroad's directors were quick to remind stockholders that such earnings could not be expected in the postwar period. The volume of traffic, for instance, would inevitably drop and competition from other transportation agencies would increase. They were correct.

Unlike the Seaboard, the Coast Line abandoned little track in Florida during the war years. That which connected Fincher with Fanlew was removed, plus the little-used line south of Bonita Springs to Naples and Marco Island. However, in connection with the latter, the Coast Line purchased the Seaboard's route from Bonita Springs to Naples. It rebuilt that line and took possession of the beautiful Mediterranean Revival station erected in Naples during the land boom. The Coast Line then reached downtown Naples, which its abandoned route had failed to do.

In 1946, after a four-year hiatus, the Coast Line's illustrious *Florida Special* resumed winter operation to both Florida coasts, and the *West Coast Champion* appeared with streamlined coaches. Further, both the Coast Line and the FEC (along with other partners) purchased a "pool" of streamlined cars for the New York–Florida market comprised of 42 sleeping cars, 10 dining cars, 20 coaches, and 2 baggage cars. Two years later, operations of the *West Coast Champion* and *Southland* were extended to Sarasota.

The Big Three located numerous industries in Florida after the war. A variety of companies built plants along the Coast Line's tracks and produced such goods as cement, newsprint, paper containers, lumber, and chemicals. Distribution centers and warehouses also were erected, often on property that the railroad sold

to these new shippers. However, no development occurred along the Coast Line's Fort Ogden Extension from East Sarasota to Southfort, built during the crazy days of the land boom. Traffic severely diminished on this 33-mile line and before the 1940s closed, the extension was almost totally removed.

Once wartime gas rationing ceased, the use of private automobiles dramatically increased in Florida and elsewhere. To attract and maintain passengers, the Coast Line offered more service, better dining, comfortable sleeping cars, and streamlined coaches. No passenger was ignored, even those whom the Coast Line (and all Southern carriers) discriminated against. As the 1949 annual report related:

> One of the more stable classes of rail travelers, particularly in the South, are colored passengers. In recognition of this, as well as in the hope of retaining and increasing the traffic, posters were placed in colored waiting rooms and in colored coaches expressing appreciation of the patronage your Company is receiving from colored passengers. A replica of the poster, against a suitable background, has also been used as an advertisement in newspapers for colored people.

But such ads could not completely eliminate the popularity of motorcars. Passenger traffic fell that year, and service on the *Sunchaser*, the *Florida Arrow*, and the *Dixieland* was halted.

Centralized Traffic Control enables a train dispatcher to remotely control signals and switches. This machine, located in Jacksonville, controlled the Seaboard's mainline route to Miami.

Phosphate was the greatest of all commodities carried by the Seaboard in Florida. The mineral is still mined and processed in Bone Valley near Mulberry.

The Seaboard continued to improve its train services and physical plant throughout the 1940s. Its famed streamliner, the *Silver Meteor*, was now enlarged to 14 cars and became powered by two diesel-electric locomotives. New shops were added to the company's Hialeah yard and a large warehouse and automobile loading platform were constructed in Miami. In 1940, a branch to the naval air base at Opa Locka was completed along with one at Starke to service Camp Blanding. The following year, new shop facilities were built at Tampa, while the existing shops at west Jacksonville were greatly expanded. Revenues of $64.6 million were recorded in 1941; a year later, they rocketed to $110.2 million. A new connecting track was installed at Fort Lauderdale so that Port Everglades could be reached.

The Seaboard continued to abandon little-used lines in Florida during the war years. After the Interstate Commerce Commission gave its approval, the company removed rails between Turkey Creek and Durant, Tallahassee and Carrabelle, Havana and Quincy, San Carlos and Truckland, Alva and LaBelle, and south Fort Myers and Naples. The once-popular branch leading to Indian Rocks Beach also vanished, plus the ICC allowed the company to abandon its Tampa & Gulf Coast subsidiary from Lake Villa to Tarpon Springs and from Elfers to New Port Richey.

During 1943, the Seaboard built a new yard at Tallahassee and made improvements to those existing at Baldwin, Wildwood, Pierce, and Tampa. The company's long-awaited reorganization plan was submitted to the federal district court and declared operational on January 4, 1945. Centralized Traffic Control (one dispatcher controlling signals and switches from a remote location) was integrated at several points, icing facilities were added to the Hialeah yard, and a new 105-foot turntable was ordered for the west Jacksonville shops. An historic moment took place on August 1, 1946, when the new Seaboard Air Line Railroad Company emerged from receivership. The firm then employed 19,000 workers and operated some 3,800 miles of track. As usual, the biggest freight item transported by the new company was "Products of Mines." In Florida, that meant one very important commodity: phosphate.

In partnership with other carriers, the Seaboard acquired partial ownership of the Pullman Company during the postwar years. Other events of note included the introduction of radio communications and a new diesel engine shop at Jacksonville. Combination freight and passenger depots were built at Wildwood and Plymouth. Tabulating machines with keypunch cards were introduced, which greatly aided the preparation of payrolls and freight accounting. In 1948, centralized traffic control was installed on the Gross-Callahan Cutoff and later between Coleman and Valrico. To document its recent accomplishments, the company released a movie about the railroad entitled "New Horizons." In July 1949, a popular new Seaboard train, the *Gulf Wind*, began service between Jacksonville and New Orleans. The Dade County Port Authority also paid to relocate the Seaboard's shops and yards at Hialeah to a new location, in turn allowing the Miami International Airport to expand.

The Florida East Coast Railway entered bankruptcy in 1941 because the company's receivers had failed to craft a reorganization plan acceptable to the railway's creditors. The company's string of losses was finally broken in 1942, when a profit of over $5 million was announced. In fact, revenues climbed as wartime traffic increased, expenses were controlled, and the firm's rickety finances greatly improved. Despite these encouraging trends, a legal battle raged as to who actually

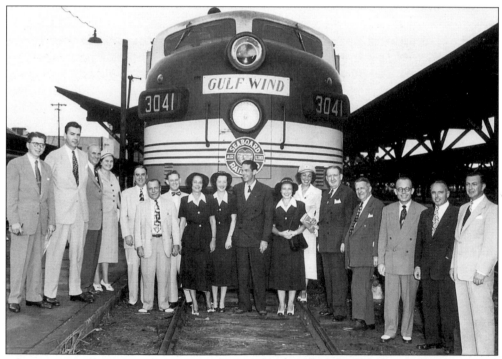

The Gulf Wind *began service between Jacksonville and New Orleans on July 31, 1949. Here, train staff and railway officials from the Seaboard and partner Louisville and Nashville Railroad pose at Jacksonville. (Courtesy Railway & Locomotive Historical Society.)*

owned the FEC, the Bingham Trust or the holders of the First and Refunding Bonds. Among those who held some of the latter was Jacksonville financier Edward G. Ball, who represented the testamentary trust of Alfred I. duPont.

The bonds in question were held by many individuals and financial institutions. Some of the larger parties bandied together and submitted reorganization plans for the court to consider. The plan that Ball presented on behalf of the duPont Trust was, at first, rejected. However, the Interstate Commerce Commission did state that whoever owned a majority of the bonds was the true owner of the railway. Since no one party had a majority, Ball decided to obtain one by purchasing the securities wherever possible or by striking alliances with key minority bondholders, such as Miami financier S.A. Lynch and the Atlantic Coast Line Railroad. But Ball underestimated Lynch and the Coast Line, who later united and made their own bid for the FEC. The Coast Line engaged a powerful political voice for its cause, Florida Senator Claude Pepper. Pepper despised Ball and the economic power that the duPont Trust held in the state. He attacked Ball from every angle, but in the end, the court favored Ball for two reasons: he had obtained a majority of the bonds and his revised plan was in the public interest. Nevertheless, the Coast Line refused to give up and a new round of appeals and hearings began. In 1947, the ICC then reversed itself to side with the Coast Line. Ball vigorously challenged the verdict in several venues and won, although the case was not settled finally until the late 1950s.

While attorneys argued the ownership feud, a world war was still being fought. The FEC performed yeomen service during the hostilities, while the firm's trustees tried to operate the property in the most economical manner possible. In 1944, the railway abandoned the portion of its Okeechobee Branch from Maytown to a remote location some 14 miles south of Okeechobee—a total of 136 miles. The company then constructed a new 29-mile cutoff from Fort Pierce inland to where the abandonment ended. The project commenced in October 1945, but completion was delayed by a lack of materials. Nearly 15,000 people turned out to celebrate its opening in March 1947. Sugar cane and cane byproducts, like molasses, were shipped from this fertile region, along with vegetables.

Florida's railroads generally prospered in the 1950s. The postwar economy bubbled, GI's wanted new homes, and many businesses and industries relocated to the Sunshine State. In fact, many newcomers had discovered the "Empire in the Sun" while receiving military training in the state. Further, the first big wave of Social Security retirees were moving in, air conditioning was affordable, and the pesky mosquito was brought under control.

The physical plant of the Atlantic Coast Line Railroad was meticulously maintained by President "Champ" Davis. Another of Davis's goals was to completely "dieselize" the company's locomotive fleet. By 1952, 564 diesel engines were on the property and only 11 steam engines remained. Three years later, the last of the dinosaurs were retired. Lightweight passenger coaches and sleeping cars also arrived on the property and immediately went into service on the *East Coast Champion*, *West Coast Champion*, *Vacationer*, and *Florida Special*.

The Florida East Coast Railway opened its branch from Fort Pierce to near Lake Okeechobee in March 1947. The area's reigning beauty queens were invited to the celebrations. (Courtesy Florida State Photo Archives.)

Passenger traffic from the Midwest to Florida also began to increase and connecting trains such as the *Dixie Flagler*, *South Wind*, and *City of Miami* began operating every other day. By 1956, workers at 32 Coast Line yards and terminals were connected with radio communication.

One goal that evaded Davis was wresting control of the Florida East Coast Railway. In 1954, the U.S. Supreme Court ruled that the Interstate Commerce Commission had exceeded its authority by forcing an involuntary merger of the two firms. It remanded the case back to the ICC and the federal district court in Jacksonville. In 1958, the ICC once again reversed itself and announced that it approved the FEC takeover proposed by Edward G. Ball, the duPont Trust, and the St. Joe Paper holding company. After years of expensive legal dueling, the Coast Line relinquished its fight.

Davis resigned as Coast Line president in 1957 and was succeeded by W. Thomas Rice, an experienced railroader and decorated military veteran. Rice's "open door" management style sharply contrasted with that of his predecessor. He was also keenly interested in marketing and public relations. That year, the

Coast Line began constructing its new corporate headquarters in Jacksonville and relocating its facilities in St. Petersburg. It also sold several large downtown parcels in Tampa for city projects. Dedicated piggyback trains were inaugurated between Alexandra, Virginia and Jacksonville in 1959—the same year that the Coast Line received the coveted Harriman Safety Award for the best overall safety record of any American railroad. Rice was also the prime mover behind the merger uniting the Coast Line with the Seaboard Air Line Railroad. The two firms were almost equal in size (the Coast Line had the advantage) and served the same territory. Moreover, they had facilities at 121 common points between Virginia and Florida. The Interstate Commerce Commission approved the merger in 1959, although litigation delayed the marriage until 1967.

The Seaboard posted solid revenues and profits during the 1950s and began numerous improvement projects in Florida. The railroad replaced the last of its steam locomotives with diesel-electric engines, becoming fully "dieselized" by 1953. It also converted its steam engine facilities at Tampa and Wildwood for diesel repairs and expanded its existing diesel facilities at Jacksonville. The company's new Hialeah yard also opened that year. A centralized traffic control system facilitated train movements between Yulee and Baldwin beginning in 1955. Teletype services were activated at Jacksonville, Orlando, and Leesburg and a new switching yard was built at Tallahassee. The City of Orlando gave the

Edward G. Ball was trustee of the powerful Alfred I. duPont Trust. His sister became duPont's wife. (Courtesy Florida State Photo Archives.)

143

railroad property for a new freight yard and facilities near the city in exchange for the railroad's parcels in the downtown district. (This "swap" relieved vehicular congestion and provided parking.) City fathers in St. Petersburg promulgated a similar plan and in January 1959, a more conveniently located passenger station resulted. The Seaboard also sold property for development, such as a large parcel in downtown Jacksonville that went for retail purposes. The displaced freight house and divisional offices were built anew on the west side of the city.

The Seaboard abandoned just one significant stretch of track during the 1950s. What remained of its Fort Myers Line from Fort Ogden to Fort Myers was removed in 1952, including its branches that led east to Alva and west to San Carlos, some 65 miles total. This line originally had been built during the boom by President S. Davies Warfield, but in recent years, traffic had greatly diminished. Potato and gladioli growers opposed the abandonment, but the Interstate Commerce Commission determined that this part of southwest Florida did not need the services of two trunk line carriers. The Fort Myers area was left to the Atlantic Coast Line Railroad.

Locating new shippers along the Seaboard's tracks was the mission of the railroad's industrial department. Among the firms that erected facilities in the Sunshine State during the 1950s were cement companies, breweries, glass producers, grocery wholesalers, chemical concerns, concrete pipe manufacturers, gypsum board producers, and bag and paper mills. As the decade closed, the Seaboard actively pursued piggyback business (trailers on flatcars) and discussed merging with rival Atlantic Coast Line Railroad.

Revenues on the Florida East Coast Railway stood at $26.8 million in 1950 and rose to a decade high of $38.9 million in 1957. Still, the cost of doing business and servicing debt proved expensive to the extent that a loss was incurred every year of that decade except 1955. In fact, the decade's losses totaled over $21 million. Management tried to cut expenses by running fewer trains and lowering payroll, but these measures did not curb the flow of red ink. As the decade closed, the problems fell squarely to the railway's new owner, St. Joe Paper Company and duPont trustee Edward G. Ball. By 1959, the railway had dispensed with steam locomotives and vigorously pursued piggyback traffic.

Stockholders of the Atlantic Coast Line and Seaboard Air Line railroads approved merging their companies in 1960. Technically, the Coast Line was be merged into the Seaboard, and the resulting firm was named the Seaboard Coast Line Railroad. The Interstate Commerce Commission signed the marriage agreement in 1963, with a start-up date to occur the following year. However, certain parties contested the proposed action, including the Florida East Coast Railway. On May 13, 1965, the U.S. District Court in Jacksonville set aside the ICC order claiming that the commission did not adequately determine whether the merger violated the antitrust standards of the Clayton Act. The decision was appealed to the U.S. Supreme Court which, in an 8-0 decision, said the Jacksonville opinion was erroneous, that the ICC did indeed have the wisdom and experience to determine if the merger was in the public interest. The Coast

Line rejoiced, but the battle blazed on. In 1966, the Southern Railway and the city of Tampa appealed the ICC decision together with certain railroad unions.

The 1960s proved to be productive years for the Atlantic Coast Line. The company's new headquarters building in Jacksonville opened, along with a new passenger and freight facility in Lakeland. In Fort Myers, the Coast Line vacated its downtown freight yard and built a new 40-acre facility south of the city. The railroad's passenger department aggressively sought customers and cosponsored organized travel, theatre train tours, *Champion* train vacations, educational excursions for kids, athletic event specials, and Santa Claus trains. To expedite passenger bookings, a new central reservation bureau opened in Jacksonville in 1961. Three years later, the railroad transported some 11,000 passengers to the New York World's Fair. The railroad's most famous passenger train, the *Florida Special*, began featuring candlelight dinners in 1964 as well as hostesses, fashion shows, movies, games, and song fests. Its recreation cars were even equipped with televisions and telephones. Computer technology was quickly embraced by the Coast Line and by 1964, the company owned the industry's first online real-time installation. High-horsepower diesel-electric locomotives—such as General Motors GP-35 models, General Electric U-25Cs, and Alco Century 628s—were also purchased. President Rice's dream of merging the Coast Line with the Seaboard finally became a reality on July 1, 1967.

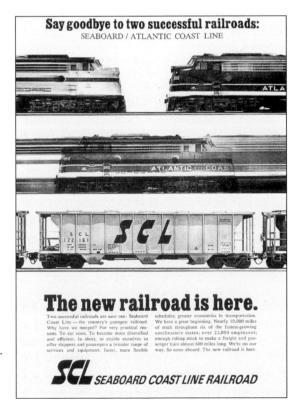

In 1967, the long-awaited marriage of the Atlantic Coast Line and Seaboard Air Line finally became official.

Like the Coast Line, the Seaboard also prospered during the 1960s. A modern freight station opened in Tampa and new piggyback platforms were completed in Orlando, Auburndale, and Hialeah. In 1961, a huge TOFC (trailer on flatcar) terminal opened in Tampa. Piggyback movements were rapidly increasing and about 11,000 carloads were transported over the system, creating about $3 million in revenues. The company's industrial department continued to locate industries along the railroad and frequently sold the land upon which the new plants were built. To bolster inventories, in 1953, the company acquired about 800 acres of government-owned land at Opa Locka, a few miles north of its Miami passenger station. In 1966, the Seaboard's new yard and shop buildings at Hialeah were fully completed, while Centralized Traffic Control was activated between Baldwin and Tallahassee. A new combination freight and passenger station was also constructed at Lake City.

The Florida East Coast Railway emerged as a new corporate entity in 1961, no longer a ward of the bankruptcy court. But Edward Ball and his management team were now confronted with the wage demands of many unions. The FEC bargained in good faith and made numerous offers, but the settlements were limited by high operating expenses and a string of losses that the company had recently experienced. None of this mattered to the workers who, in January 1963, went on strike. Picket lines went up and traffic on the railway halted. The Ball management team then decided on a new tactic: allowing supervisory personnel to operate its trains. This action, of course, sparked more ill will between the company and the unions—so much so that several workers began committing crimes against the railway. Rail was removed, guns were fired at passing trains, switches were tampered with, and wrecks occurred. On February 9, 1964, two trains were even dynamited. President Lyndon Johnson flew over the carnage and wasted little time involving the Federal Bureau of Investigation. Within weeks, the perpetrators were arrested and later imprisoned. Even though acts of violence subsided, the strike continued. Passenger train service resumed in August 1965, albeit on a very limited basis. Three years later, the service was scrapped.

Ball's executives ultimately introduced many innovative ideas to the FEC, such as small train crews, basing crew's wages on an 8-hour day, running short, frequent freight trains without cabooses, and installing welded rail and concrete crossties. In 1970, one of the striking unions finally accepted the company's terms and its members returned to work. However, not until the mid-1970s did the last of the holdouts reach a settlement and this disturbing chapter in American labor history come to an end.

As noted earlier, 22 railroad companies existed in Florida in 1930. This chapter has explored events of the Big Three during that period, but who were the remaining 19? Collectively they operated less than 1,000 miles of track, or about 17 percent of the state's total. Biggest among them was the 245-mile Louisville and Nashville (owned by the Atlantic Coast Line), followed by the 158-mile Georgia Southern & Florida (owned by the Southern Railway), and the 100-mile Apalachicola Northern. The next group of players operated fewer than

100 miles apiece: the 77-mile Live Oak, Perry & Gulf; the 66-mile Atlanta & St. Andrews Bay; the 48-mile St. Louis–San Francisco Railway; the 45-mile South Georgia Railway; the 42-mile Marianna & Blountstown; the 38-mile Jacksonville, Gainesville & Gulf; the 38-mile Alabama & Western Florida; the 37-mile Tavares & Gulf; and the 30-mile St. Johns River Terminal Company. The remaining six firms operated fewer than 20 miles of railroad: the 18-mile Jacksonville Terminal Company; the 13-mile Georgia & Florida; the 11-mile Trans Florida Central; the 10-mile Alabama, Florida & Gulf; the 3-mile Tampa Northern; the 2-mile Tampa Union Station Company; and the Port St. Joe Dock & Terminal Company, which owned less than 1 mile of track. Each of these firms maintained common carrier status with the Interstate Commerce Commission and had to abide by certain federal safety and reporting regulations.

For years, Florida has been home to several private railroad operations, including switching companies that served the ports of Jacksonville and West Palm Beach. Largest among the military lines in the state was a 60-mile entity that ran from Mossy Head (on the Louisville and Nashville Railroad) to Eglin Air Force Base. The latter was completed in 1952 and until 1975, hauled everything from food to tanks. Although all of these firms experienced their own trials and tribulations between 1930 and 1970, none impacted Florida railroad history more than the Big Three.

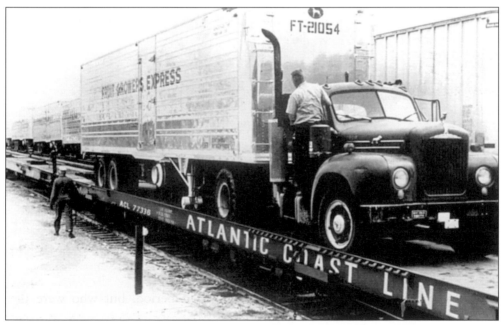

During the 1950s, TOFC (trailer on flatcar) traffic came of age. The Coast Line and other Florida carriers aggressively pursued piggyback traffic.

12. SURVIVORS

The Americans are alone in assuming that railroads have to be profitable.
~ *The Economist* magazine, August 24, 1985

From 1967 to 1980, the railway affairs of the Sunshine State were dominated by a single carrier, the Seaboard Coast Line Railroad. Formed in 1967 from the Atlantic Coast Line and Seaboard Air Line firms, the SCL instantly became the eighth largest railroad in America with nearly 23,000 employees, 9,600 route miles, 62,000 cars, and over 1,000 locomotives. (The SCL included the Louisville and Nashville Railroad, which the Coast Line had obtained in the early 1900s.) John W. Smith, former president of the Seaboard, was chairman of the new entity while W. Thomas Rice, former president of the Coast Line, was president. Management expected five years for the full financial benefits of the marriage to be realized. In the meantime, the company began the job of eliminating redundant tracks and facilities, retiring little-used routes, pooling locomotives and cars, and consolidating stations, yards, and terminal facilities.

During its first year of operation, the SCL generated $417.3 million in revenues. A variety of freight commodities were hauled on the system, including foodstuffs, pulp, paper, phosphate, fertilizer, farm products, coal, minerals, forest products, and piggyback trailers. Over 300 businesses located along SCL tracks in 1967 and many companies selected sites in Florida. Often, the railroad sold land to these new shippers. To bolster its inventory of parcels, the SCL purchased a 535-acre industrial tract near Orlando and, in 1968, a 135-acre tract near Deerfield Beach. The railroad also built a state-of-the-art marine terminal, called Rockport, near Tampa in July 1970. It rapidly loaded phosphate rock and related products into vessels.

For several years, the Seaboard Coast Line ran its own passenger trains and aggressively advertised its New York–to–Florida service. In 1967, the *Florida Special* began its 80th season of winter operation. However, lack of patronage forced the withdrawal of several local trains, including those that ran from Jacksonville to St. Petersburg and from Jacksonville to Chattahoochee. In 1970, Congress passed the Rail Passenger Service Act, creating a quasi-public entity known as the National Railroad Passenger Corporation, or Amtrak. Railroads that joined this new organization paid an entrance fee and were relieved from

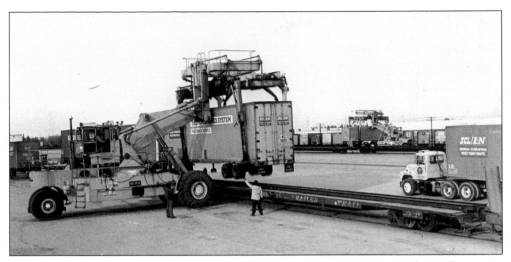

Piggyback traffic greatly contributed to Seaboard Coast Line revenues. At Jacksonville, gantry tractors effortlessly load and unload truck trailers.

operating passenger trains unless Amtrak contracted them to do so. Seaboard Coast Line (and subsidiary Louisville and Nashville) made a one-time payment of $22.1 million and on April 30, 1971, the last Seaboard Coast Line passenger train operated in Florida. The following day, Amtrak became operational with SCL operating its Florida service. A second entity that surfaced was the Auto Train Corporation, conceived to transport automobiles and their passengers between Lorton, Virginia and Sanford, Florida. The two terminals and the train's locomotives and cars were owned by the privately owned firm, while the Seaboard Coast Line furnished tracks and crews. Operations began in December 1971, but financial problems plagued the firm and Amtrak assumed its service in 1983.

During the 1970s, the Seaboard Coast Line rehabilitated its big yard in Baldwin and developed its attractive land holdings near its headquarters in Jacksonville. The firm also nationally advertised its various railroad units as the "Family Lines System." The biggest freight commodity that the SCL transported in Florida was phosphate. This mineral was mined and processed in the Bone Valley region, where the SCL serviced 16 major chemical plants. Other big revenue producers in Florida included coal, piggyback trailers, automobiles, paper, and chemicals.

In 1978, Seaboard Coast Line Industries announced merger discussions with the "Chessie System" of railroads: the Baltimore & Ohio, Chesapeake & Ohio, and Western Maryland. Stockholders ratified the merger on February 13, 1979 and within 20 months, the Interstate Commerce Commission sanctioned the marriage. On November 1, 1980, the CSX Corporation came into existence as the largest railroad system in the United States with 70,000 employees and 27,000 miles of track. (CSX also owned publishing firms, an aviation company, resorts, a real estate firm, and a natural resources subsidiary.) The company reported

Mechanized equipment handles most track chores these days, but there's still a need for the human touch. This Seaboard Coast Line gang is replacing a switch at Owensboro. (Courtesy Fred Clark Jr.)

first year revenues of $4.8 billion. That same year, Congress approved the famed Staggers Act, freeing railroads like CSX from outdated economic regulations.

After the merger was consummated, CSX eliminated many redundant facilities and offered new services. For example, its huge phosphate facility at Rockport dispensed with the need for a loading dock at Port Boca Grande, thus the latter was dismantled beginning in late 1981. To increase piggyback traffic, the company launched a new train between Orlando and Wilmington, Delaware called the *Orange Blossom Special.* (It carried 45-foot refrigerated trailers that contained fresh fruits and vegetables.) In 1982, the company's railroad properties were folded into a new division called CSX Rail Transportation. Later, in 1986, a $19 million intermodal terminal opened in Jacksonville to expedite the movement of piggyback trailers. CSX Transportation abandoned many money-losing lines in the 1980s or occasionally sold or leased such routes to smaller railroad companies called shortlines. To streamline its rail operations, CSX also reduced its number

of operating divisions from 15 to 9, plus the company constructed a centralized dispatching center in west Jacksonville.

1n 1988, CSX revenues topped $7.5 billion. Again, management reiterated its desire to reduce the railroad's size to 15,000 miles and about 30,000 workers. To achieve these goals, labor buyouts and furloughs became the order of the day and many unprofitable lines were taken up. Today, CSX Transportation operates about 23,000 miles of track in two dozen states and parts of Canada. About 1,700 miles are located in Florida, nearly 60 percent of the state's total. The company employs approximately 7,700 workers in the Sunshine State and its annual payroll amounts to $360 million. Major freight yards are located in Jacksonville, Tampa, Orlando, and Pensacola, with additional support facilities at Auburndale, Baldwin, Lakeland, Mulberry, and Wildwood. The company also operates several automobile distribution centers, notably at Jacksonville and Tampa.

During the 1970s, the Florida East Coast Railway purchased new locomotives, improved its mainline track, razed decrepit stations, and aggressively sought piggyback traffic. The branch from Titusville to Benson Junction vanished along with the one stretching to East Palatka from Bunnell Junction. Revenues broke the $100 million mark in 1980, the same year that the company declared its very first dividend. In 1984, FEC stockholders allowed an existing subsidiary, Florida East Coast Industries, to become a holding company for the railway along with its real estate division. In 1990, the FEC hauled about 400,000 piggyback trailers and containers. The following year, the company signed a haulage agreement with the Norfolk Southern Corporation. The latter conveyed piggyback trailers from Macon, Georgia to Bowden Yard in Jacksonville, while the FEC supplied engines, cars, and crews. In 1996, the FEC operated about 540 miles of track and owned nearly 80 locomotives and over 2,700 freight cars. Major traffic producers included piggyback trailers, containers, rock and mineral aggregates, automobiles, and sugar. At Jacksonville, the company continues to interchange traffic with Norfolk Southern and CSX. Other major yards and intermodal ramps are operated at Fort Pierce and Hialeah. In 2000, FEC reported a net income of $25.7 million on revenues of $276.2 million. Currently, the Florida East Coast Railway operates about 350 miles in Florida, about 13 percent of the state's total.

CSX sold that portion of its railroad between Sebring and Lake Harbor (by way of Palmdale and Moore Haven) to the railroad unit of Lukens Steel in June 1990. The latter organized a new company to operate the acquisition, the South Central Florida Railroad based in Clewiston. In September 1994, Lukens sold this shortline to the United States Sugar Corporation, which renamed it South Central Florida Express. Among the commodities transported by the company are cut cane, bulk raw sugar, fertilizers, molasses, liquid petroleum gas, pulpwood logs, rolled paper, and farm equipment. The shortline signed a traffic agreement with the Florida East Coast Railway in 1998, enabling to operate the FEC's branch from Lake Harbor to Fort Pierce. In 1999, South Central Florida Express moved approximately 72,000 carloads of freight. Today, the company operates about 158 miles, roughly 6 percent of the state's total.

CSX leased two rail lines in Southwest Florida in November 1987 to the Bay Colony Railroad of Lexington, Massachusetts. Its owners then organized a partnership called Seminole Gulf Railway. Seminole Gulf immediately acquired used locomotives and began operations on its 78-mile Fort Myers Division from Arcadia south to Punta Gorda, Fort Myers, Bonita, and Vanderbilt. Then, it started service on its 30-mile Sarasota Division from Oneco south to Sarasota and Venice. Connections with CSX are made at Arcadia and Oneco. In 1988, the Fort Myers–based shortline transported 14,500 carloads of traffic—10 percent more than CSX had in the prior year. Among the commodities conveyed by Seminole Gulf are building materials, plastics, liquefied petroleum gas, forest products, stone, beer, and newsprint. Later, the company inaugurated dinner and excursion trains.

The Apalachicola Northern Railroad—whose origins were highlighted in Chapter 7—was failing in the late 1930s due to competition from truckers, buses, and automobiles. Little maintenance occurred, its track rapidly deteriorated, and the 96-mile shortline could not afford new cars and engines. All that changed in the late 1940s, when the company was acquired by St. Joe Paper (in turn, owned by the testamentary trust of Alfred I. duPont). Edward G. Ball, its trustree, oversaw a rehabilitation of the Apalachicola Northern. Heavier rail was installed, many bridges were rebuilt, and new diesel-electric locomotives were acquired. In recent years, though, traffic patterns have shifted on this carrier. In September 2002, the St. Joe Paper Company turned its railroad operation over to Rail Management Corporation, a firm that also operates the Bay Line Railroad out of Panama City. Two months later, the dismantlement of the huge Port St. Joe paper mill began,

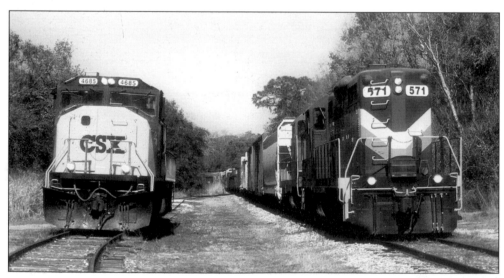

CSX makes life possible for the Seminole Gulf Railroad. At Arcadia, the shortline receives its cars from CSX, whereupon its "Arcadia Turn" journeys back to Fort Myers. (Courtesy Scott A. Hartley.)

"Street running" can still be observed in Florida. Here, a Florida Northern train (with Florida Central power) advances along Osceola Avenue in Ocala in May 2001. (Courtesy Bob Pickering.)

promising to furnish the railroad with many carloads of scrap metal. The shortline continues to make connections with CSX at Chattahoochee.

The Georgia, Southern & Florida operated several lines into Florida from southern Georgia. In 1895, the Southern Railway acquired a large stake in the GS&F and gained control of the firm. In 1982, the Southern merged with the Norfolk & Western to form the 17,000-mile Norfolk Southern Railway—a marriage that united two of the most progressive carriers in America. Today, Norfolk Southern oversees two routes into the state from Valdosta, Georgia. One terminates at Jacksonville, where the firm operates a large switching yard and intermodal facility, plus serves the port area. The second route once terminated at Palatka. However, in recent years, the line has been cut back to Navair, south of Lake City. In 2001, Norfolk Southern had revenues of $6.1 billion. In Florida, it employs 140 workers and generates an annual payroll of $4.2 million. The company maintains running rights over portions of the Florida East Coast Railway and CSX.

The Pinsly group of shortlines was founded in New England in 1938 by Samuel M. Pinsly. Three entities of the corporation operate in Florida, using track formerly owned by CSX. The Florida Central, which began operations in 1986, operates from the CSX connection at Orlando to Umatilla by way of Toronto, Plymouth, Zellwood, and Eustis. Several branches stem from the mainline to reach Sorrento, Forest City, and Winter Garden. The Florida Midland Railroad began operations the following year with two unconnected segments of track: one from West Lake Wales to Frostproof and another from Winter Haven to Gordonville.

Connections with CSX are made at West Lake Wales and Winter Haven. Service on the Florida Northern Railroad began in 1988. CSX connections are made at Ocala. From there, the Florida Northern track runs north to Lowell and south to Candler. A variety of traffic is handled on the Pinsly Lines, such as limestone products, fertilizer, coal, foodstuffs, chemicals, lumber, stone, scrap metal, fly ash, furniture, and citrus juices. The company's trio of Florida operations are based in Plymouth.

The aforementioned Georgia, Southern & Florida subsidiary of the Southern Railway acquired two north Florida lines in 1954: the South Georgia Railroad (from Adel, Georgia south to Perry, Florida) and the Live Oak, Perry & Gulf Railroad (from Perry east to Live Oak). For many years the GS&F operated the two firms independently; however, in 1972 the Southern merged them as the Live Oak, Perry & South Georgia Railroad. A decade later, the Southern Railway merged with Norfolk & Western to become the Norfolk Southern Corporation. Business and traffic changed on the north Florida line to Foley and in 1995, Norfolk Southern sold its Live Oak, Perry & South Georgia subsidiary to the Gulf & Ohio Railway. Four years later, the line was picked-up by Georgia & Florida RailNet, based in Albany, Georgia. (Its parent firm is North American RailNet.) Today, the Georgia & Florida RailNet transports wood, pulp, paper, and allied products.

The State of Florida, through its Department of Transportation, owns 81 miles of railroad from West Palm Beach to Miami. The state acquired the South Florida Rail Corridor from CSX in May 1988 for $264 million. At that time, Interstate 95 was being widened, and state transportation planners envisioned a temporary commuter rail to ease congestion as the project progressed. The popularity of the railroad, however, proved successful and consequently it became a permanent fixture. The Tri-County Commuter Rail Authority (TCRA) began push-pull train operations in January 1989 using a contract operator. Marketing and customer services are provided by Tri-Rail, while CSX maintains the track and dispatches trains. Construction of a second mainline track will be fully completed in 2005. Increased ridership prompted Tri-Rail to lately erect new stations at Sheridan Street in Hollywood, Opa Locka, and Mangonia Park. Engine and car maintenance is carried out at Hialeah using facilities of the old Seaboard Air Line Railroad. Today, about 8,000 passengers are transported daily on Tri-Rail. Administrative offices are located in Pompano Beach, and the carrier employs about 70 people.

A brief sketch of the Atlanta & St. Andrews Bay Railway appeared in Chapter 7. Stone Container Corporation eventually acquired the 81-mile carrier, which runs north of Panama City to Cottondale and Dothan, Alabama. In January 1994, Stone sold the firm to Rail Management Corporation, which operates 13 railroads in 11 states. The Florida carrier then received a shortened name: Bay Line Railroad. Company headquarters remain in Panama City and traffic consists of wood chips, paper products, chemicals, steel pipe and plate, aggregates, petroleum products, agricultural commodities, pulp board, and truck trailers. Connections with CSX are made at both Cottondale and Dothan. In 2002, the Bay Line

Railroad employed 35 workers and owned 12 locomotives. About 28,000 carloads of freight are transported annually.

The Florida land boom of the 1920s spawned many rail lines. The St. Louis–San Francisco Railroad got into the act by rebuilding a line into Pensacola from Kimbrough, Alabama. In 1980, the Frisco was acquired by the Burlington Northern which, in 1995, merged with the Santa Fe forming the Burlington Northern Santa Fe (BNSF). Two years later, BNSF sold its line into Pensacola to States Rail. Today, Rail America of Boca Raton, the world's largest shortline operator, owns it. The latter renamed the firm the Alabama & Gulf Coast Railroad and established headquarters at Monroeville, Alabama. Forest products and paper are principally carried on the shortline, which operates about 44 miles in the Sunshine State.

The Florida West Coast Railroad started operations in 1989 by leasing track from CSX. Initially, its line ran between Newberry and Chiefland, but today the shortline terminates at Trenton, site of company headquarters. Cars are interchanged with CSX at Newberry. Cattle feed is the main commodity transported on this 14-mile carrier. About 800 carloads are transported over the route each year, and at Christmas the railroad operates its popular "Santa Claus Special."

As noted earlier, Amtrak evolved during the days of the Seaboard Coast Line Railroad. The company itself owns no tracks in Florida (it relies on CSX and the South Florida Rail Corridor for such), but does own its locomotives and cars. Periodically, the frequency and routing of its Florida trains are changed due

Amtrak's Auto Train pounds through DeLand in September 1996. The chisel-nose "Genesis" locomotives by General Electric are either loved or despised by rail enthusiasts. (Courtesy Bob Pickering.)

to ridership patterns or funding changes. A number of Florida cities currently benefit from Amtrak service. In the winter of 2002, five long-distance passenger trains were in operation: the *Palmetto* (from New York to Jacksonville, Ocala, Tampa, West Palm Beach, and Miami), the *Silver Star* and the *Silver Meteor* (from New York to Jacksonville, Orlando, West Palm Beach, and Miami), the tri-weekly *Sunset Limited* (from Orlando to Jacksonville, Tallahassee, Pensacola, New Orleans, and Los Angeles), and the *Auto Train* (from Lorton, Virginia to Sanford). In May 2001, Amtrak and the Florida East Coast Railway signed an agreement allowing Amtrak to use the FEC's coastline route from Jacksonville to Miami by way of Fort Pierce. Funding issues continue to be fine-tuned and the service has yet to commence.

In addition to the above companies, several industrial-type railroads currently operate in Florida, such as Jacksonville's Talleyrand Terminal Railroad and the NASA railroad operation at the Kennedy Space Center. Several tourist railroads also operate trains in the state, including the Orlando & Mount Dora Railroad in Mount Dora and the Florida Gulf Coast Railroad Museum in Parrish. Florida is also home to a number of railroad attractions, such as the Pioneer Florida Museum in Dade City, the Palatka Railroad Preservation Society, the South Florida Railway Museum in Deerfield, the Railroad Museum of South Florida in Fort Myers, the Gold Coast Railroad Museum in Miami, the Central Florida Railroad Museum in Winter Garden, and the West Florida Railroad Museum in Milton.

In bygone years, the nerve center of almost every Florida community was its railroad station or depot. Hundreds dotted the landscape, with some locales boasting two or more. Although most have met their demise, many have survived and today have been thoughtfully preserved. Some contain railway artifacts, while others are commercially occupied or used for nonprofit purposes. Several even serve railroad passengers. Among the many are Archer, Arcadia, Barberville, Deerfield Beach, Dade City, DeLand, Dunedin, Fort Lauderdale, Fort Myers, Frostproof, Hollywood, Jacksonville, Lady Lake, Lake Placid, Lake Wales, Largo, Mulberry, Naples, Ocala, Orlando, Palatka, Pompano Beach, Punta Gorda, San Antonio, Tampa, Trenton, Trilby, Umatilla, West Palm Beach, Winter Garden, and Zephyr Hills. Several stations are being restored as this book goes to press, including the splendid Seaboard Air Line Railway structure at Venice that was constructed during the land boom of the 1920s.

In closing, about 2,900 miles of railroad routes currently exist in Florida. Local, state, and federal agencies continue to study projects that will enhance railway transportation within the state. One of the most significant and controversial initiatives is the Florida High Speed Rail Act, which the legislature passed after a public mandate in March, 2001. Members to the authority were appointed that July and since then, the entity has conducted numerous meetings throughout the state. Currently, the authority is developing ridership studies and soliciting design proposals for the portion of its project between Tampa and Orlando. Electrified 120-mile-per-hour train service is envisaged all the way to Miami.

BIBLIOGRAPHY

Bathe, Greville. *The St. Johns Railroad*. Philadelphia: Allen, Lane & Scott, 1958.

Black, Robert C. III. *The Railroads of the Confederacy*. Chapel Hill: The University of North Carolina Press, 1998.

Bowden, Jesse Earle. *Iron Horse in the Pinelands*. Pensacola, FL: Pensacola Historical Society, 1982.

Bramson, Seth. *Speedway to Sunshine*. Erin, Ontario: The Boston Mills Press, 2003.

Daniels, Jonathan. *Prince of Carpetbaggers*. Philadelphia, PA: J.B. Lipincott, 1958.

Dodd, Dorothy. "Railroad Projects in Territorial Florida." Masters thesis, Florida State College for Women, 1929.

Doherty, Herbert J., Jr. "Jacksonville as a Nineteenth-Century Railroad Center." *Florida Historical Quarterly*, Vol. 58: 373–386.

Fenlon, Paul E. "The Florida, Atlantic and Gulf Central Railroad." *Florida Historical Quarterly*, Vol. 32 (October 1958).

———. "The Notorious Swepson-Littlefield Fraud." *Florida Historical Quarterly*, Vol. 32 (April 1954).

Gallagher, Dan. *Florida's Great Ocean Railway*. Sarasota, FL: Pineapple Press, 2003.

Gerstner, Franz Anton. *Early American Railroads*. Sacramento, CA: Stanford University Press, 1997.

Goolsby, Larry. *Atlantic Coast Line Passenger Service, The Postwar Years*. Lynchburg, VA: TLC Publishing, 1999.

Griffin, William E., Jr. *Atlantic Coast Line—Standard Railroad of the South*. Lynchburg, VA: TLC Publishing, 2001.

———. *Seaboard Air Line Railway, The Route of Courteous Service*. Lynchburg, VA: TLC Publishing, 1999.

Hildreth, Charles W. "Railroads Out of Pensacola." *Florida Historical Quarterly*, Vol. 37. (January 1959).

Hill, Ralph J. and James H. Pledger, compilers. "The Railroads of Florida." Tallahassee, FL: Florida Railroad Commission, 1939.

Hoffman, Glenn. *A History of the Atlantic Coast Line Railroad Company*. Richmond, VA: CSX Corporation, 1998.

Johnson, Dudley S. "The Railroads of Florida, 1865-1900." Doctoral thesis, Florida State University, 1965.

———. "Henry Bradley Plant and Florida." *Florida Historical Quarterly*, Vol. 45. (October, 1966).

Johnson, Robert Wayne. *Through the Heart of the South, The Seaboard Air Line Railroad Story*. Erin, Ontario: Boston Mills Press, 1995.

Johnston, William R. *William and Henry Walters, The Reticent Collectors*. Baltimore: The Johns Hopkins University Press, 1999.

Joubert, William Harry. "A History of the Seaboard Air Line Railway Company." Masters thesis, University of Florida, 1935.

Key, R. Lyle, Jr. *Midwest Florida Sunliners*. Godfrey, IL: RPC Publications, 1979.

Long, Durward. "Florida's First Railroad Commission, 1887–1891 (Part 1)." *Florida Historical Quarterly*, Vol. 42. (October, 1963).

———. "Florida's First Railroad Commission, 1887–1891 (Part 2)." *Florida Historical Quarterly*, Vol. 42. (January, 1964).

Lord, Mills M. Jr. "David Levy Yulee, Statesman and Railroad Builder." Masters thesis, University of Florida, 1940.

Mann, Robert W. *Rails 'Neath the Palms*. Burbank, CA: Darwin Publications, 1983.

McCullough, Mildred W. "Legislative Regulation of Florida Railroads, 1845–1897." Masters thesis, Florida State College for Women, 1940.

Murdock, R. Ken. *Outline History of Central Florida Railroads*. Winter Garden, FL: Central Florida Chapter, National Railway Historical Society, 1999.

Parks, Pat. *The Railroad That Died at Sea*. Key West, FL: Langley Press, 1998.

Parry, Albert. *Full Steam Ahead!* St. Petersburg, FL: Great Outdoors Publishing, 1987.

Pettengill, George W. Jr. *The Story of the Florida Railroads*, Jacksonville, FL: Railway & Locomotive Historical Society, 1998.

Prince, Richard E. *Atlantic Coast Line Railroad—Steam Locomotives, Ships and History*. Bloomington, IN: Indiana University Press, 2000.

———. *Seaboard Air Line Railway—Steam Boats, Locomotives and History*. Bloomington, IN: Indiana University Press, 2000.

Shappee, Nathan D. "The Celestial Railroad to Juno." *Florida Historical Quarterly*, Vol. 40. (April 1962).

Shofner, Jerrell H. and William Warren Rogers. "Confederate Railroad Construction: The Live Oak to Lawton Connector." *Florida Historical Quarterly*, Vol. 43 (January 1965).

Shrady, Theodore and Arthur M. Waldrop. *Orange Blossom Special—Florida's Distinguished Winter Train*. Valrico, FL: Atlantic Coast Line and Seaboard Air Line Railroads Historical Society, 2000.

Smyth, G. Hutchinson. *The Life of Henry Bradley Plant*. New York: G.P. Putnam, 1898.

Standiford, Les. *Last Train to Paradise*. New York: Crown Publishers, 2002.

Stover, John F. *The Railroads of the South, 1865–1900*. Chapel Hill, NC: University of North Carolina Press, 1955.

Turner, Gregg M. *Railroads of Southwest Florida*. Charleston, SC: Arcadia Publishing, 1999.

Watkins, Caroline. "Some Early Railroads in Alachua County." *Florida Historical Quarterly*, Vol. 53. (1975).

Warren, Bob and Fred Clark, Jr. *Seaboard Coast Line, A Pictorial History*. Newton, NJ: Carstens Publications, 1985.

Welsh, Joseph M. *By Streamliner, New York to Florida*. Andover, NJ: Andover Junction Publications, 1995.

Williamson, Edward C. "W.D. Chipley, West Florida's Mr. Railroad." *Florida Historical Quarterly*, Vol. 25. (April 1947).

INDEX